ISLE OF MAN TT
THE PHOTOGRAPHIC HISTORY

With special thanks to
Steve Colvin, Steve Parker, Ian Kerr,
Island Photographics and David Wright.

First published in 2015 by
Carlton Books
20 Mortimer Street
London W1T 3JW

This revised edition published in 2016 by Carlton
Books Limited

10 9 8 7 6 5 4 3 2 1

A CIP catalogue record for this book is available
from the British Library.

ISBN: 978-1-78097-872-7

Project Art Editor: Luke Griffin
Editorial: Caroline Curtis, Steve Dobell & Philip Wain
Picture Research: Paul Langan
Production: Maria Petalidou
Project Editor: Matthew Lowing and Chris Mitchell

Opposite Grimsby-born Guy Martin
at Guthries in 2014, with the north
of the Island as a stunning backdrop.

ISLE OF MAN TT

THE PHOTOGRAPHIC HISTORY

100 Years of Images from the World's Greatest Road Race

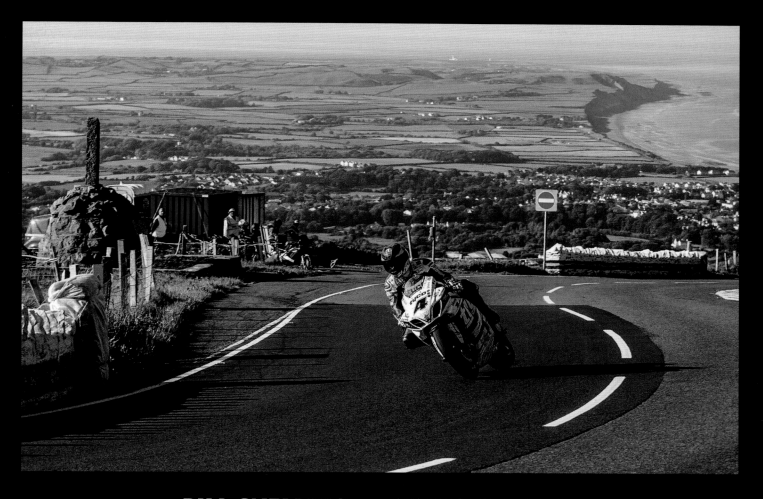

BILL SNELLING WITH **MICHAEL SCOTT**

FOREWORD BY TT RACE LEGEND **JOHN McGUINNESS**

CARLTON
BOOKS

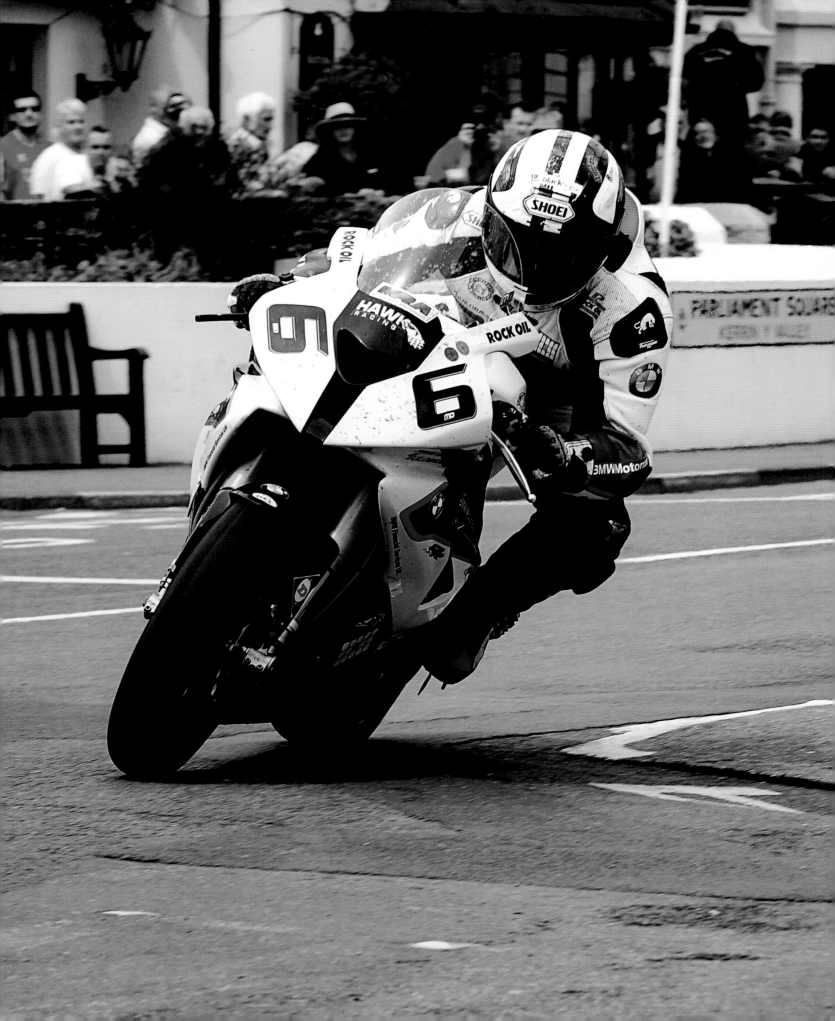

Contents

Opposite Michael Dunlop (BMW) is the latest member of the Dunlop dynasty to win multiple TT races. His father, Robert, won five TTs and his uncle, Joey, an incredible 26.

Foreword John McGuinness

Anyone who goes to the Isle of Man TT races year on year knows what a magical, iconic and unique spectacle it is. Quite simply, there's nothing else like it and not only is it the greatest motorcycle race in the world, it's, without doubt, one of the greatest sporting events in the world.

I went for the first time in the early 1980s and even though I was just a kid, I knew that racing at the TT was the one thing I wanted to do more than anything else. The atmosphere, the course, the island, the riders, the event, everything about it grabbed me and it's been well documented how I used to jump on the ferry with my BMX to go and watch people like Joey Dunlop and Steve Hislop in action. I just knew that I wanted to be a TT rider.

When that time came, in 1996, I had no idea if I was going enjoy it, never mind be any good. I just went with the attitude that I'd go there and if I didn't like it, I'd put the bike in the van. And if I did enjoy it, it would be mission accomplished. I never in a million years thought I'd go on to win one TT, never mind be sitting here now with 21.

Nothing can prepare you for that first lap, no matter how much homework you've done, but it's a feeling you'll never forget. I had rain, wind, sun and all sorts on my first lap! At the same time, though, it was exhilarating and I can 100 per cent say that the feeling of riding on the Mountain Course is like no other, but also one that's hard to describe.

From the outside, it may all look a bit mad, but we know what we're doing and I know for a fact that there are some incredibly skilled and talented sportsmen – and women – in each and every race. You have to be professional, committed and dedicated otherwise you wouldn't be able to do it. You'll never succeed if you don't approach it that way.

I still get nervous, just like anyone else. When I'm sat on that grid, moments before a race, I get butterflies. But as soon as you get that tap on the shoulder and you head towards the terrifying drop down Bray Hill, they disappear. Years ago, you could ease your way into a race, but now it really is a case of every second counts, so the moment you drop the clutch, you're giving it everything you can.

So many people have played a part in the history of the TT, and wherever you are in the world, if there's one motorbike race people will have heard of, it's the Isle of Man TT. They know of its heritage, its importance in the sporting world and also to the Manx population and why it attracts thousands of people year after year.

Sometimes, words don't do it justice. Pictures say a thousand words, though, and I think that's certainly true in regards to the TT, as whenever you see pictures, whether old or new, they always tell a story. They always capture the essence of what it's all about and there are always things on a TT picture that will create plenty of conversation and intrigue.

This book gives a superb snapshot of the history of the TT, so I hope you all enjoy it as much as what I have.

Opposite John McGuinness is one of the greatest TT motorcycle riders of all time. The race legend has an incredible 23 course wins and more podium finishes than any other rider.

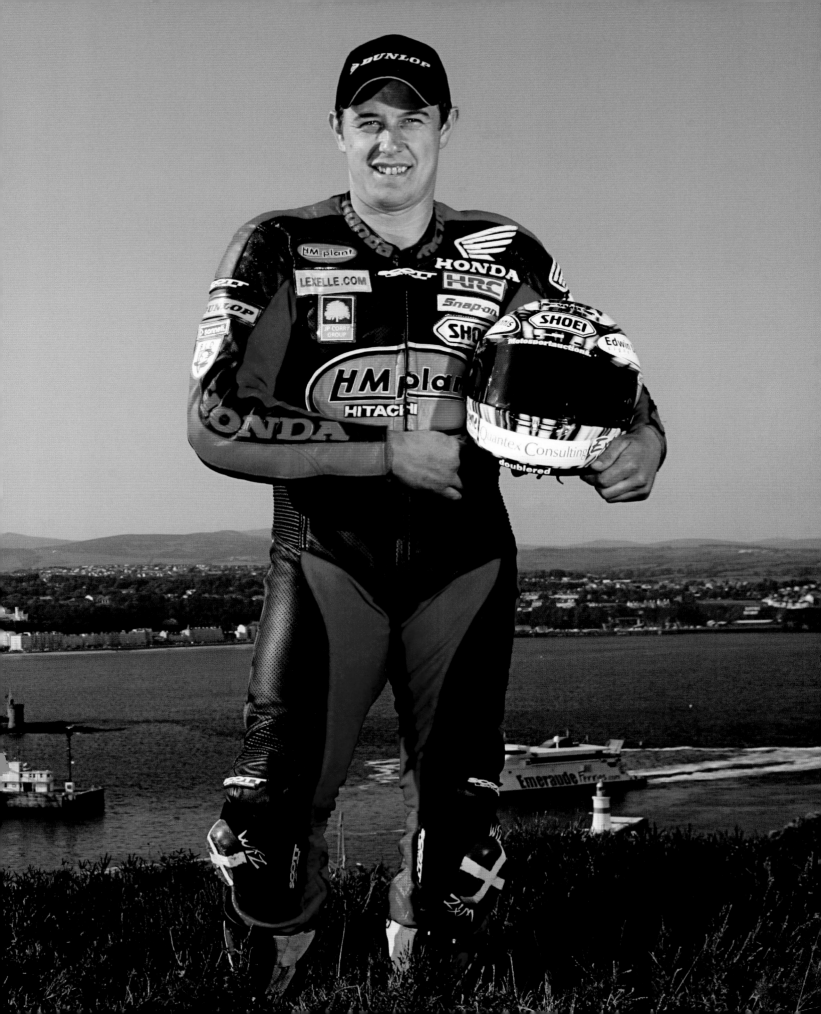

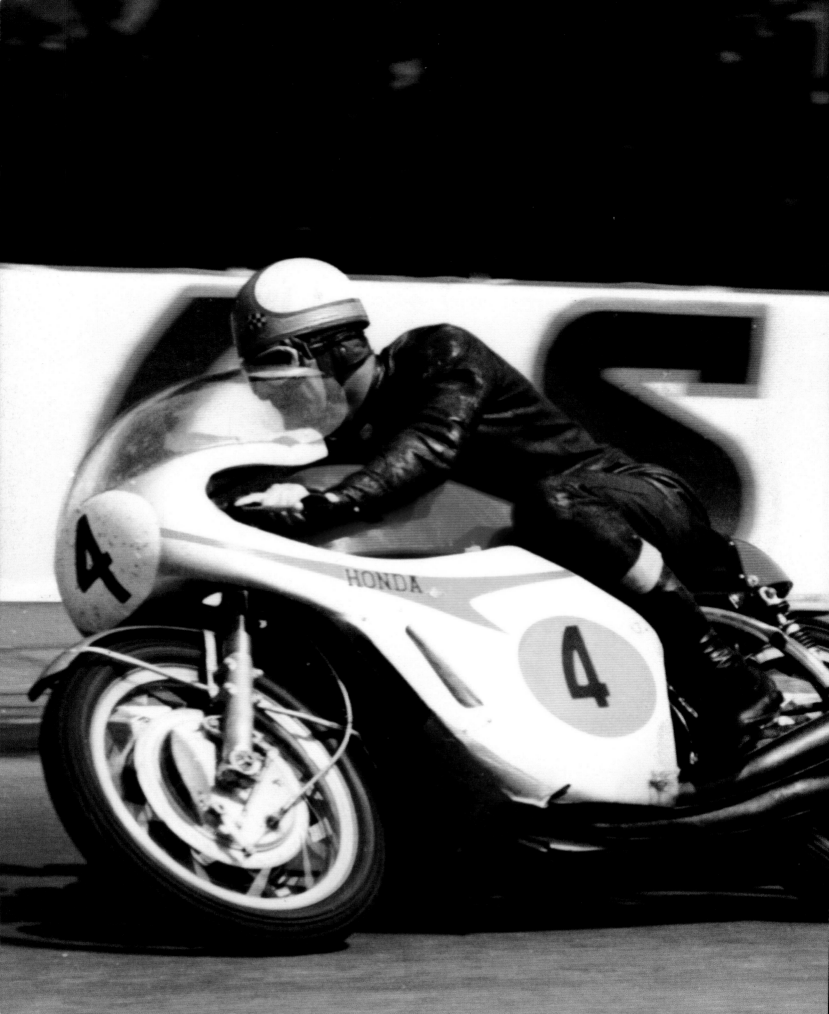

Introduction Bill Snelling

My interest in the TT races was fuelled by the weekly magazines *The Motor Cycle* and *Motorcycling*, which gave a full report of the practice and race weeks. Our first visit was in 1960; the family set up camp on the bank at Glen Helen and we waited for the 1960 Ultra Lightweight TT. The third rider to come through, slid gracefully to earth at our feet; it was Mike Hailwood (Ducati), then only a rising star.

Coincidentally, I was sitting in the Braddan churchyard one morning in 1966 when a multi-cylindered machine came wailing down Bray Hill, rounding Quarter Bridge and heading for Braddan. It changed down twice and then – silence. Into view came Mike the Bike, alongside his Honda; a missed gear and no flywheel effect had stopped the Honda 6 engine dead. The marshals collected Mike and bike, checked them over and he rode back to the Grandstand via Cronk-ny-Mona.

Mike's return to the TT in 1978 gave a big boost to the attendance figures. In 1979 I was watching at Ramsey Hairpin as Mike and Alex George fought out the Senior Classic race. The sound of the crowd as Mike rounded the hairpin was awesome, but as he headed for the Waterworks he shook his head. His RG 500 Suzuki was being outpaced by the twice-the-size Honda.

I attended most TTs until 1977, when I saved the boat fare by living on-Island. The Cadbury refreshment tent, getting the midnight boat and heading straight from the docks to watch early morning practice – all are distant memories now.

In the 1970s I was the gofer and pit attendant for Ray Knight at the TT. In 1970 Ray had borrowed a Boyers of Bromley Triumph Daytona for the 500 Production race. The motor was, in Stan Shenton's words, a little "tired", so we worked out an agenda for the pit stop. I handed Ray the fuel filler to recharge the tank, then ran round the bike to drop a quart of oil in the tank. It was enough to get the bike to the finish, Ray taking third place after a fairing-bashing session at Hillberry with runner-up Gordon Pantall. In the finishers' enclosure, all we could see in the oil tank was – smoke!

I was fortunate enough to ride the Mountain Course myself in 1978, starting at No. 1 in the first Newcomers MGP. From three rides I achieved a 100 per cent finish rate – not fast, but not last!

I was also lucky to see the unforgettable 1992 Senior TT duel between Hizzy and Foggy. Foggy had plenty of supporters on the bank that day, but as he passed us on the last lap at Brandish, he shook his head, knowing that victory had gone away from him. A colleague who was at the Creg that day recalls a Mexican wave of noise coming down the mountain, following Hizzy's progress.

These days, I run a charity TT / MGP photo and art exhibition at the Laxey Woollen Mills. Hope to see you all!

Opposite Mike "The Bike" Hailwood (Honda) during his epic dice with Giacomo Agostini (MV) in the 1967 Senior TT.

Introduction Michael Scott

In 1907, the Isle of Man TT pioneered motorcycle racing. For many years afterwards, it was *the* Motorcycle Race. Then, in the mid-1970s, the TT was stripped of World Championship status.

For riders and fans today, however, the TT remains *the* Motorcycle Race. Far from a small dedicated band, they flock to "the Island" 40,000-strong. Entry lists are full, accommodation overflowing, the hillsides crowded. The TT is an obsession that cannot be stopped.

Why should it be? Undoubtedly the most dangerous race in the world, the course runs on public roads, passing through towns and villages and over high misty hillsides, it can have none of the safety provisions of a modern race-track. In almost 38 miles, it is lined with kerbs and cottages, stone walls and trees, bus stops and graveyards...

It does not easily forgive.

The Mountain Course has claimed many lives and is the grim side of a pervasive fascination; the risks are part of the challenge. A sort of horizontal Everest.

The TT has more heroes than the Himalayan giant. It was a gruelling event from its inception in 1907. A 20 mph speed limit on the British mainland saw racers turn to the more accommodating Manx government. Cars were first, with the 1904 Gordon Bennett Trial. The next year the name Tourist Trophy appeared, and motorcycles joined in.

The all-motorcycle TT proper began in 1907: part economy and reliability run, and part feat of endurance. The first winners were Charlie Collier on his own-brand Matchless and Rem Fowler on a Norton,

in the surprisingly slower twin-cylinder class. The names would echo down the years. Especially Norton.

Collier took just over four hours to complete ten laps of a 15.8-mile circuit, at an average of 38.22 mph. By the time the race moved to the 37.7-mile Mountain Course in 1911, Indian-mounted winner Oliver Godfrey had raised it to 47.63 mph. Today's lap record, on fundamentally the same circuit, stands at 132.298 mph.

The final refinements to the Mountain circuit came in 1920. Measured at 37.733 miles (60.73 km), it starts and finishes at the IoM capital Douglas. Gallop across the breadth of the Island to Ballacraine, it then turns right, swerves through a narrow glen and swoops at staggering speeds across open country. At the 13th Milestone you are not even halfway; through Kirkmichael village and some more fast and complex bends and right again at Ramsey. Now the mountain section, at each end a slow hairpin. The road cuts across the flank of Snaefell at 2,034 feet (620 m); highest point on the Island, then across the adjacent hillside to plunge down to the famous Creg ny Baa hotel. Then back through Hillberry and Bedstead towards Douglas, the Governor's Bridge hairpin, and the end of a breath-taking lap.

The TT is not one of those races where you elbow your way to the front. From its inception, riders were started in pairs, nowadays singly, at timed intervals.

TT riders race the clock, their fears, their skills, at barely imaginable speeds.

The only reference is the road. Almost 38 miles of it. And a story for every inch.

Opposite Bruce Anstey on his way to victory in the 2015 Superbike race, securing his tenth Isle of Man win.

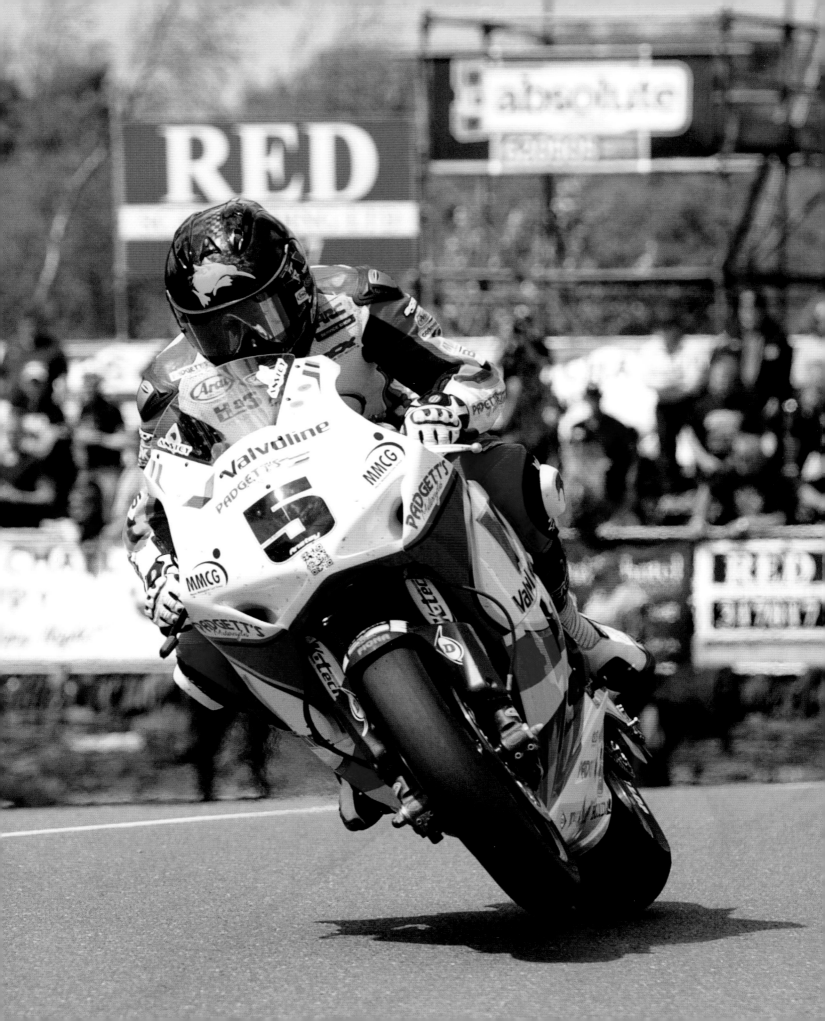

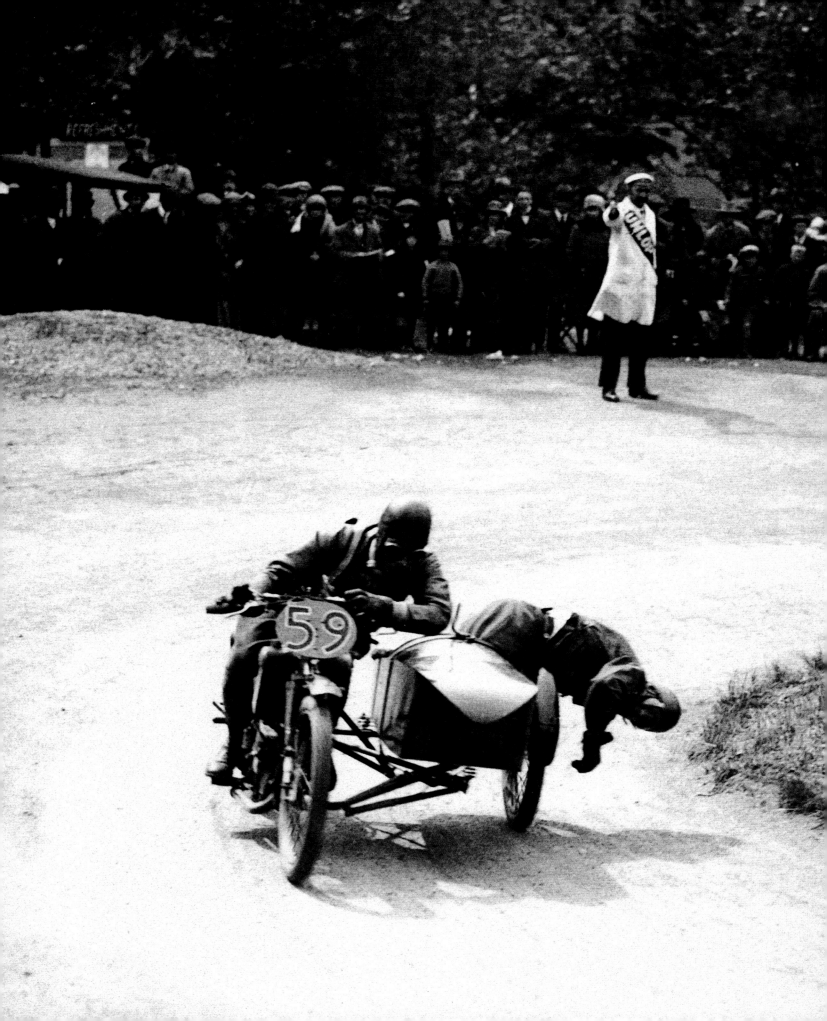

ISLE OF MAN TT
Before the Wars

Opposite Harry Langman and his acrobatic passenger Ernie Mainwaring take Ramsey Hairpin. They led the 1923 Sidecar TT, until Langman wiped Mainwaring against the brick wall at Braddan Bridge and overturned the outfit.

Before the Wars

The first controversy struck 1907 winner Charlie Collier. He'd used pedals on the steep climbs. For 1908, pedalling was banned.

In 1911 the race switched from the original St John's Short Course to the Mountain Course, and Junior (eventually 350cc) and Senior (500cc) classes were introduced; in 1920 Lightweights (250cc); in 1923 sidecars.

The roads were largely unpaved, the machines primitive – riders had to fix punctures and perform running repairs. Then in 1914, the First World War called a halt.

For the 1920 return, the track had been fully surfaced; by 1925 tarred.

The machines had leapt forward; the lap record now reached almost 70 mph.

Norton's Tim Hunt was the first double winner, Senior and Junior; other great names were Wal Handley and Scotsman Jimmy Guthrie. The greatest was Irishman Stanley Woods, with ten wins on a variety of machines.

His record would stand until 1967.

The final pre-war 1939 TT was ominous, as state-backed German BMWs took the first two places. Within months, Britain was at war with Germany.

Opposite Allwin Boldt (NSU) leads Charlie Collier (Matchless) at Cronk-ny-Mona in the 1911 Senior TT. Prior to 1920, the TT course turned right at Cronk-ny-Mona, missing out on the Signpost Corner/Governor's Bridge section. After the First World War, the course took its current 37.73-mile form.

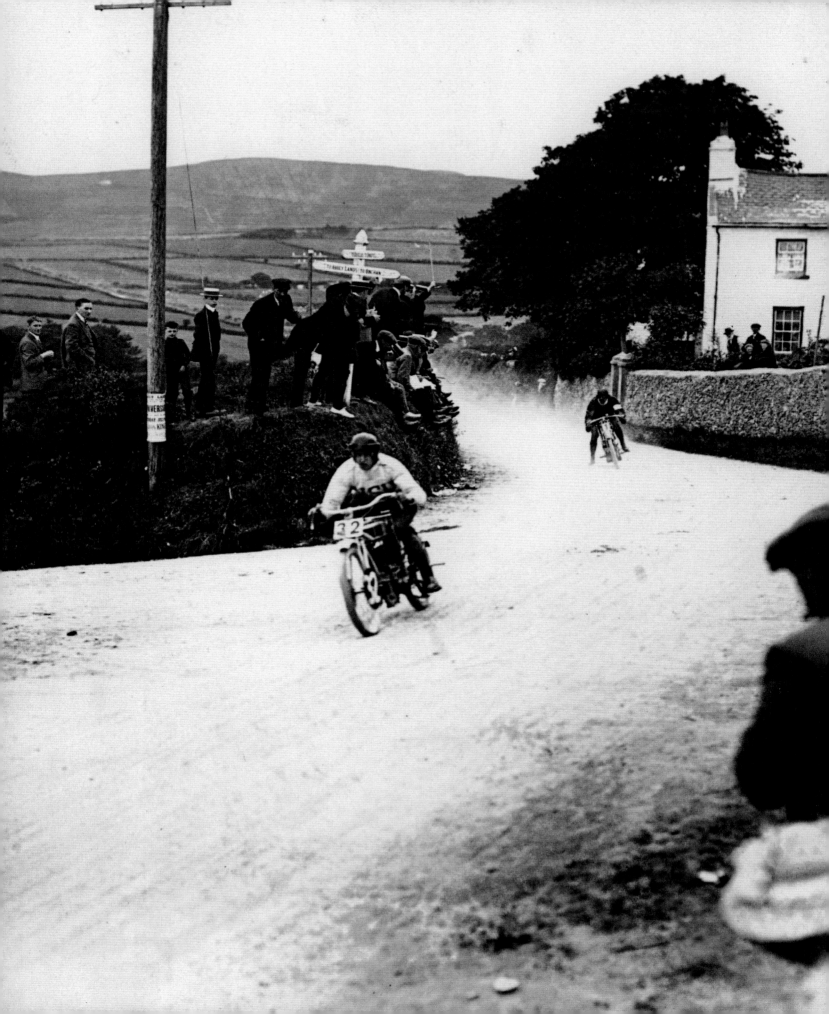

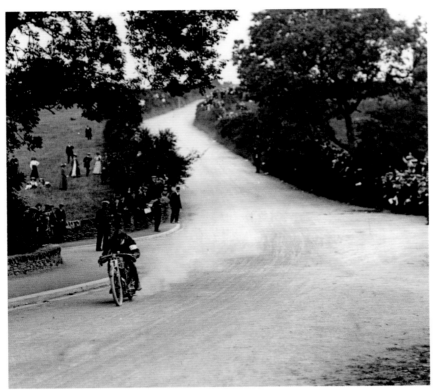

Left Harry Collier (Matchless) descends Bray Hill on his way to the finish on Quarter Bridge Road in the 1911 TT; this was the first year the Mountain Course was used. The Collier family made the Matchless motorcycles in Plumstead, London from 1899.

Below Eddie Kickham (Douglas) finished second in the 1912 Junior TT, beaten only by his team-mate Harry Bashall, but he set the fastest lap at 41.76 mph.

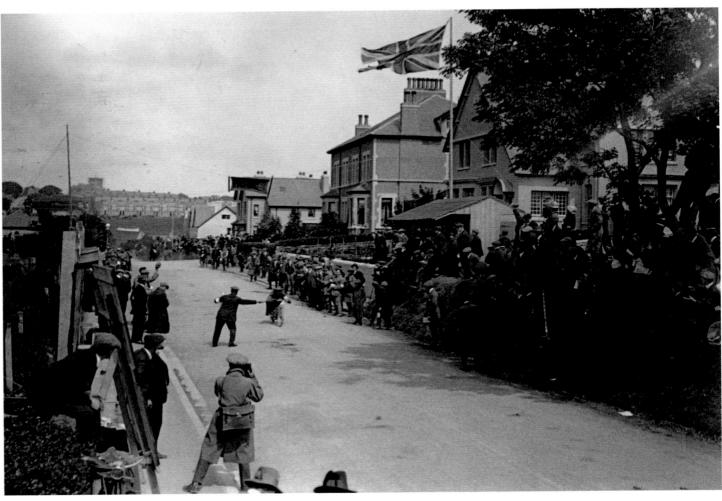

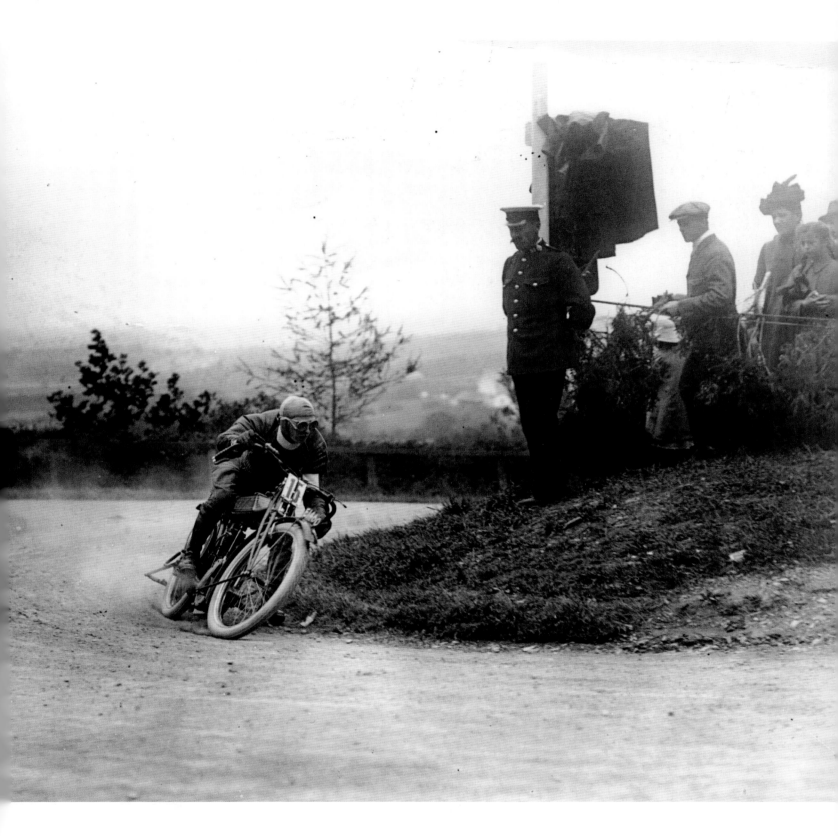

Above David C Bolton (Rudge) rounds Ramsey
Hairpin in the 1912 Senior TT. The Mountain
Course rises from sea level in Ramsey to
1,394 ft (425 m) at Brandywell. Bolton raced
cars and motorcycles at Brooklands.

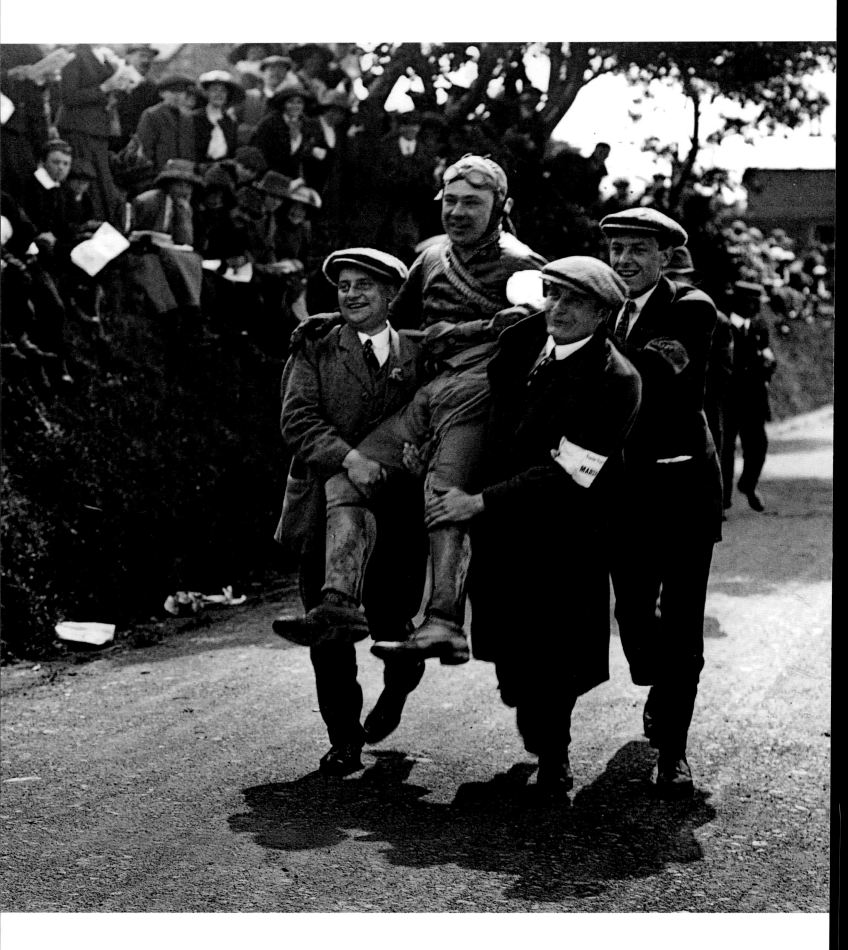

Opposite W Harry Bashall is carried shoulder-high after winning the 1912 Junior TT on a Bristol-built Douglas; they may be congratulating him, but equally they may be giving him physical assistance after a race of 150 miles on dirt roads, which took him over three-and-three-quarter hours!

Right Rider-manufacturer Jack Woodhouse on a 3.5 Regal Precision leading E B Ware on a 3.5 Zenith at Ramsey Hairpin; 1912 Senior TT.

Below The start line was moved to the top of Bray Hill for the 1914 Senior TT. No. 123 is J McMeekin Jr (Rudge), 124 is E H "Gaffer" Littledale (Ariel) and 125 is Ray Abbott (Triumph). Within months, the First World War had started.

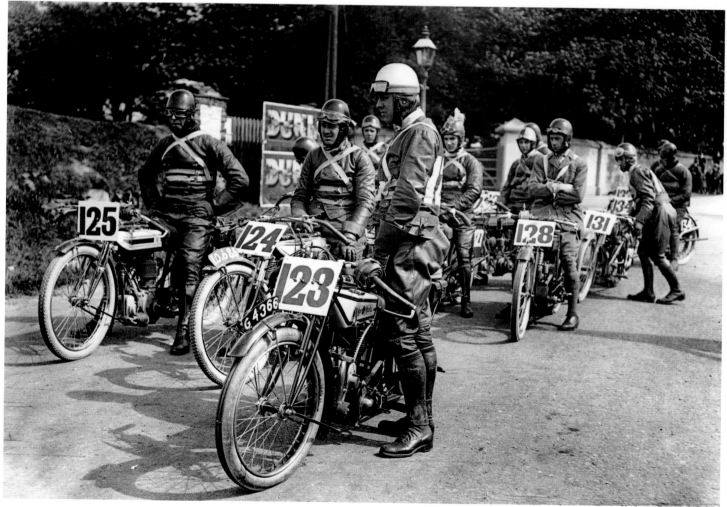

Above June 1923: The hairpin bend at Governor's Bridge catches out S Baines (Levis) in the 1923 Lightweight TT; H J Chambers (O.K. Junior) prepares to take avoiding action. Neither finished the race.

Right Luigi Archangeli (Moto Guzzi) finished second in the 1927 Lightweight TT, giving the Lake Como-based manufacturer their first TT podium.

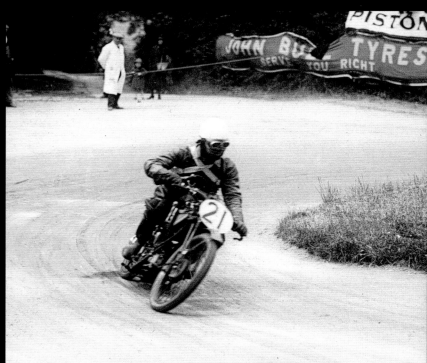

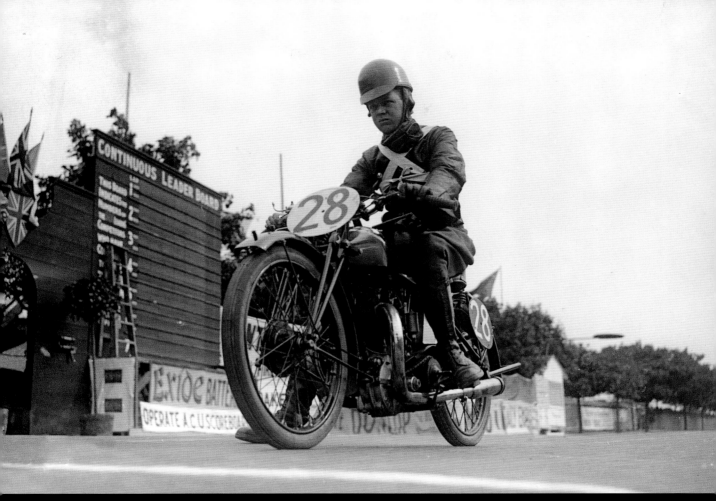

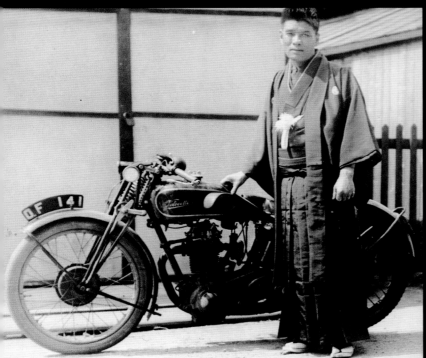

Above L Higson astride his Montgomery at the start of the 1927 Lightweight TT. He stopped mid-race to assist a fallen rider, but still finished tenth, winning a replica.

Left The first Japanese rider to compete at the TT, in 1930. Kenzo Tada worked for the Velocette agent in Japan; it took him 40 days of sailing and rail travel to get to the Island. Despite many falls in practice, Kenzo finished his only TT in 15th place.

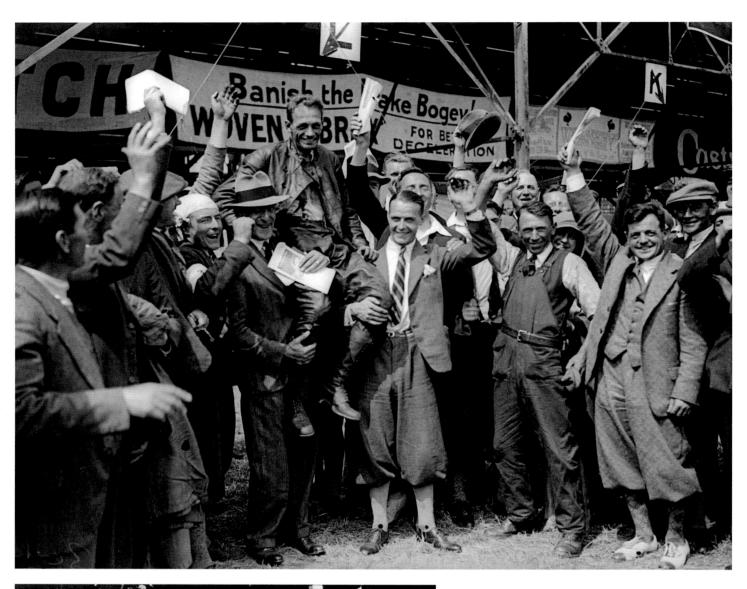

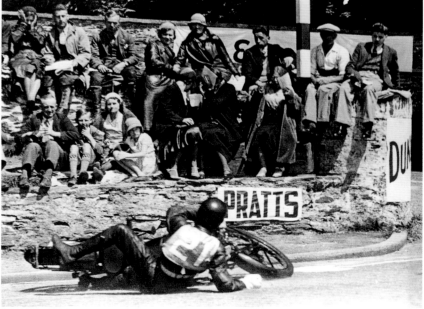

Above Scotland's Jimmy Guthrie taking the plaudits for his winning ride in the 1930 Lightweight TT on an AJS. Guthrie won six TT races, and is commemorated by the Guthrie Memorial on the mountain.

Left Wal Handley skids and comes off his Velocette in the 1933 Junior TT as the crowd looks on. He remounted his machine to finish seventh. Handley won four victories in his 12-year TT career.

Opposite The starting line-up for the 1938 Lightweight Manx Grand Prix, which is held on the TT course later in the year. Plans were in hand for the next year's meeting – in fact, some machines and riders were already on the island – when news of the Second World War brought an end to any hopes of racing on the TT course for eight long years.

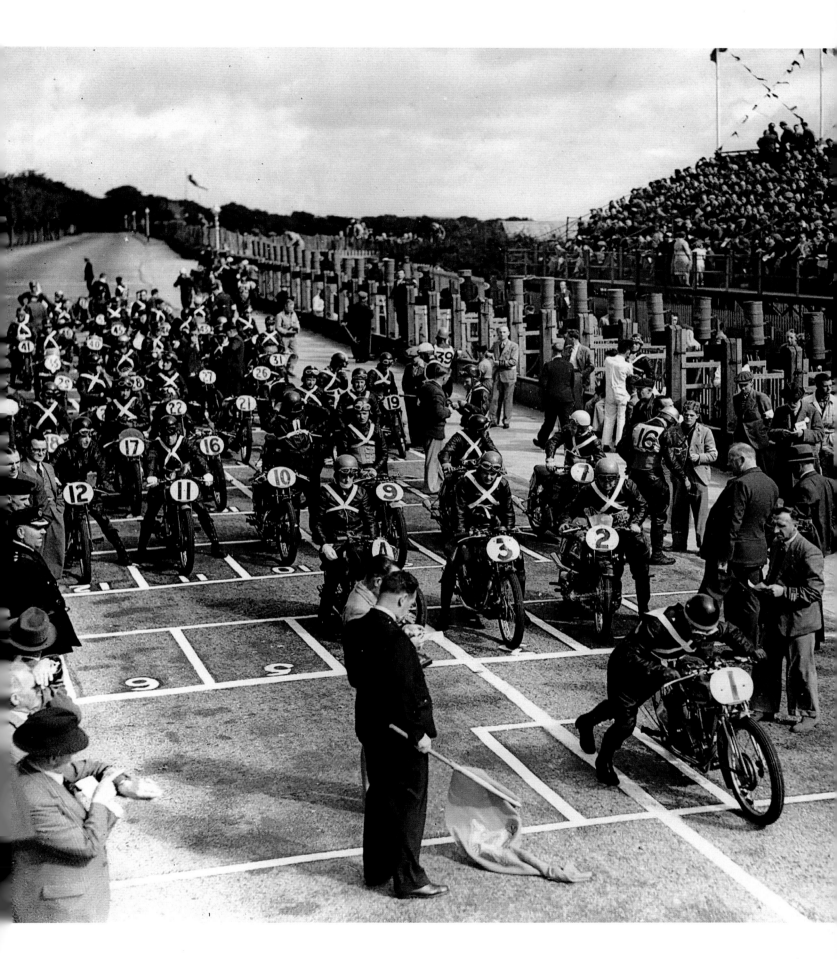

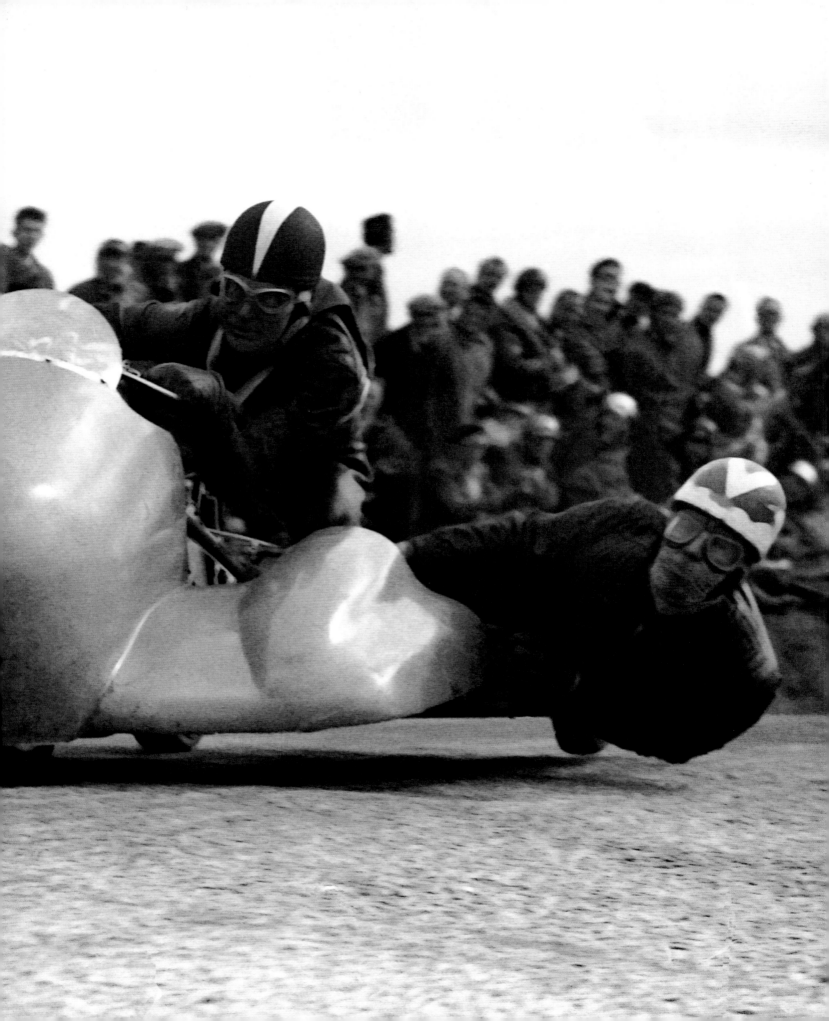

ISLE OF MAN TT
Post War
and the 1950s

Opposite Charlie Freeman and John Chisnall
(Norton) at Cronk-ny-Mona in the 1957 Sidecar TT,
held on the Clypse course (used between 1954
and 1959). Charlie finished fifth in this, his first TT.

Post War and the 1950s

The most significant event of the decade was the arrival of the "Featherbed" – the nickname given to Norton's well-sprung new frame by returning pre-war hero Harold Daniell.

The glory went to his new young team-mate Geoff Duke, who won the Senior at his first attempt, the Featherbed's first appearance.

Duke, a stylish and innovative rider, would go on to win six TTs, and post a tantalizing lap record of 99.97 mph in 1955, now riding a Gilera.

The ton – a full 100 mph – was breached two years later, by Bob McIntyre, also on a Gilera; but by then a new force was on the scene. In 1956 six-time winner and future F1 four-wheel champion John Surtees claimed the first Senior TT win on an MV (their first TT winner was Cecil Sandford, 1952 Ultra Lightweight TT).

Then another new force: Mike Hailwood, who first rode in 1958, winning four replicas from four rides; his first win was the 1961 Ultra Lightweight TT.

Machines now modernized, young stars blazing bright, the TT was set to begin a golden age.

And one major standard bearer had made a low-key start. Honda entered the 125 TT in 1959, winning the team prize.

Opposite Packed vantage points at Quarter Bridge watch Artie Bell (Norton), 1948 Junior TT. Artie finished third behind Freddie Frith (Velocette) and Bob Foster (Velocette), but went on to win the Senior TT that year.

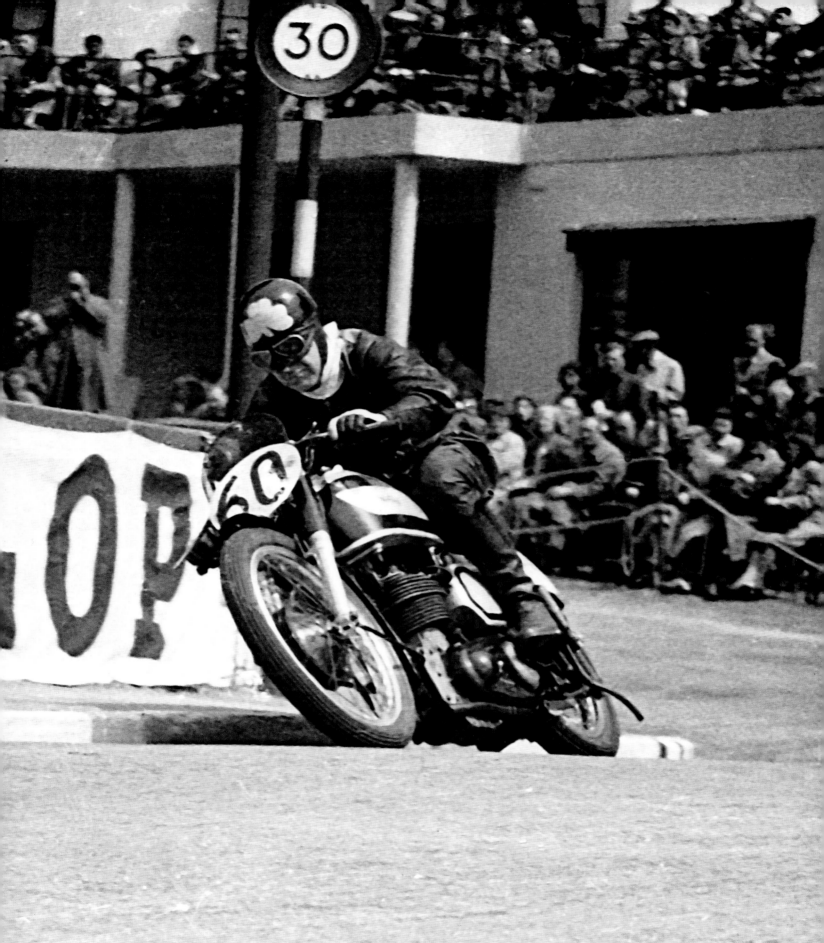

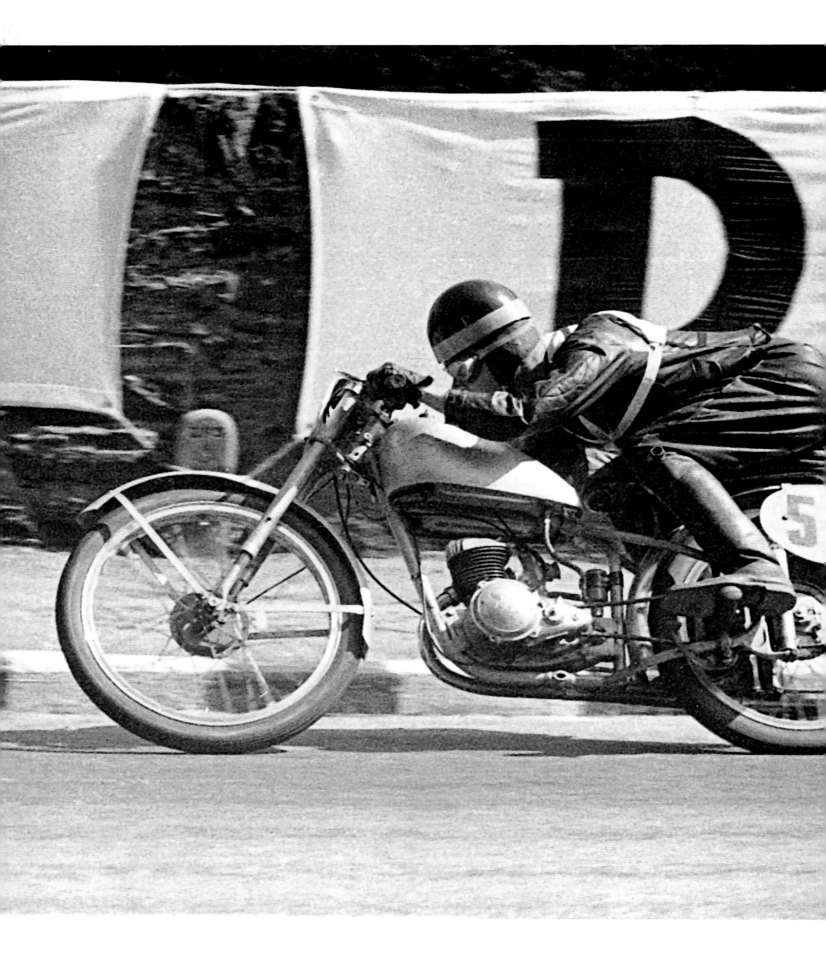

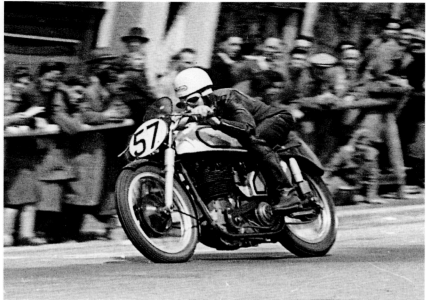

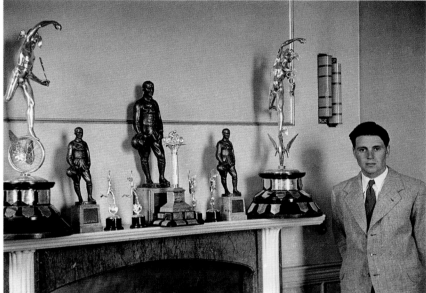

Top Geoff Duke on the Rex McCandless-framed "Featherbed" Norton shows supreme style on Bray Hill, winning the 1950 Senior TT.

Above Geoff Duke displays a magnificent mantelpiece of silverware, won at the 1951 TT. The Mercury trophies are the Junior and Senior TT-winning trophies, the figurine is the Jimmy Simpson trophy, the others replicas and team prizes. What a haul!

Left Charlie Salt coaxing every ounce of power out of his BSA Bantam in the 1951 Ultra Lightweight TT. Despite his heroic efforts, he finished 13th, 26 minutes behind the leader Cromie McCandless (Mondial).

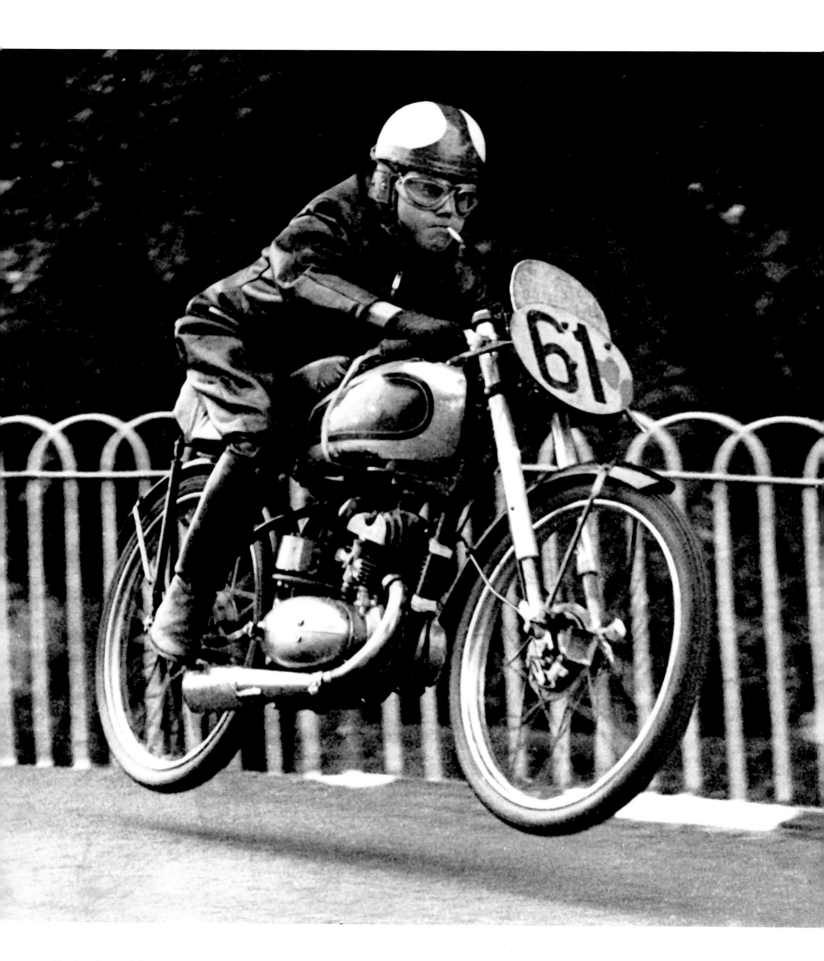

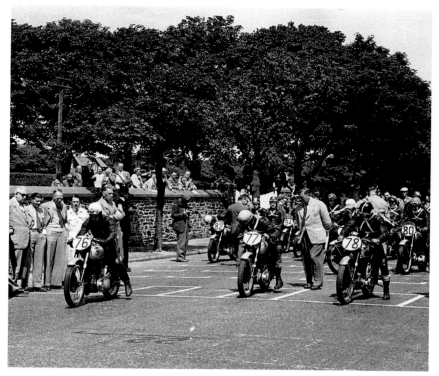

Opposite Smoking and racing are bad for your health! Harvey Williams snapped smoking in mid-flight on his BSA during practice for the 1952 Ultra Lightweight TT. We can only surmise; either the plug went or he seized up just before Ballaugh. Effecting repairs after lighting up, he took off again to get to the warmth of the Cadbury refreshment tent behind the Grandstand.

Left Bob McIntyre (76) kickstarts his BSA off the line for the 1952 Junior Clubman TT. Struggling to start their machines are W R Smith (BSA, 77) and G R Brown (Norton, 78).

Below Bob McIntyre on Bray Hill, on his TT debut, the 1952 Junior Clubman TT. Bob finished second, but he was to win three TT races later on.

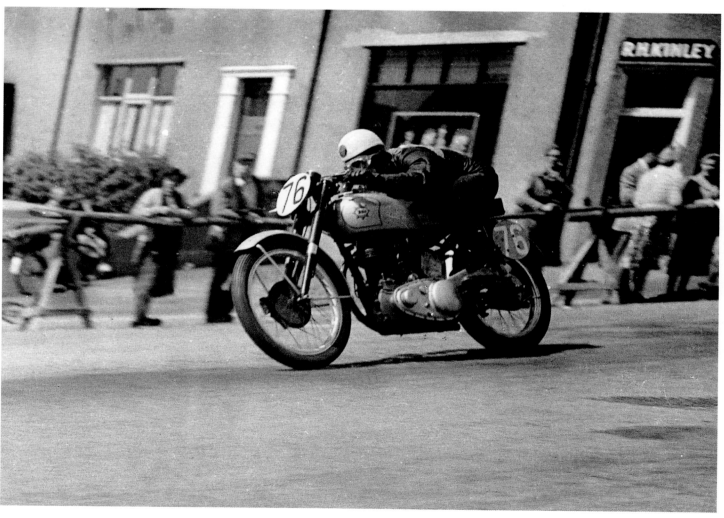

Opposite top Ray Amm rode this prototype Norton "kneeler" in practice for the 1953 TT, but reverted to the standard Manx Norton models to win both the Junior and Senior TT races that year. Later, the Rex McCandless-designed "kneeler" was developed into the all-conquering sidecar racing outfits of the 50s and 60s.

Opposite bottom Eric Oliver and Les Nutt (Norton) lead the field into Parkfield Corner after the massed-start of the 1954 Sidecar TT, held on the Clypse course. Eric held the lead throughout to win the first Sidecar TT since 1925.

Below Les Graham winning the 1953 Ultra Lightweight TT on the 125 MV. Les, who won the DFC during the Second World War, was to lose his life in an accident during the Senior TT the very next day.

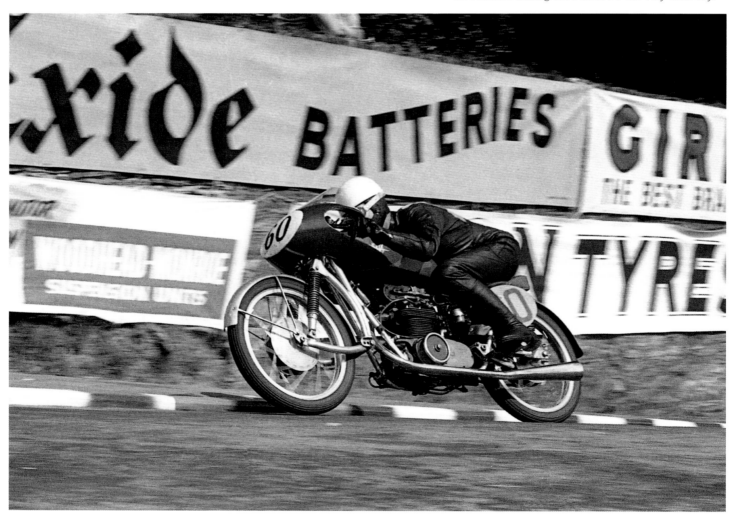

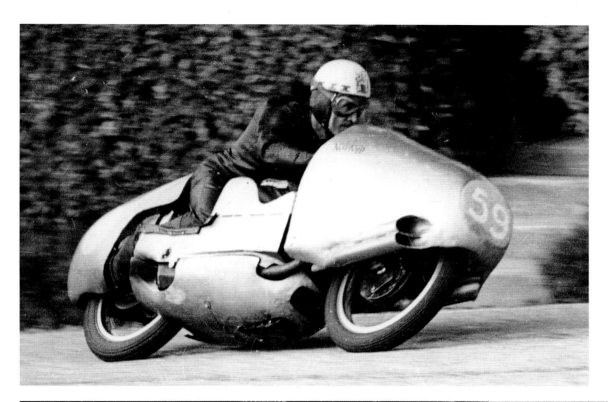

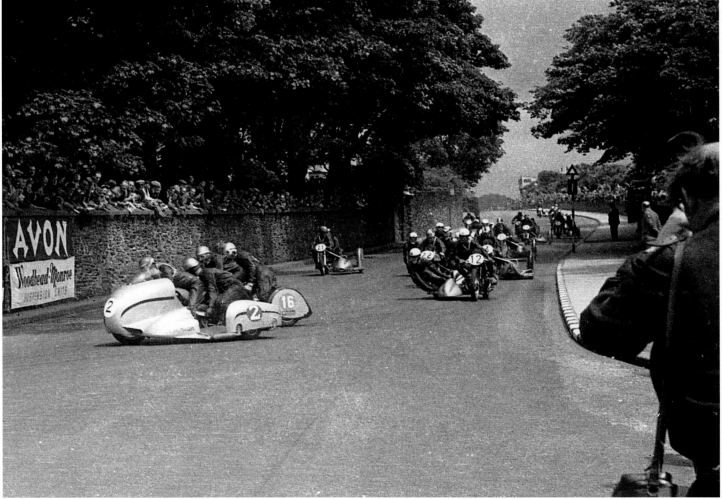

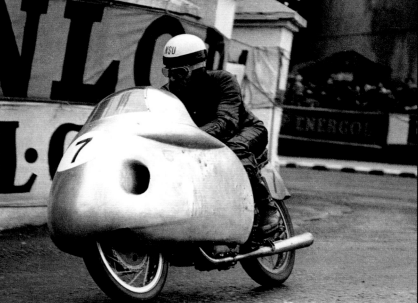

Above History was written when German Inge Stolle-Laforge became the first female TT competitor riding with Jaques Drion. The Norton-powered duo finished fifth in the 1954 Sidecar TT.

Left Hermann Paul Muller at Parkfield Corner; 1955 Lightweight TT. Pre-war "H P" drove for Auto Union, then returned to two wheels after WWII, winning the 1955 250cc World Championship on his NSU.

Opposite Willi Faust and Karl Remmert (BMW) leave Governor's Bridge; 1955 Sidecar TT (the Clypse course did not take in the Governor's dip). Despite retiring from this race, Willi and Karl won the 1955 World Sidecar Championship.

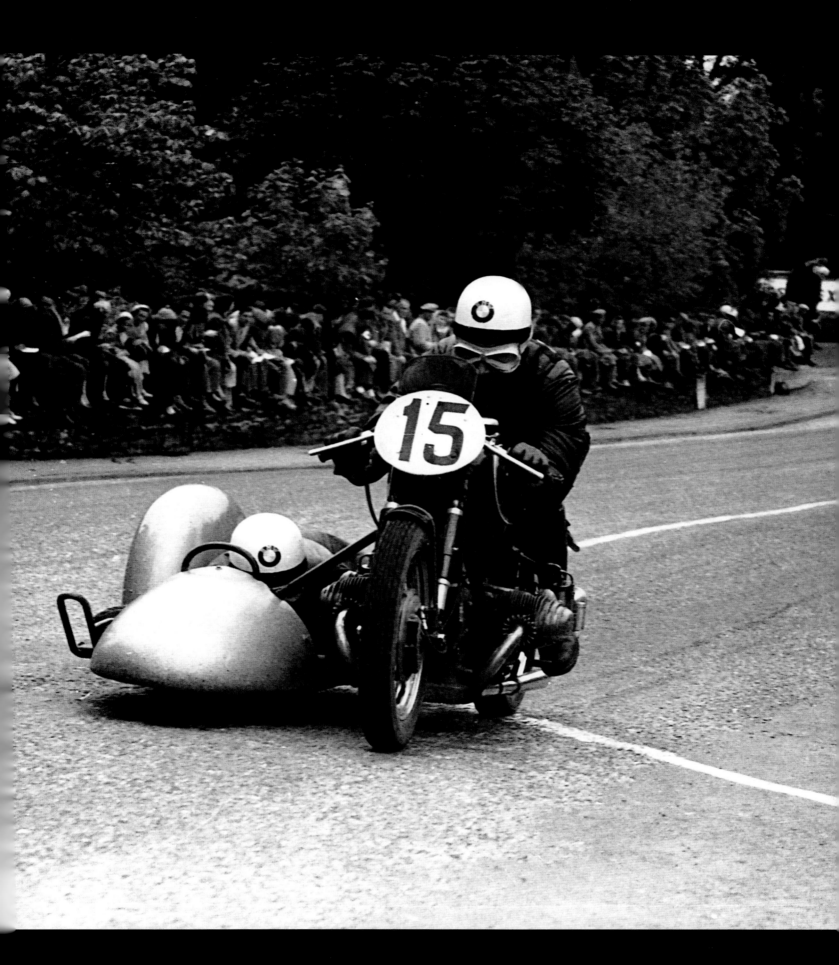

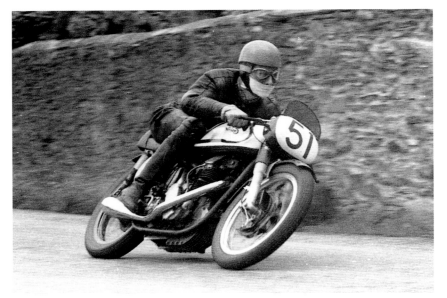

Left Jack Brett at Cronk-ny-Mona; 1956 Junior TT. The 1956 Norton works team was Jack Brett, Alan Trow and John Hartle, still masterminded by Joe Craig but entered under the Slazenger banner with assistance from Lord Montagu of Beaulieu.

Below Spaniard Francesco Gonzales (Montesa) at the Manx Arms; 1956 Ultra Lightweight TT. For Montesa, 1956 was their best TT result, finishing second, third and fourth, and winning the manufacturers' team award.

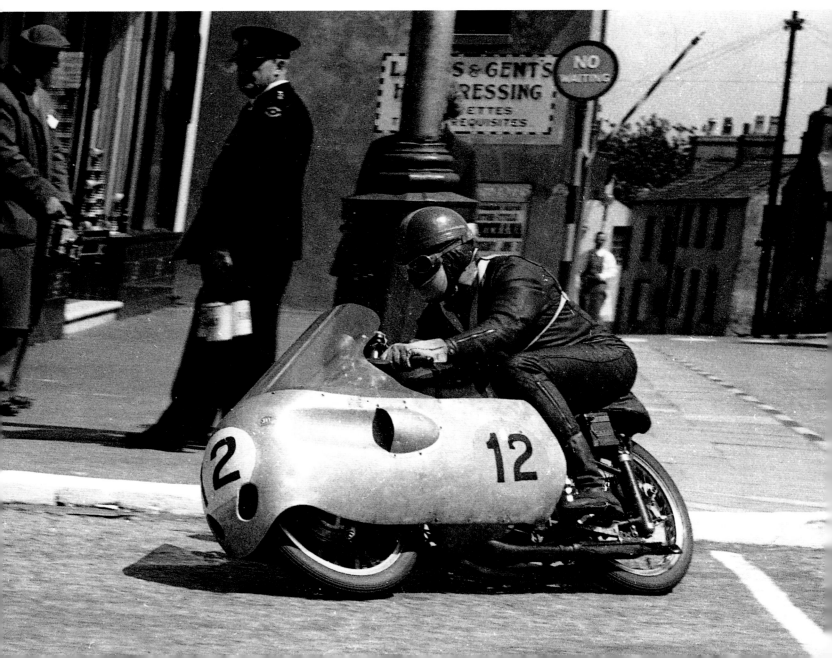

"You never really master the Isle of Man circuit."
Bob McIntyre

Below "The Flying Scot" Bob McIntyre (Gilera) winning the 1957 Senior TT, finally breaking the 100 mph lap record. "Dustbin" fairings were banned as dangerous at the end of that year.

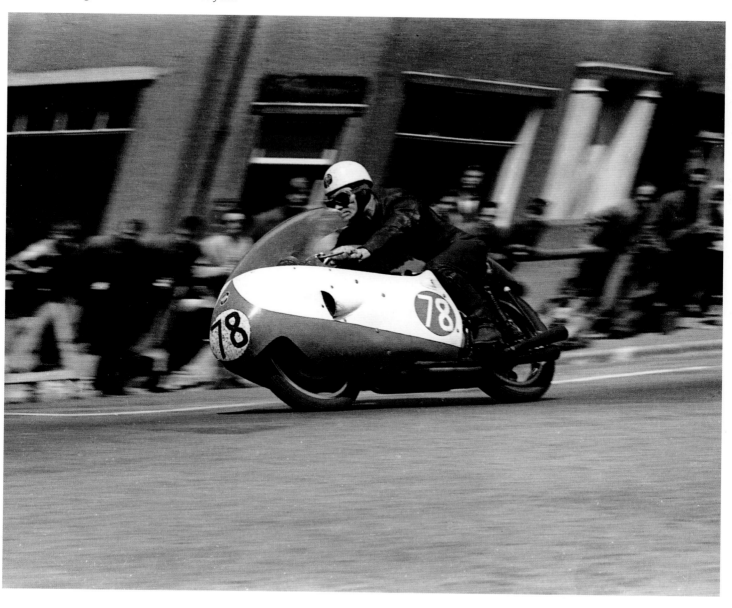

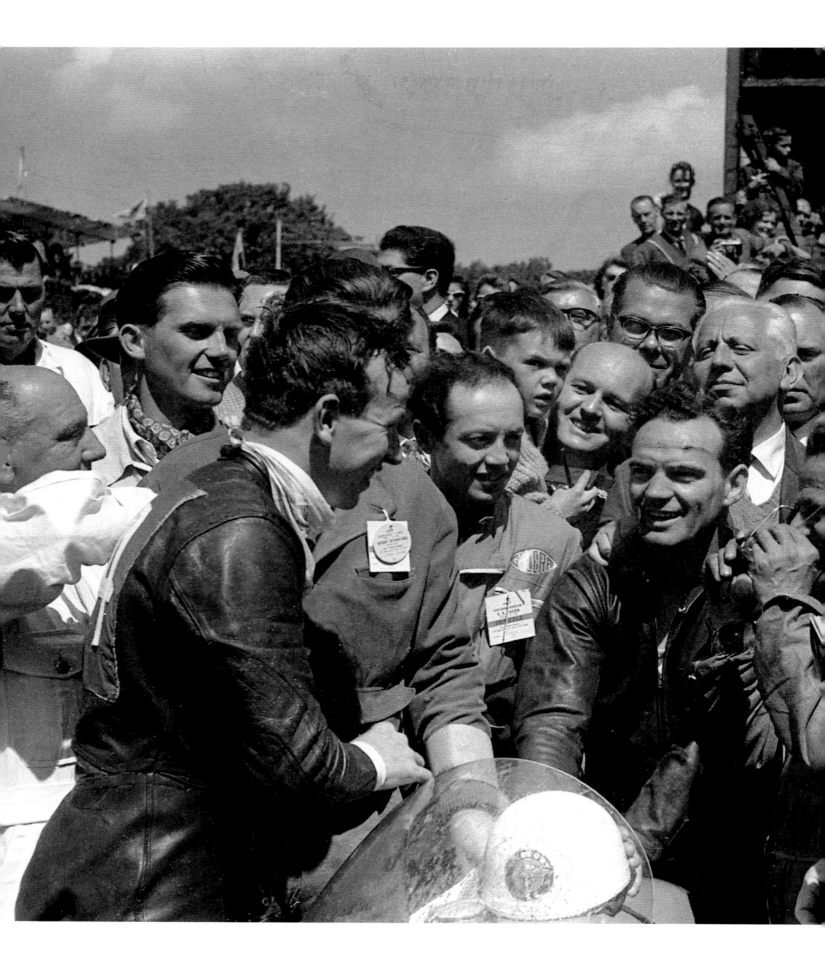

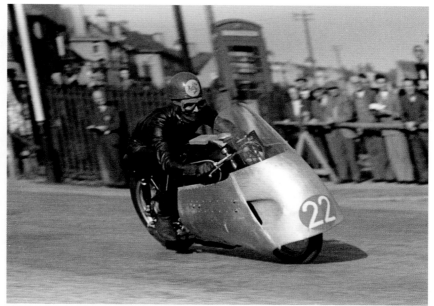

Top Proudly bearing the three-legs insignia on his helmet, Manxman Dennis Christian takes his dustbin-faired AJS 7R through the Bray Hill dip.

Above Pavement racing! Carlo Ubbiali takes the pavement route to second place in the 1957 Ultra Lightweight TT.

Left Bob McIntyre (seated on bike) is congratulated by runner-up John Surtees (MV) after his record-breaking 1957 Senior TT. To Bob's left is Giovanni Fumagalli, long-time Gilera mechanic, and the Lieutenant-Governor of the Isle of Man, Ambrose Dundas Flux-Dundas.

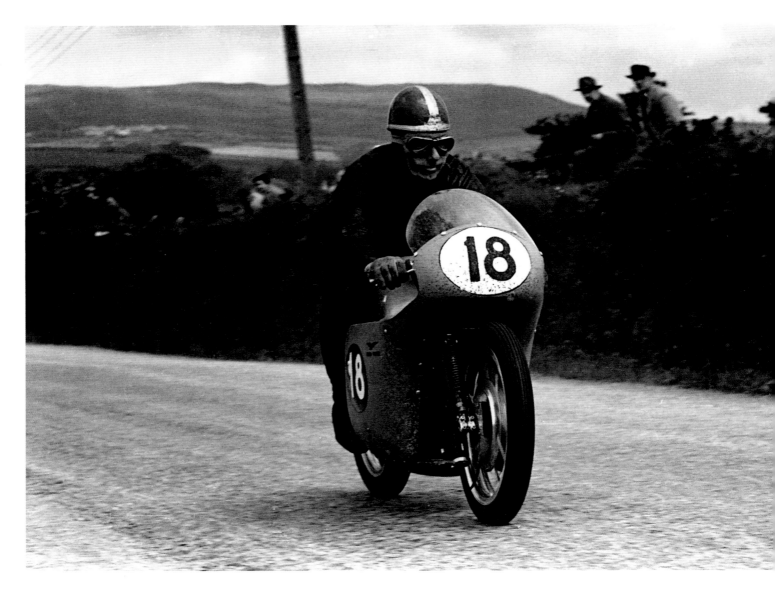

Above Dickie Dale approaching Cronk-ny-Mona on the fabulous Moto Guzzi V-8. Despite only running on seven cylinders for most of the race, Dickie finished fourth in the 1957 Senior TT.

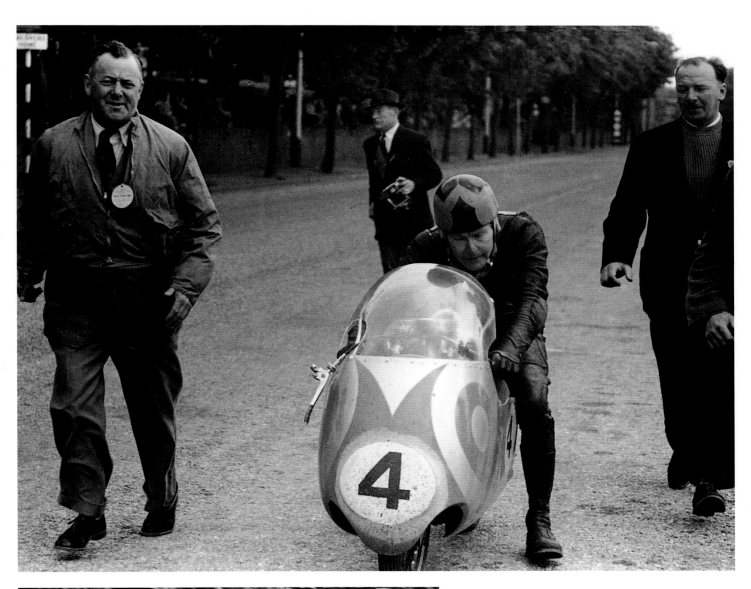

Above Sammy Miller is on the point of collapse after pushing his Mondial over the line; he crashed at Governor's Bridge when leading the 1957 Lightweight TT. He finally finished fifth.

Left John Surtees (MV) at Union Mills in the Junior TT, 1957. He finished fourth in this race but took the runner-up place in the Senior TT. Later, John took six TT wins and six world championships before turning his considerable talent to four wheels, winning the 1964 Formula One World Championship in a Ferrari.

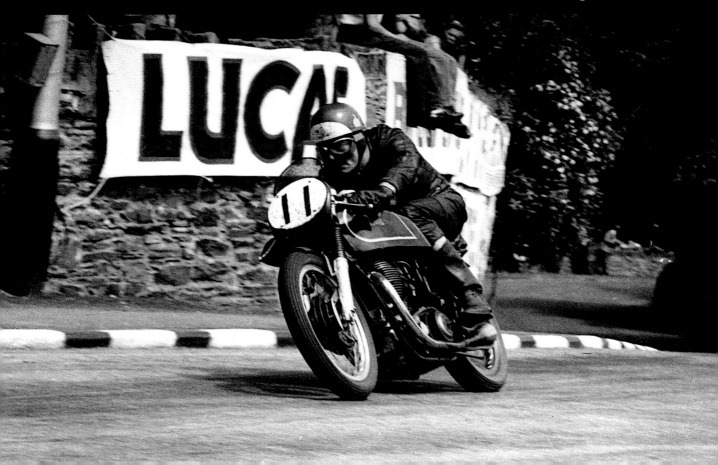

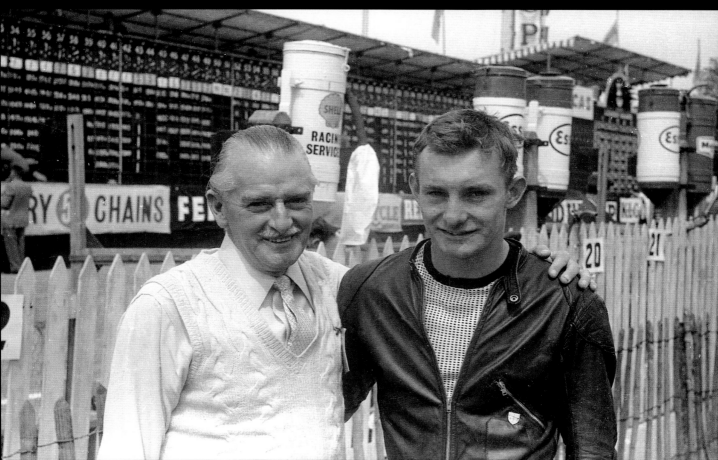

Right Bob McIntyre (500 Norton, 6) and Alistair King (350 AJS, 27) in the winners' enclosure after their victorious rides in the 1959 "Formula" Senior and Junior races.

Below The start of the Japanese invasion. Two years after Soichiro Honda declared his intention to race his machines at the TT, Honda fielded a team of twin-cylinder machines in the 1959 Ultra Lightweight TT. Naomi Taniguchi races through the Nursery Bends.

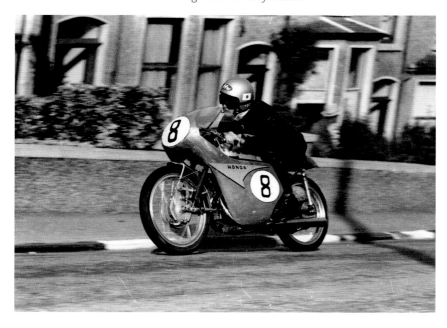

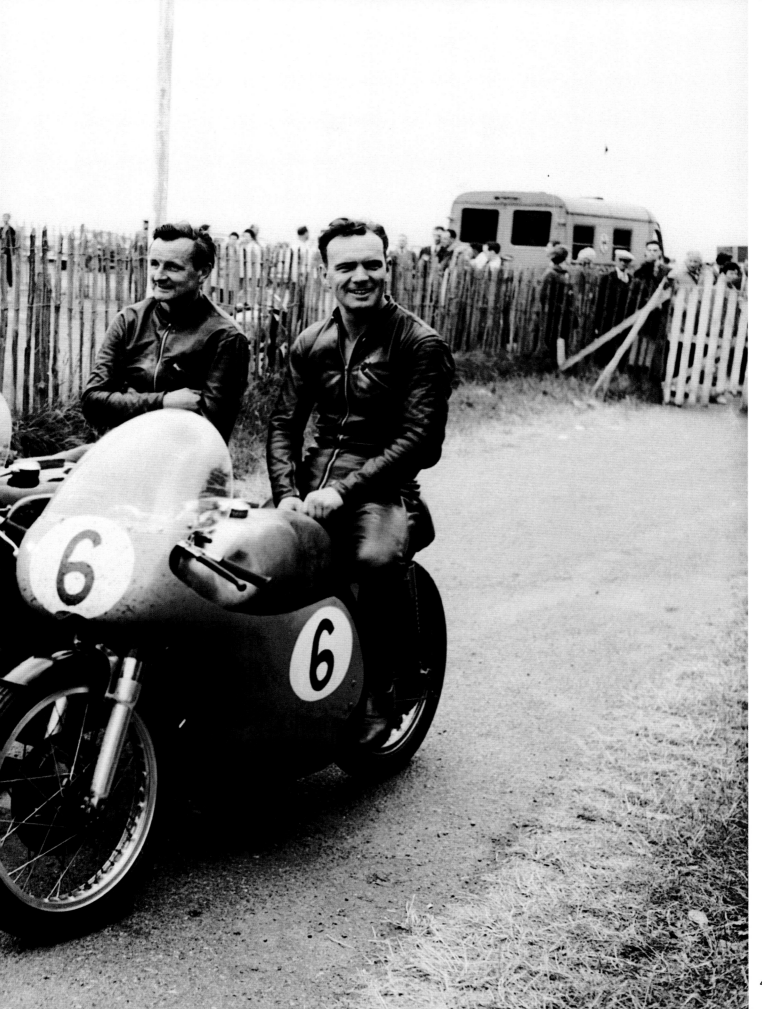

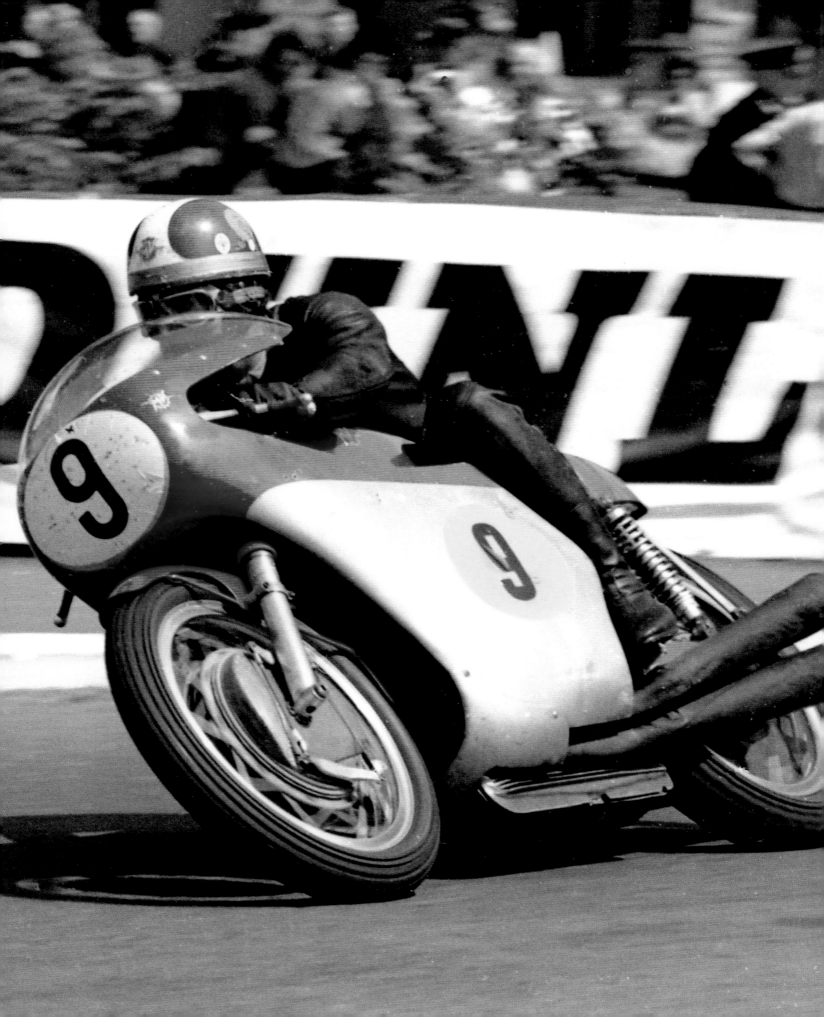

ISLE OF MAN TT
1960s

Left Giacomo Agostini (MV) fought tooth and nail for the honours in the 1967 Senior with Mike Hailwood (Honda). Chain failure on the Mountain robbed Ago of a potential victory.

1960s

The 1967 Senior TT was the climax of the swinging 60s.

Honda took two years for a first win, with their 125 and howling 250/4 taking first to third places. Japan soon dominated the smaller classes, in an explosion of technical adventure. Suzuki's first win was in 1962; Bill Ivy's 100mph lap on a four-cylinder Yamaha 125 in 1968 was not bettered until 1989. In the 250 and 350 classes, the Redman/Read, Honda/Yamaha battles raged furiously.

Mike Hailwood was already four times a Senior TT winner. Now he'd quit dominant MV Agusta to join Honda's long-feared 500cc attack.

Plus a handsome new meteor from Italy: Giacomo Agostini, riding Hailwood's MV 500.

On corrected time, the pair were neck and neck. Then Ago led, after Hailwood fixed a loose twist-grip. But on the fifth of six laps, the MV's chain broke. Hailwood won his fifth straight Senior, Honda its first. "Afterwards Mike said to me: 'Today you are the winner, not me.' He was a really nice person," recalls Ago today.

The next year, when technical regulations curbed runaway technology, Honda (whose latest 125cc miniature had five cylinders!) withdrew. They would be back.

Right Honda came of TT age on 12 June 1961, when the trio of their machines, ridden by Mike Hailwood (right), Luigi Taveri (centre) and Tom Phillis took the first three places in the Ultra Lightweight TT. The celebrations continued in the afternoon, with Mike the Bike also winning the Lightweight race, heading another top three for machines from the Land of the Rising Sun.

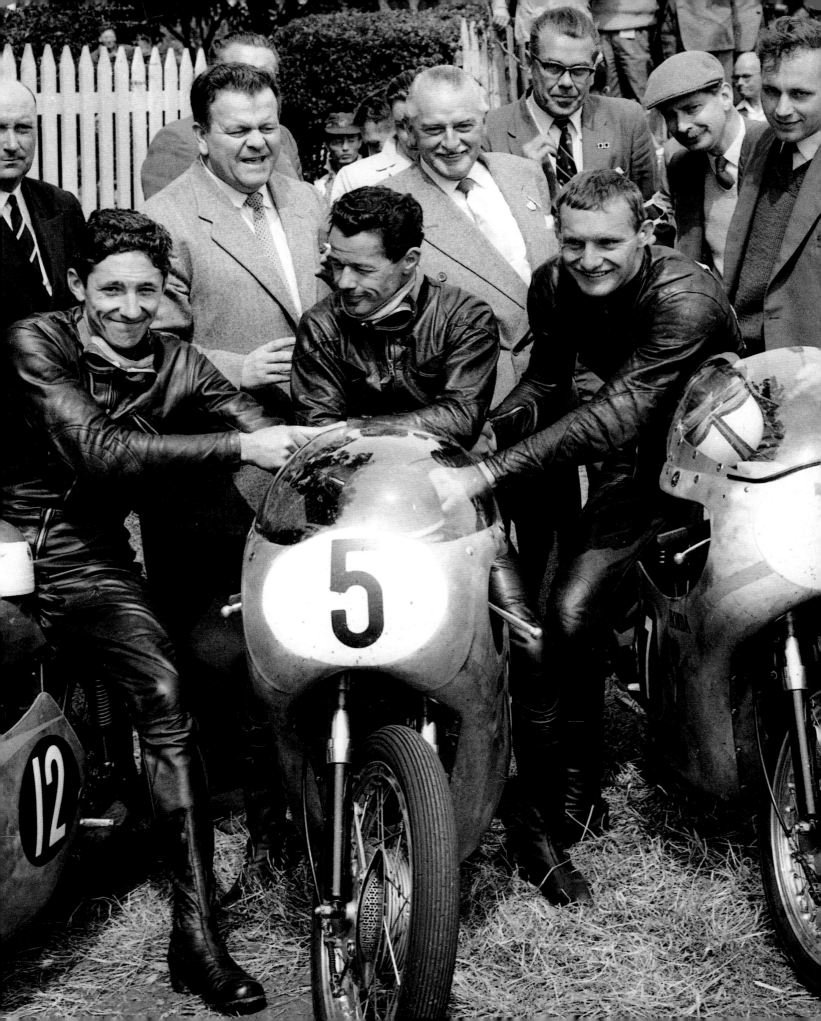

Right Mike O'Rourke gave Britain some racing pride with a fighting fifth place on his Herman Meier-tuned Ariel Arrow in the 1960 Lightweight TT.

Below Former TT winners Eric Oliver and Stan Dibben prepare to start their ill-fated practice lap for the 1960 Sidecar TT. The front forks of their Norton outfit sheared off above Guthries, captapulting the team and their machine down the mountainside. Both escaped with minor injuries.

Bottom Helmut Fath and Alfred Wohlgemuth (BMW) take Braddan Bridge. They won the TT, plus a further three Grand Prix races that year, to become the 1960 World Champions.

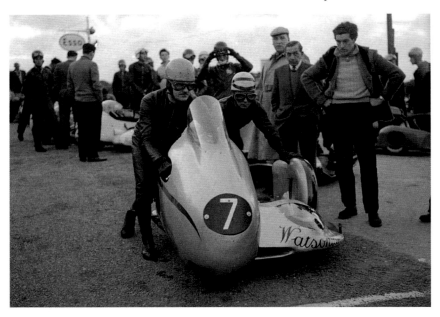

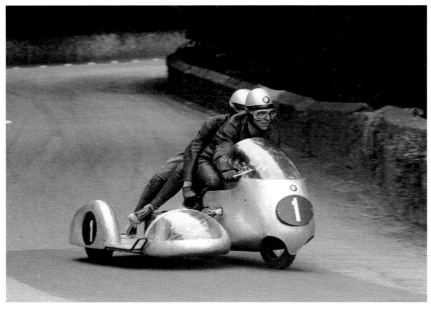

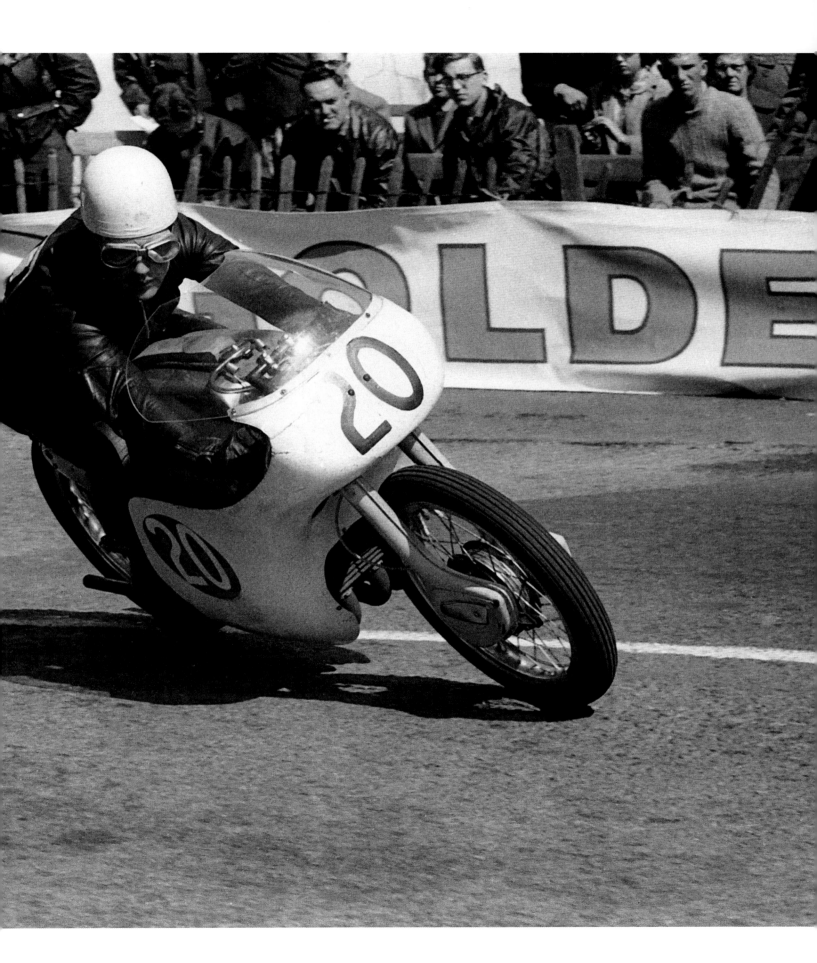

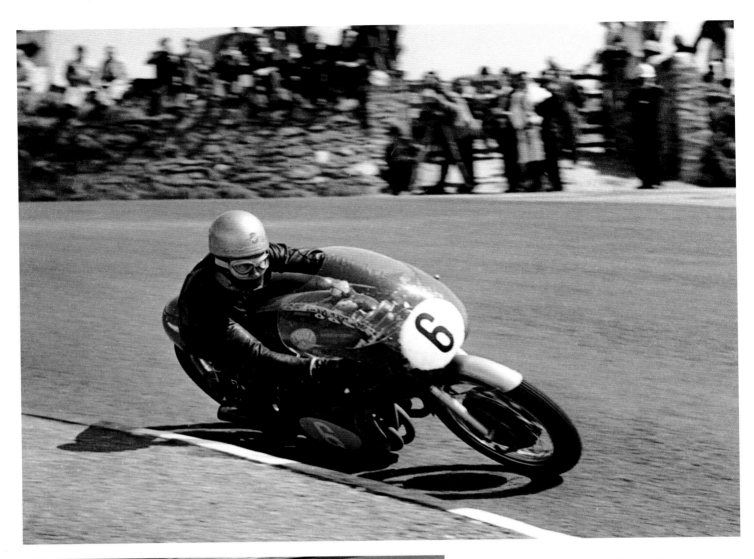

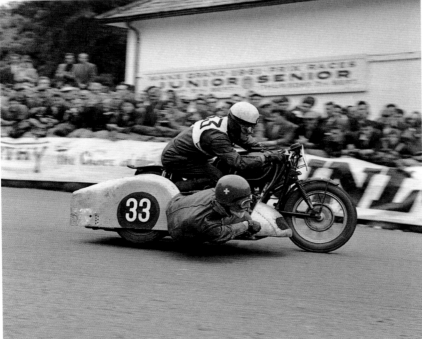

Above Gary Hocking (MV) at Signpost Corner; 1961 Junior TT. Engine troubles slowed the MV and he finished second to Phil Read (Norton).

Left Heinz Luthringhauser and Heinrich Vester (BMW) at Quarter Bridge; 1961 Sidecar TT. This was Luthringhauser's first TT and he finished 11th.

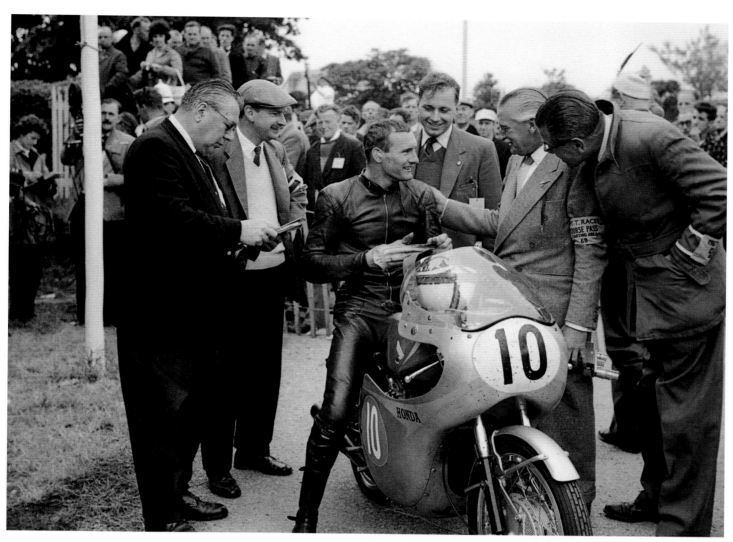

Above "Well done, son". Stan Hailwood congratulates his son Mike (Honda), after his second win of the day, the 1961 Lightweight TT. Looking over Stan's shoulder is Lew Ellis, for many years racing manager for Shell Petroleum.

Right Bob McIntyre gives the BBC an interview as a Shell technician tops up his petrol tank prior to the 1961 Senior TT. He is quoted as saying that, in 1961, he was riding a fast 250 (Honda), a slower 350 (Bianchi) and an even slower 500 (Norton). It is ironic that the only one of the trio that finished was the Norton! He took second place to Mike Hailwood in the 1961 Senior TT.

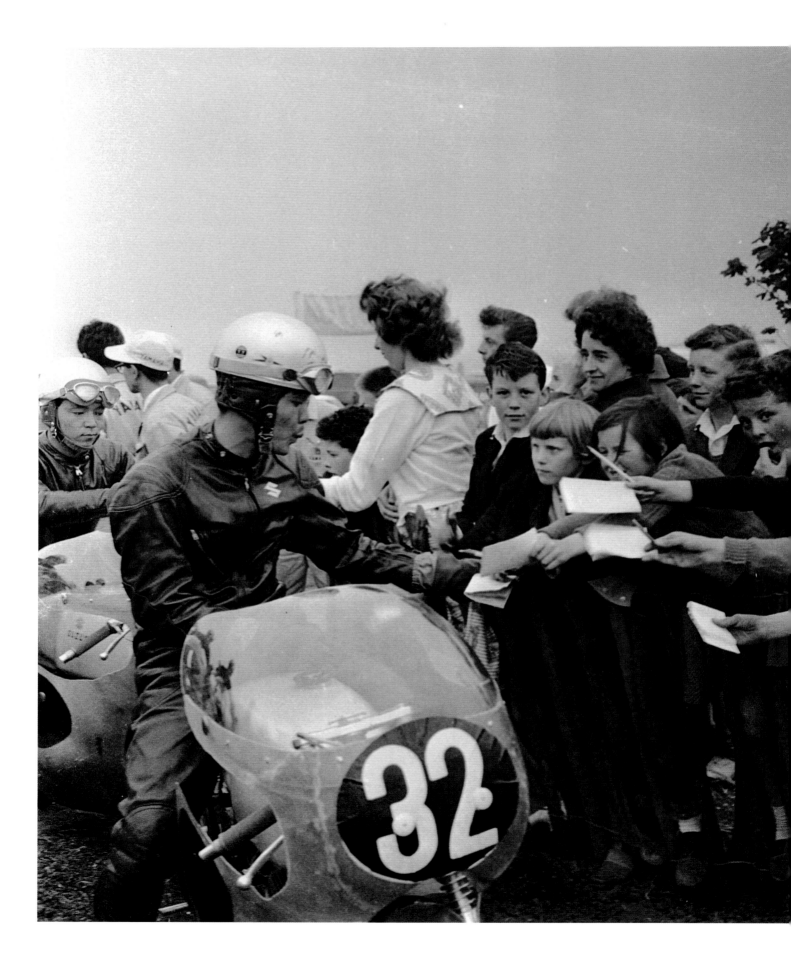

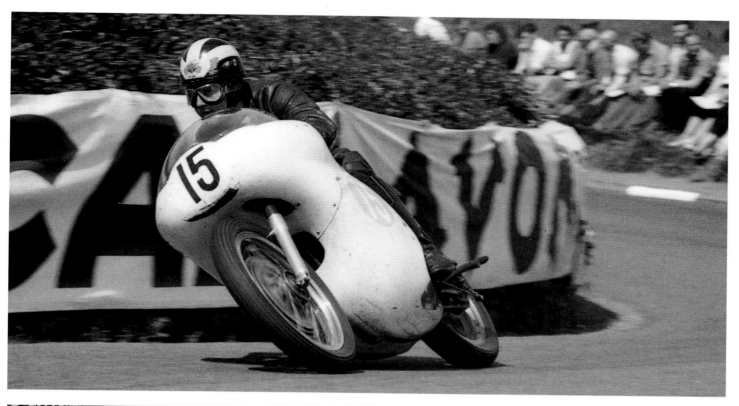

Above Phil Read (Norton) was the surprising winner of the 1961 Junior TT, outlasting the MV of Gary Hocking and the AJS of Mike Hailwood.

Left The first female to ride solo at the TT: Beryl Swain receives her TT finishers' medal from Norman Dixon, Chairman of the Auto Cycle Union.

Opposite Suzuki rider Mitsuo Itoh, Japan's first and only TT winner, signs autographs for some young TT fans as they wait for evening practice.

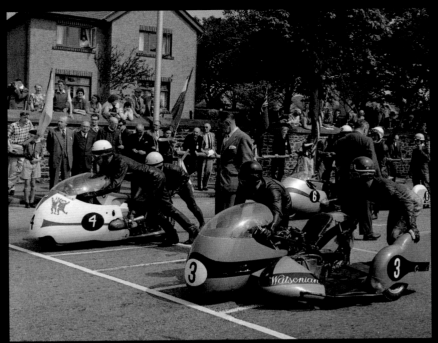

Left Max Deubel/Emil Horner (BMW, 4) and Chris Vincent/Eric Bliss (BSA, 3) wait for the starter's flag to drop before the 1962 Sidecar TT. Chris won after a race of attrition – all the leading German BMW contenders ran into trouble.

Below MV team-mates Mike Hailwood and Gary Hocking walk into the winners' enclosure after the 1962 Junior TT, won by Mike by 5.6 seconds from Gary.

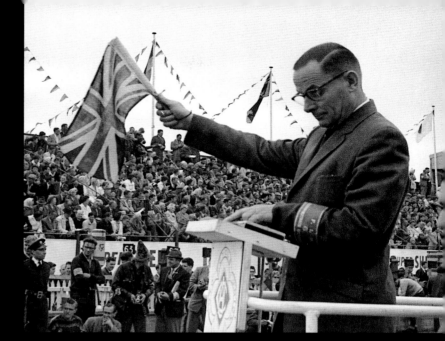

Right Countdown to a send-off. Chief Timekeeper John Stott waits for the very second to drop the flag to start the 1962 Senior TT.

Below Broke it! Aussie Jack Ahearn coasts his lifeless Norton down from Signpost Corner in the 1962 Senior TT.

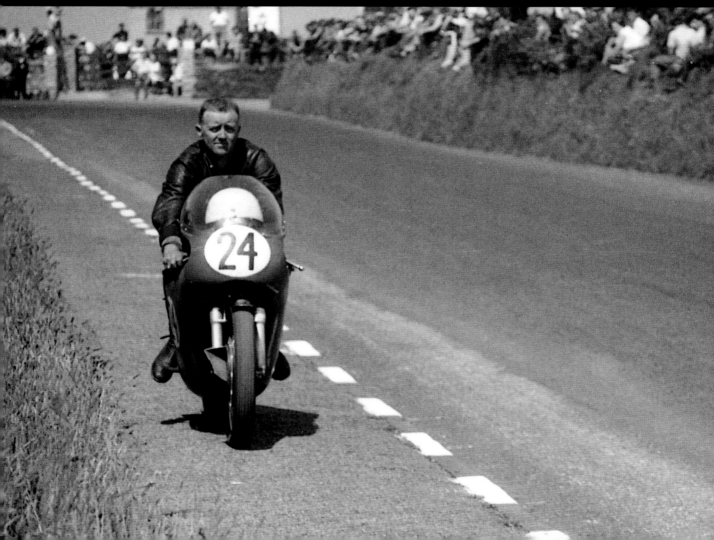

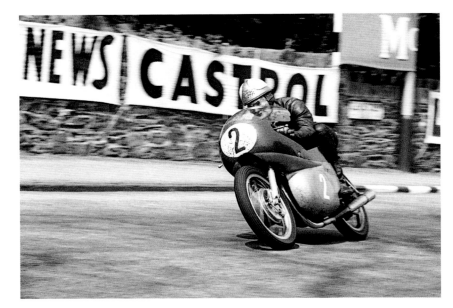

Right Mike Hailwood leaves Governor's Bridge on the Benelli in the 1962 Lightweight TT. After a pit stop to tear off a broken fairing, engine failure finally finished his race.

Below Wolfgang Gedlich uses up all his Kreidler's suspension as he bottoms out on Bray Hill.

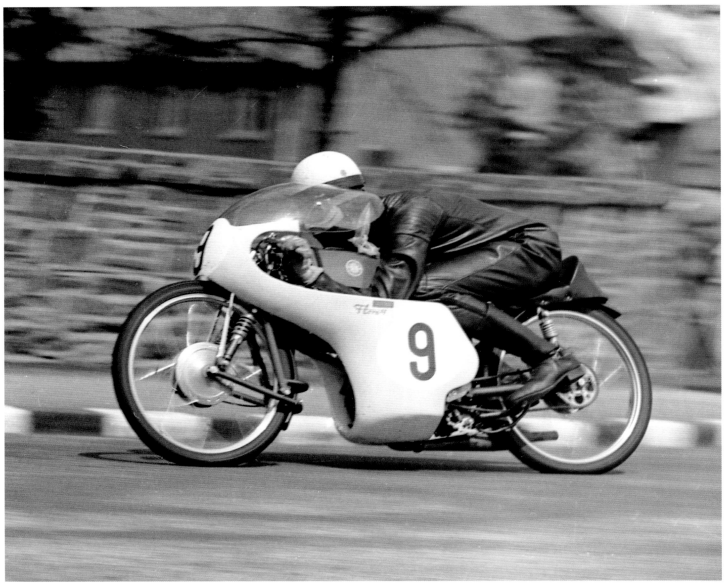

"TT racers are among the most precise, disciplined, focused racers on the planet."
Simon Head

Below John Hartle rode the Scuderia Duke Gilera at the 1963 TT. With minimal development since they were mothballed in 1957, the Arcore fours were no match for Mike Hailwood and his MV.

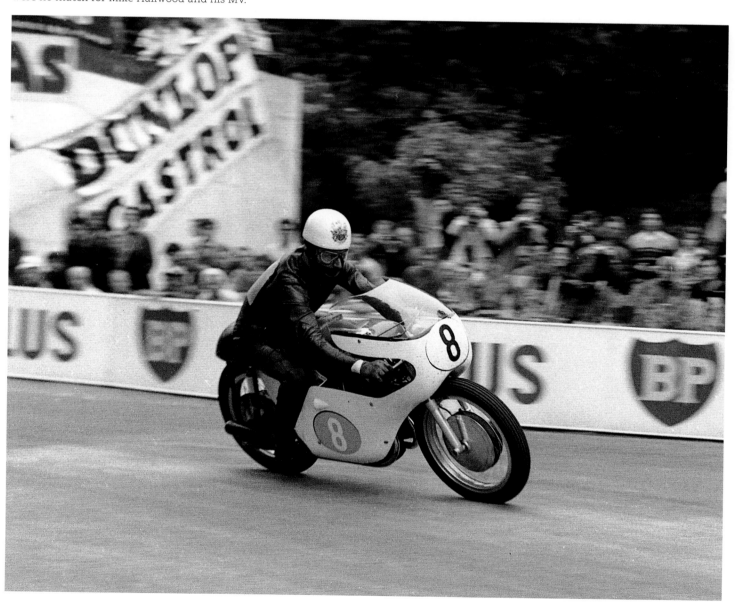

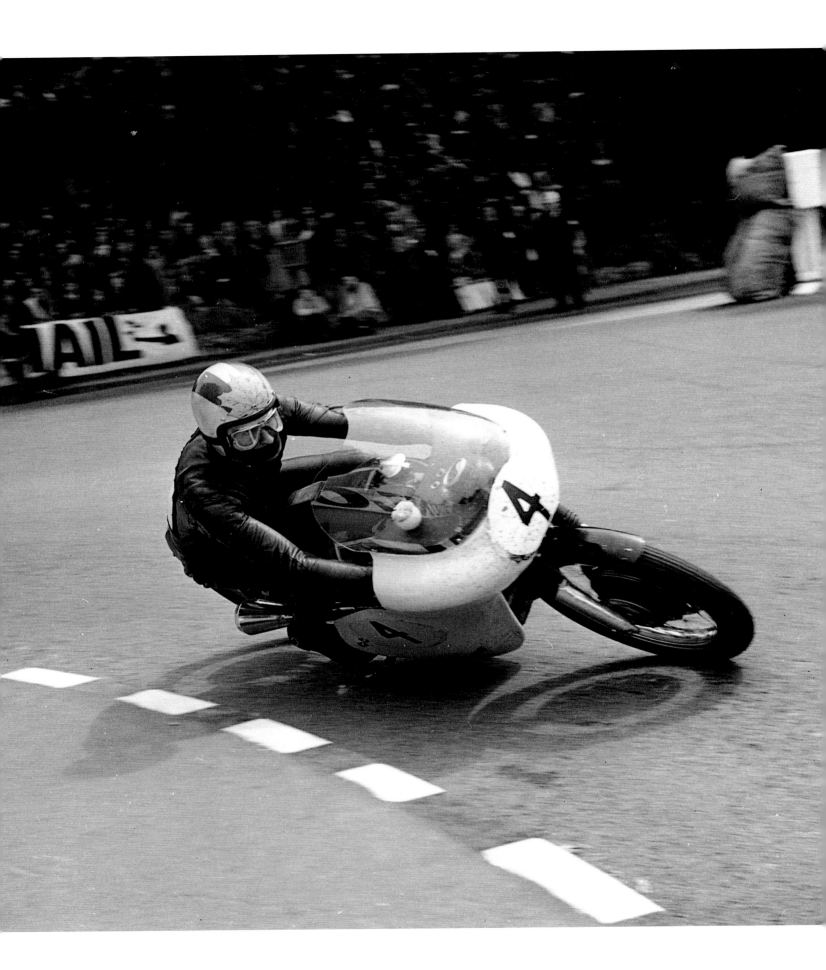

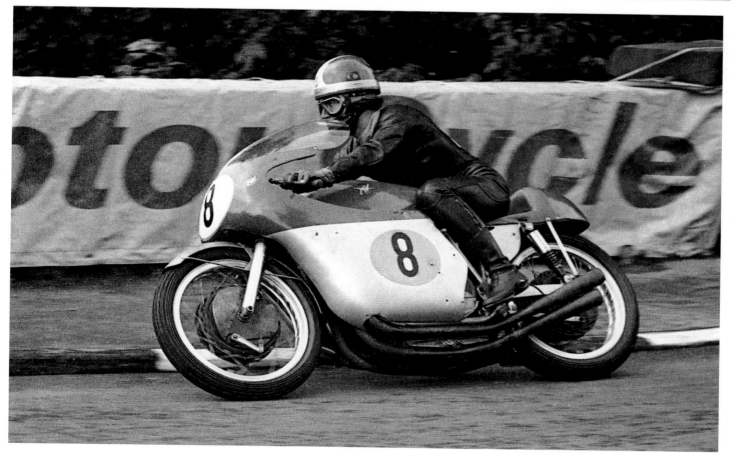

Left Canadian Mike Duff (Arter Matchless), who later became Michelle Duff, at Quarter Bridge; 1964 Senior TT. Mike later became a works Yamaha rider.

Right A Brit, despite the Swiss emblem on his helmet, John Robinson stares at the camera as Fritz Scheidegger steers their BMW out of Parliament Square.

Below At his debut TT, Giacomo Agostini rode the older four-cylinder MV machines. His ten TT wins would come on the later three-cylinder "fire engines".

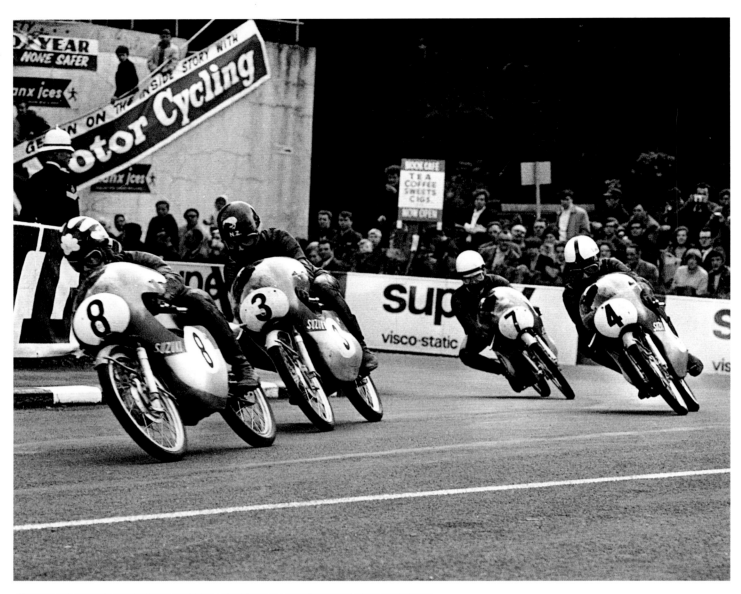

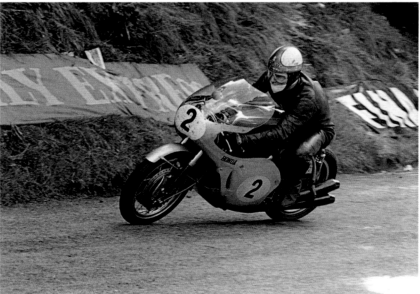

Above Suzuki team action: Tommy Robb, leads Hugh Anderson (3), Ernst Degner (4) and Hans Georg Anscheidt at Quarter Bridge on the opening lap; 1966 50cc TT.

Left Mike Hailwood (Honda) leaves Ramsey Hairpin; 1966 Senior TT. This was thought to be his last TT: 11 years later, he would prove everyone wrong!

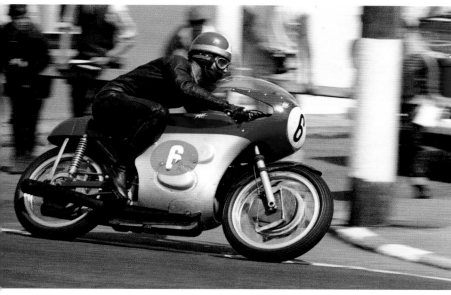

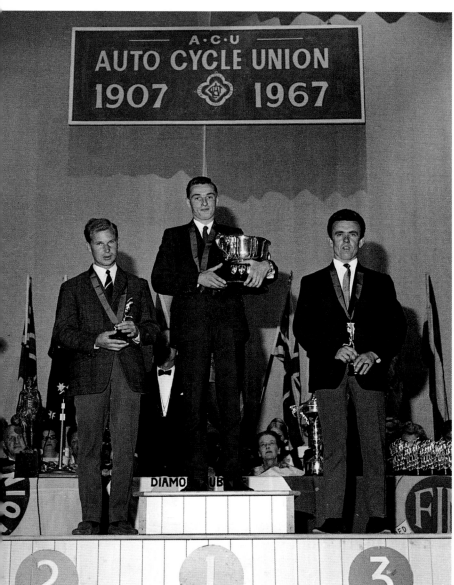

Top Giacomo Agostini (MV) leaves Ramsey in the 1967 Junior TT; he finished second to Mike Hailwood (Honda).

Left Fourteen years after his father Les was tragically killed in the 1953 Senior TT, Stuart Graham tasted TT victory in the 1967 50cc race: flanking him at the prize-giving are runner-up Hans Georg Anscheidt (left) and Tommy Robb (right). All three were racing Suzukis.

Opposite top BMW enthusiasts Dave Dickinson and Stan Cooper take Braddan Bridge on the DFD BMW in the 1969 750cc Sidecar TT.

Opposite bottom Ago leaps at – Ago's Leap! Riders have been aviating at the junction of Bray Hill and Somerset Road for years, but it was the aerial display by Giacomo Agostini that gave it its name.

Below Tommy Robb (Bultaco) at Signpost Corner; 1967 Ultra Lightweight TT. Note the plug spanner peeping out the top of his boot, the two-stroke riders' friend! Tommy rode works bikes at the TT for Honda, Suzuki and Yamaha.

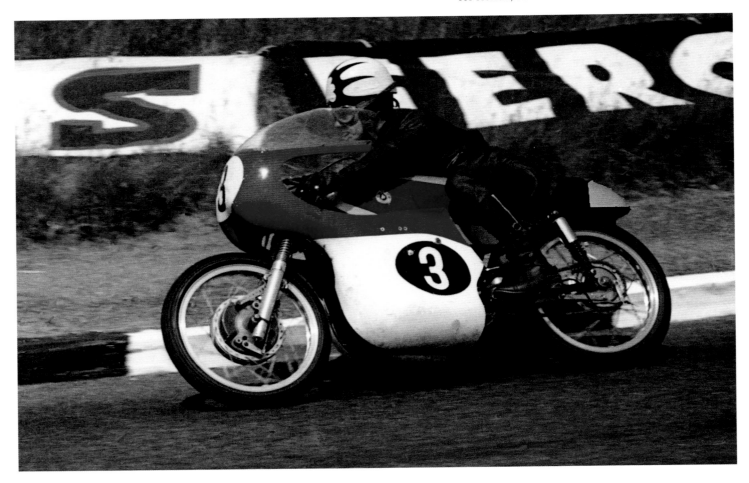

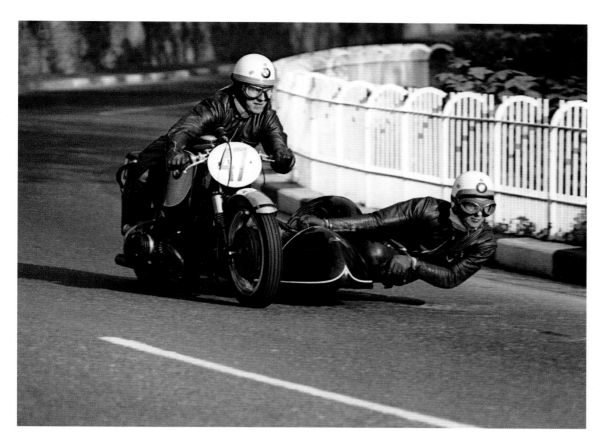

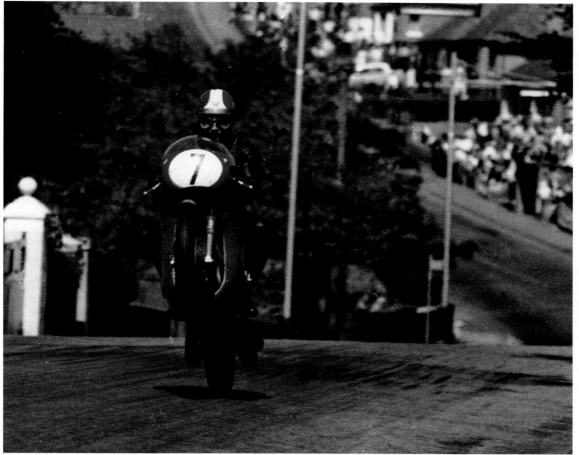

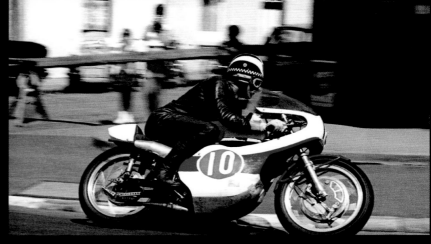

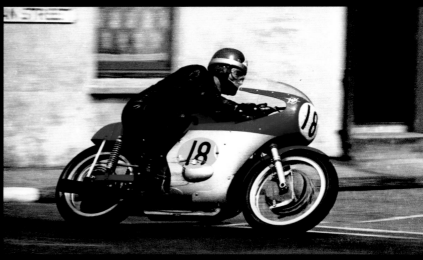

Above Eight times TT winner, eight times World Champion Phil Read in Ramsey; 1968 Lightweight TT.

Right Giacomo Agostini leaves Parliament Square, Ramsey; '69 was another double TT victory year for the Italian ace, who won ten TTs.

Bottom Steve Murray resumes normal service after slipping off his 125 Honda in the 1969 Ultra Lightweight TT; despite this, he went on to finish fourth.

Opposite Dave Simmonds gave Kawasaki Heavy Industries their first TT victory in the 1969 Ultra Lightweight TT. Checking the rear tyre for wear is Vic Willoughby, former TT racer and Technical Editor of *The Motor Cycle* magazine.

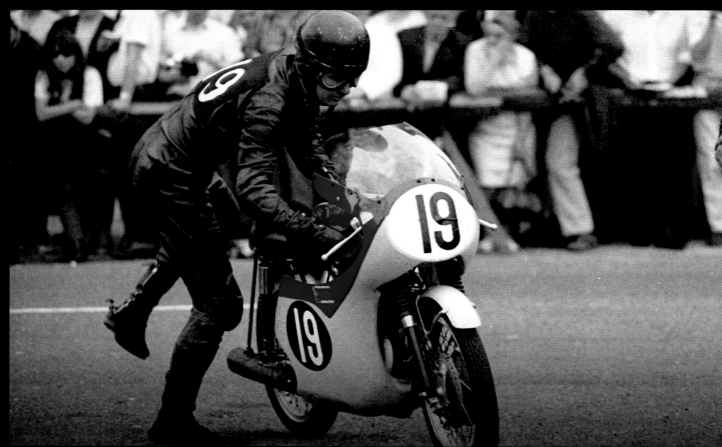

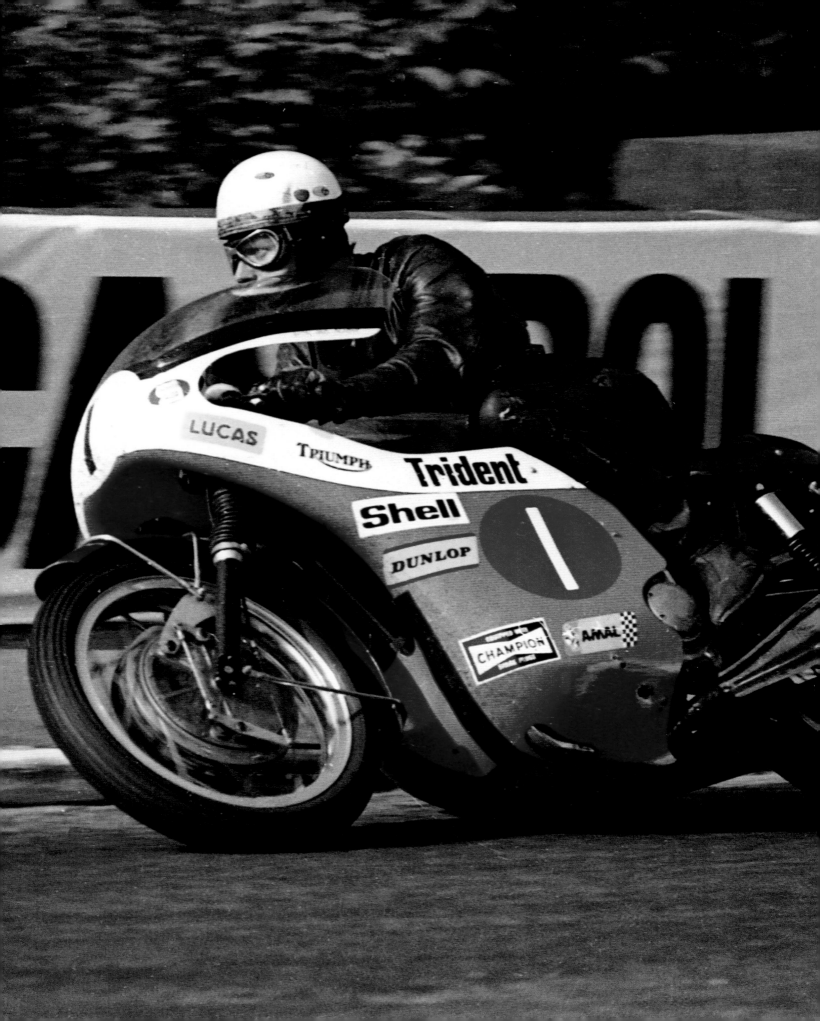

ISLE OF MAN TT
1970s

Left After winning the previous year's
Production TT on a Triumph Bonneville, Malcolm
Uphill gave the Triumph Trident its maiden TT
victory in the 1970 Production TT. One of the few
motorcycle racers to have a pub named after him!

1970s

Tradition took a back seat to safety in 1977, when the TT was dropped from the GP World Championships. Its status had changed, but not, as it turned out, its character.

The crucial event had been the 1972 death of Italian Gilberto Parlotti. Compatriot Agostini reluctantly won his sixth straight Senior, then he and MV Agusta withdrew. This was followed in 1973 by a big-name boycott that included multi-winner Phil Read.

Bereft of stars, the TT was still a major biking festival, with fans and racers aplenty. New names appeared at the top: Mick Grant, Tom Herron ... and in 1977 Joey Dunlop, in a heroic Jubilee TT victory on a ramshackle private Yamaha.

The TT had been given a special one-race World Championship: Read made a controversial return to win the first "Formula One" TT in 1977.

More sensational in 1978 was the return to victory of long-retired Mike Hailwood on Ducati. A final hurrah to underline the legend was a Senior TT win in 1979.

But 1978 was also a year of tragedy, with three sidecar competitors killed within less than a mile of the race start, and GP star Pat Hennen (in 1978 the first to break 20 minutes) grievously hurt.

Right With his sponsor's initials on his helmet, Mick Grant leaves Quarter Bridge on the Jim Lee Yamaha. Wakefield-born Mick won seven TT races.

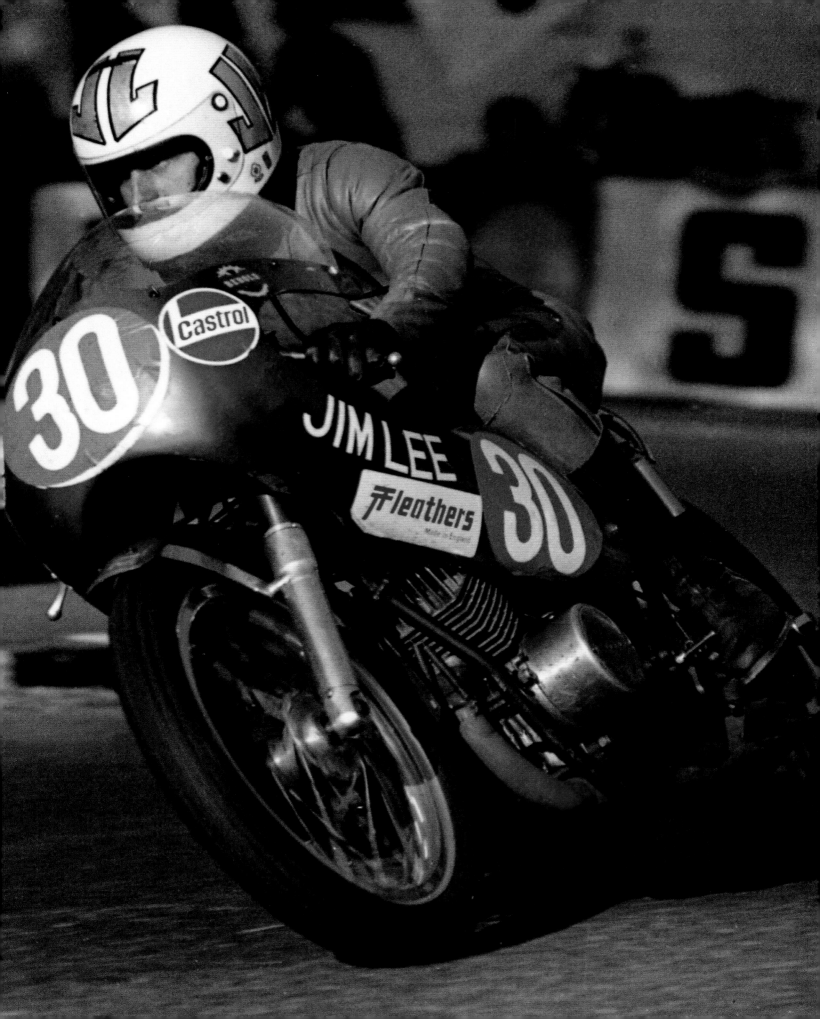

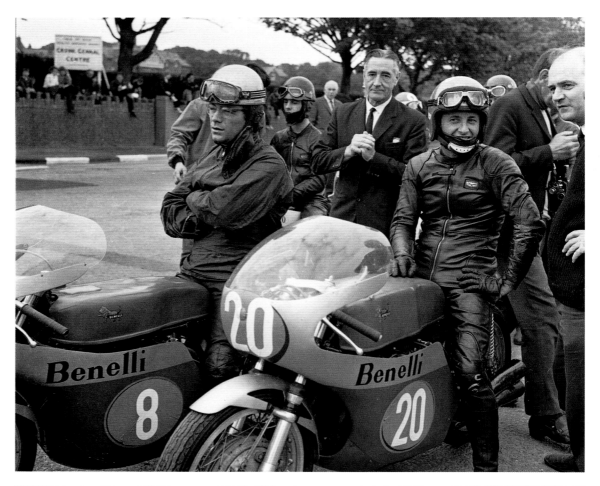

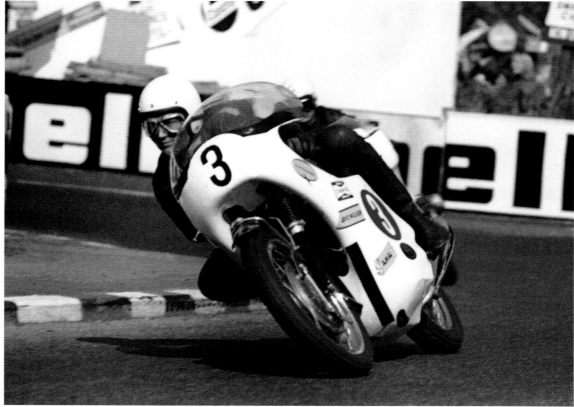

Right Bob Kewley and John Whiting (BMW) leave Ramsey, 1970 500 Sidecar TT. Bob was the first Manxman to win a world championship point when he finished tenth in the 1970 Ulster Grand Prix.

Opposite top Benelli team-mates Renzo Pasolini (8) and Kel Carruthers (20) wait for a practice session to start. Kel is talking to motorcycle pressman John Brown.

Opposite bottom "Small Parts": Paul Smart (Triumph Trident) at Quarter Bridge in the 1970 Production TT.

Bottom Siegfried Schauzu and Horst Schneider (BMW) at Governor's Bridge in the 1970 500 Sidecar TT. The spare goggles on their helmets show this to be taken early in the race.

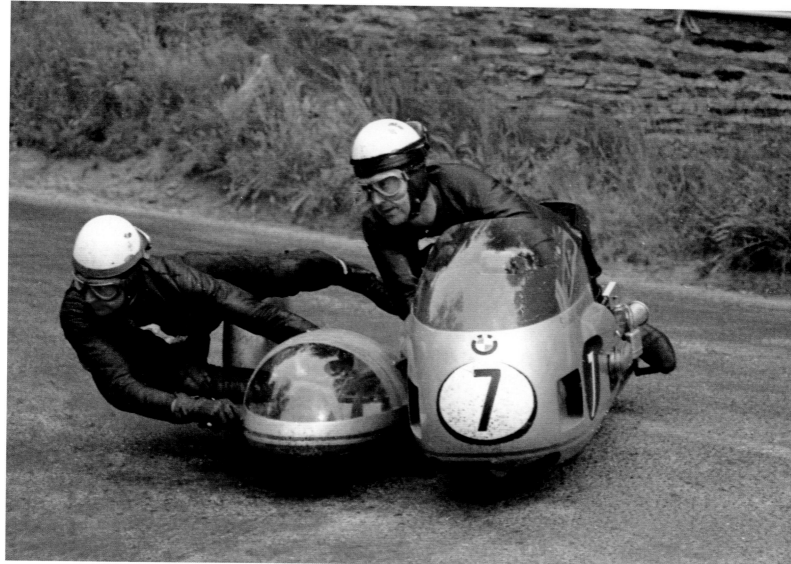

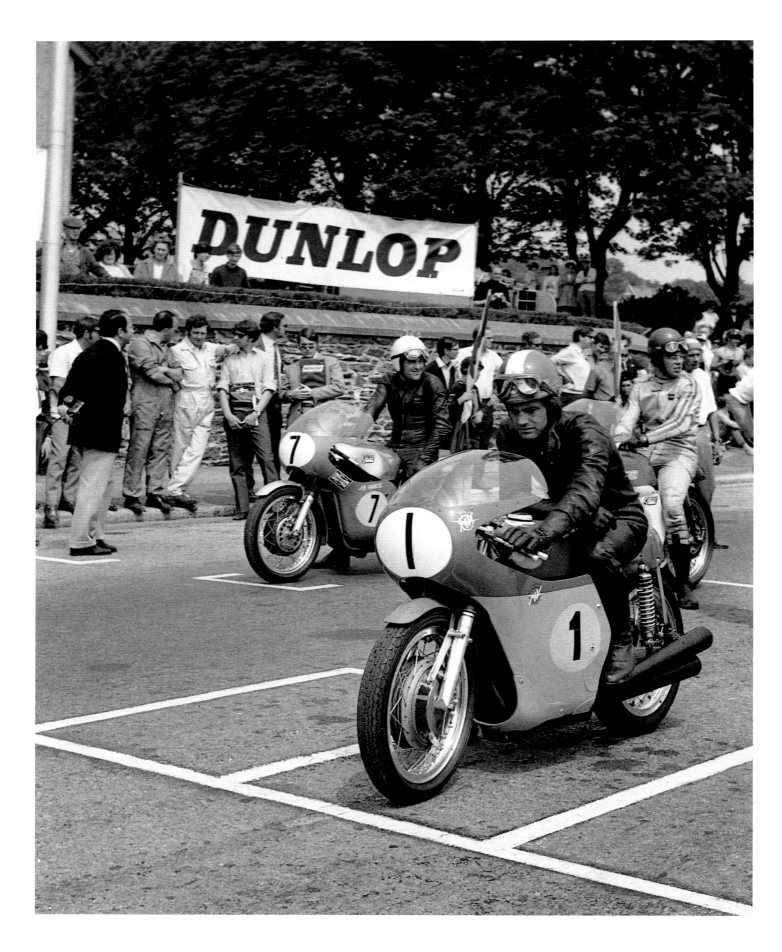

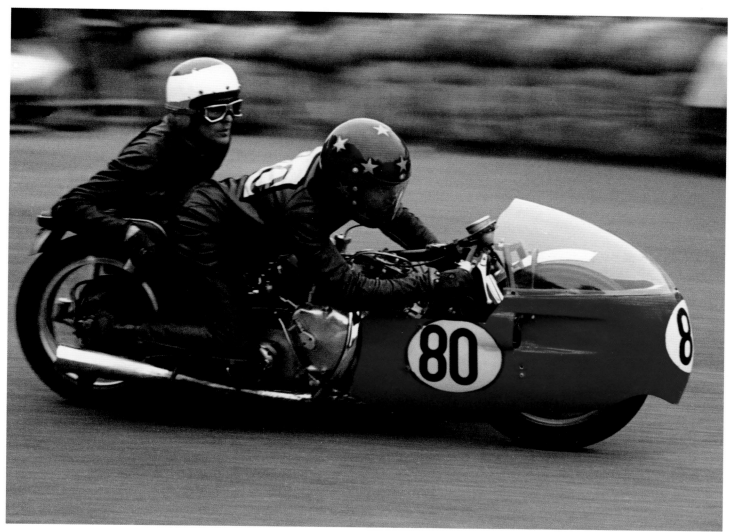

Above John Renwick and P Kennard (Vincent); 1971 750 Sidecar TT. John Renwick later constructed the Renwick Konig, raced by the Boret brothers.

Right Mick Grant (Jim Lee Commando) 1971 Formula 750 TT. Note the under-engine underfelt "nappy", helping to mop the oil up!

Opposite Scant minutes to go before blast-off: Giacomo Agostini mentally prepares himself for the Senior TT, 1971. His Junior MV had inexplicably retired; would the 500 last the six laps? He did not have to worry, lightning does not strike twice; he won by six minutes!

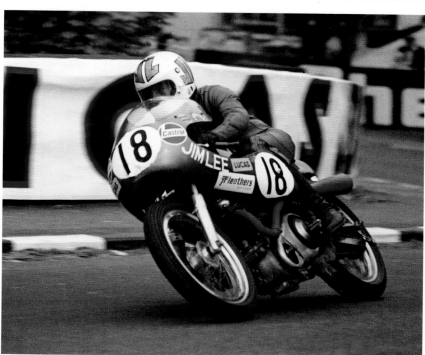

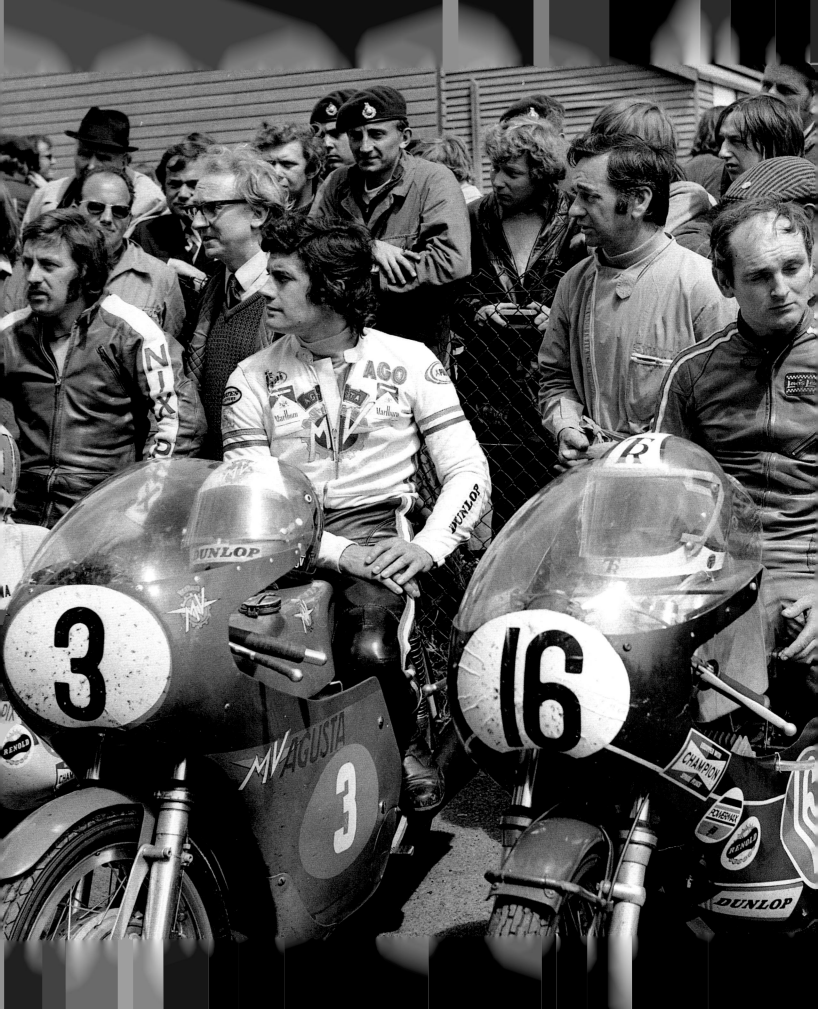

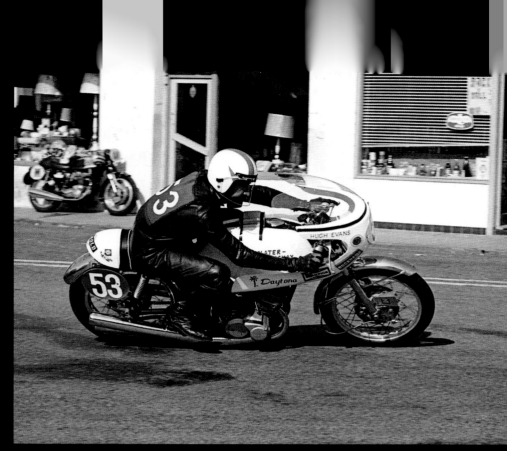

Right Hugh Evans (Kawasaki H1) at Parliament Square, Ramsey, 1972 Production TT. This bike was purchased in America; it was taken apart and brought into the UK as "hand-baggage" by motorcycle fans returning from the Daytona races! A fair bit of excess baggage was paid that day.

Opposite Winners' enclosure for the 1972 Junior TT. Left to right; third place man Mick Grant (Yamaha, 7), winner Giacomo Agostini (MV, 3) and runner-up Tony Rutter (Yamaha, 16). This was Ago's ninth TT win, two days later he took his tenth and final TT win.

Below The flag has fallen, the riders have sprinted across the road and the 1973 Production TT is under way. Prominent are Dave Nixon (Triumph, 3), Dave Croxford (Norton, 7), Darryl Pendlebury (Triumph, 16), Graham Bailey (Triumph, 23) and Ernie Pitt (Triumph, 27).

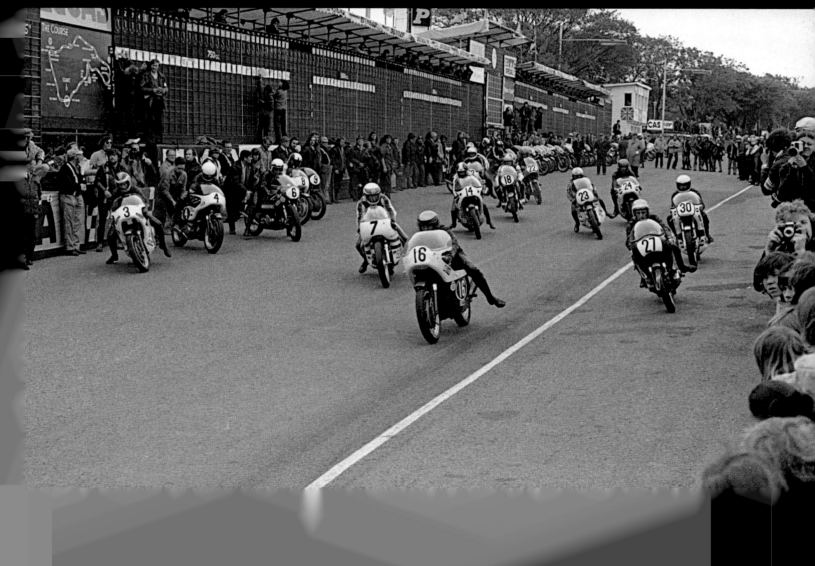

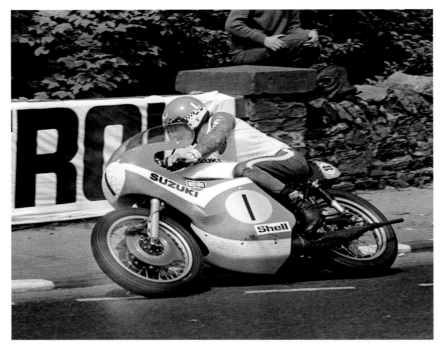

Left Aussie Jack Findlay gave Suzuki their first big-bike TT victory when winning the 1973 Senior TT on this TR500 twin.

Below It was a very hot day, and melting tar and previously dropped oil catch out Mick Grant (Yamaha) in the 1973 Senior TT. Mick was leading at the time.

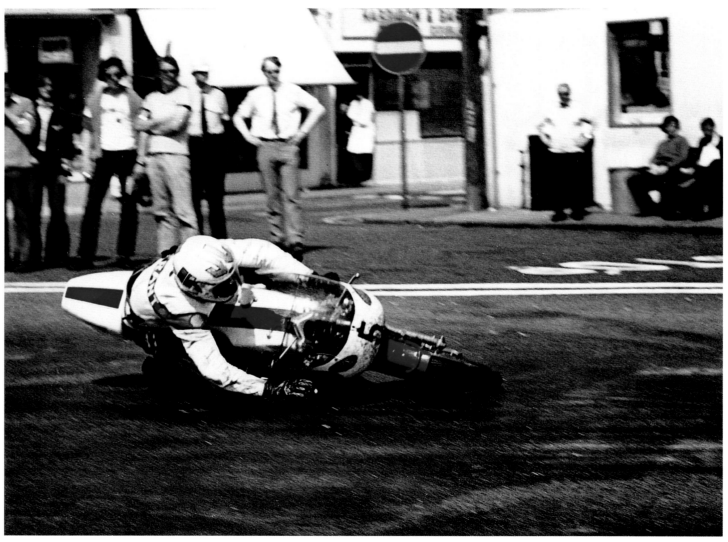

"The most dangerous mongrel of a road race in the world…"
John Britten

Below Jeff Gawley and Ken Birch (RMB Konig) fly Ballaugh Bridge; 1974 500 Sidecar TT.

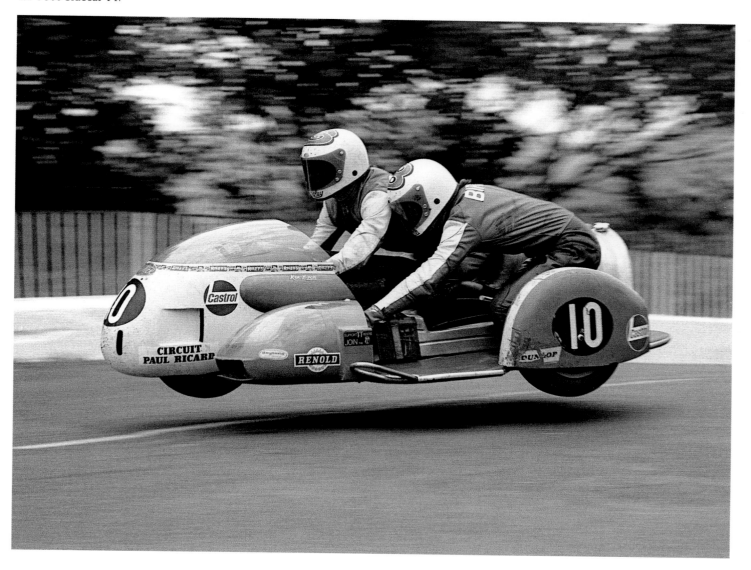

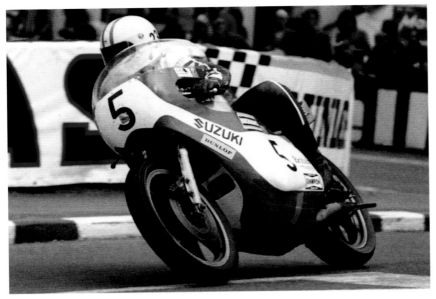

Left Paul Smart (Suzuki), Quarter Bridge; 1974 F750 TT. Paul won the Imola 200 in 1972 on a Ducati.

Opposite A Yamaha 1-2-3. Chas Mortimer receives the congratulations from runner-up Derek Chatterton and third place man John Williams in the 1975 Lightweight TT.

Below Spalding's Lindsay Porter (Benelli 2C) flies Ballaugh Bridge; 1974 Production TT.

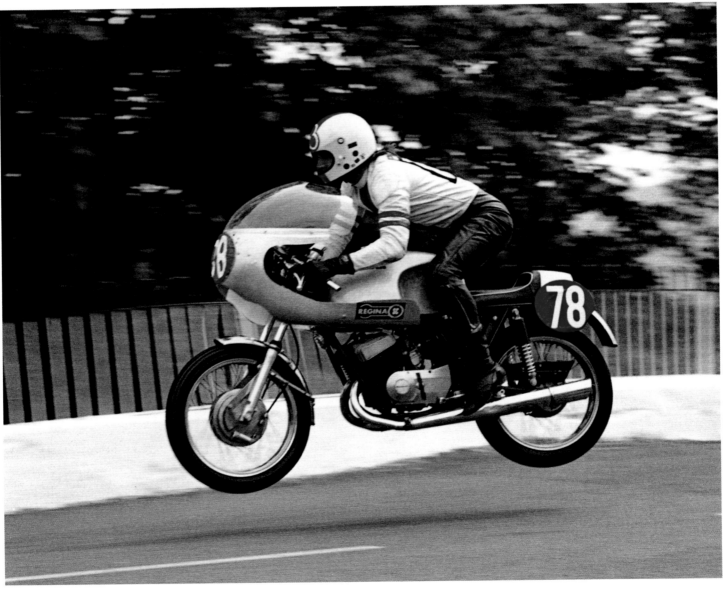

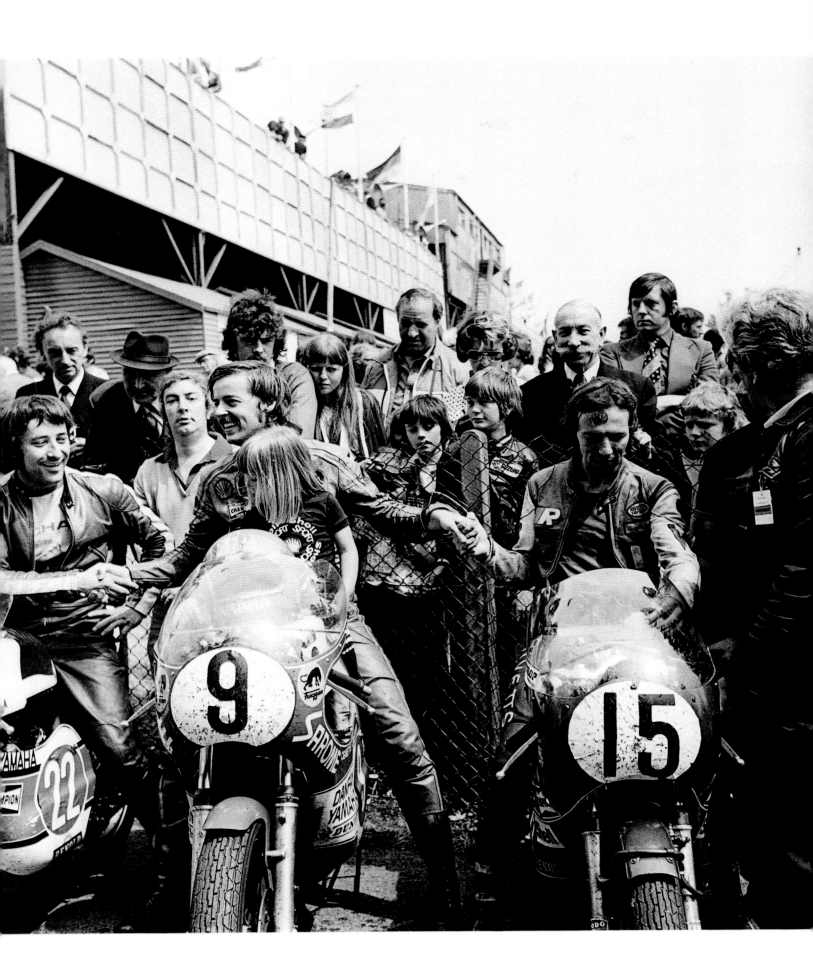

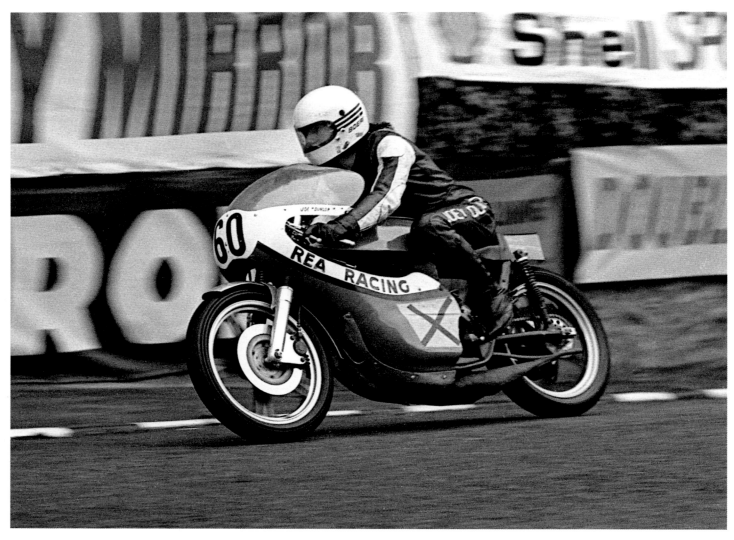

Above The first TT lap for a TT legend. Joey Dunlop (Yamsel) is barely a mile from the end of his first ever TT practice lap, 1 June, 1976. In the next 24 years, he garnered 26 TT wins from 100 races.

Right Nigel Rollason and Michael Coomber (500 Devimead BSA) leave Parliament Square, Ramsey. Nigel was one of two people to win both a solo race (1971 Senior Manx Grand Prix) and a sidecar one (1986 Sidecar B TT) on the TT course. The other was Freddie Dixon (1923 Sidecar, 1927 Junior).

Opposite John Williams at Quarter Bridge; 1976 Senior TT. He was leading for nearly the whole race, but his Suzuki's clutch failed within a mile of the finish. John manfully pushed his RG500 home to finish in seventh place.

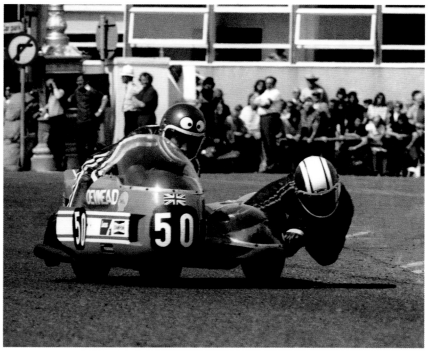

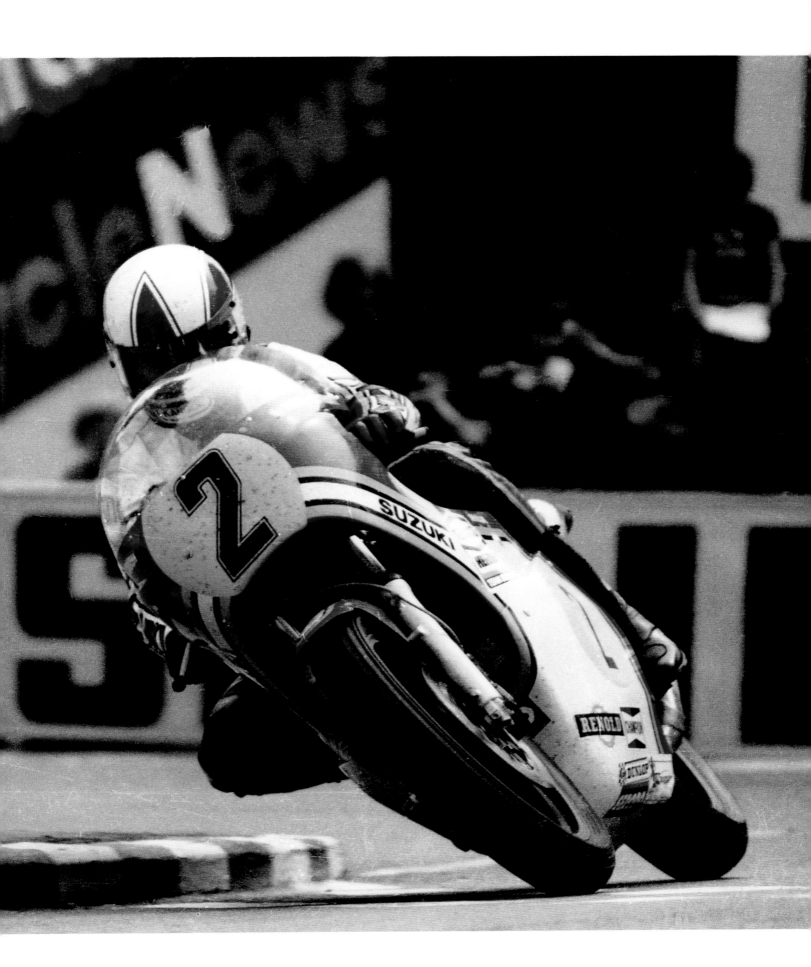

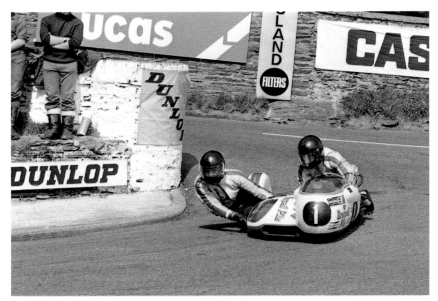

Left Germany's Rolf Steinhausen and Josef Huber swing their Busch Konig round to Governor's Bridge in the 1976 Sidecar 500cc TT. This was their second consecutive 500 Sidecar victory.

Below Tom Herron (Yamaha) at Parliament Square in the 1976 Lightweight TT. Tom won both the Lightweight and Senior TTs that year, the last time the Isle of Man meeting counted towards the World Championship.

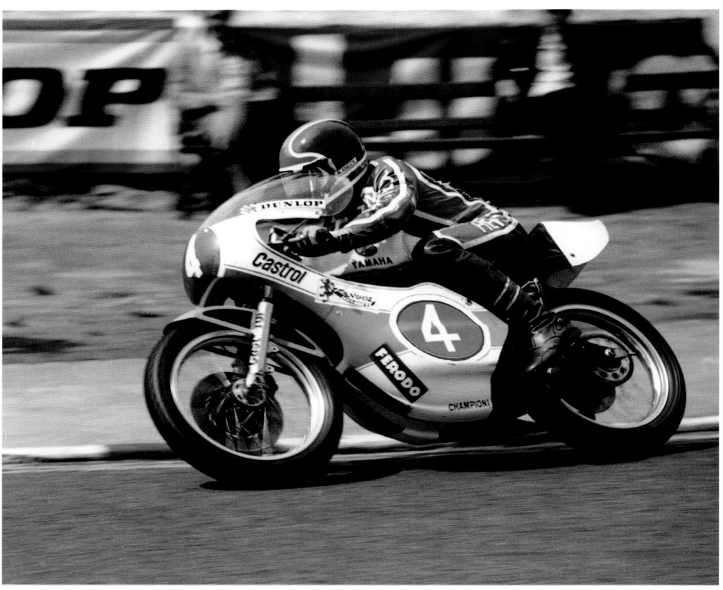

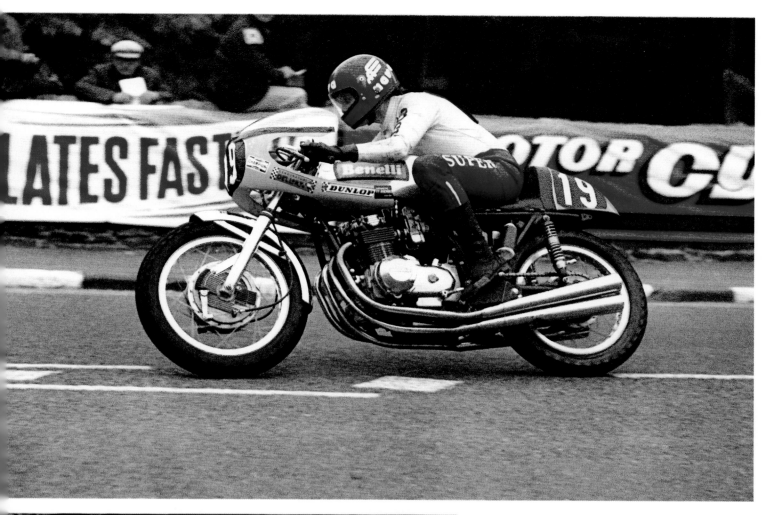

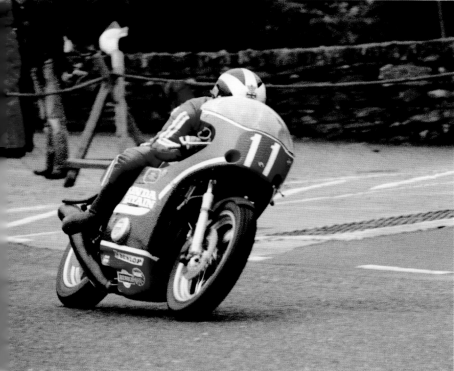

Above Alistair Copland rode this very Honda-esque 500cc four-cylinder Benelli in the 1977 Formula 2 TT. The Formula races were planned to replace the World Championship that was lost after 1976.

Left Phil Read (Honda), seen charging through Union Mills. Read had criticized the TT back in 1973, but came back to win the inaugural Formula One TT in 1977.

"It was wet, I rode a 250, and I'd never been round the circuit before, even in a car. I remember coming up to Ballacraine and didn't know whether to turn right, left or straight ahead!"
Joey Dunlop

Opposite top One year after his introduction to the TT, Joey Dunlop tasted victory on the Rea Racing Seeley Yamaha in the 1977 Jubilee TT. He was still called Joe on the fairing.

Opposite bottom Graham Milton and John Brushwood (British Magnum) at Laurel Bank in the 1977 Sidecar TT.

Below Mick and the Green Meanie. Mick Grant leaves Quarter Bridge and his competitors behind, as he easily won the 1977 Classic TT, setting an absolute lap record of 112.77 mph.

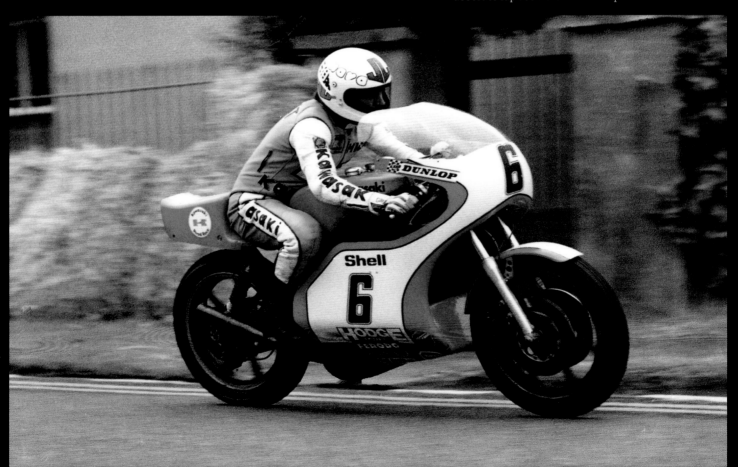

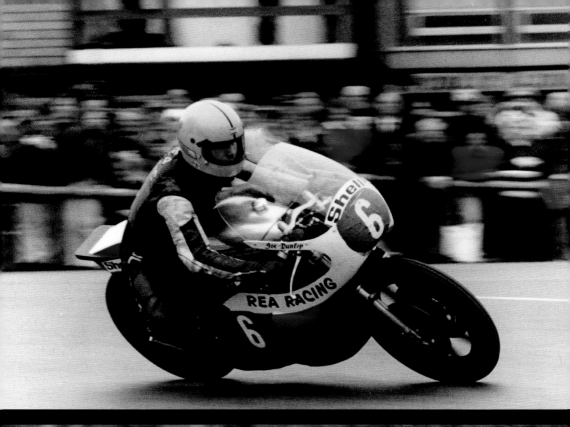

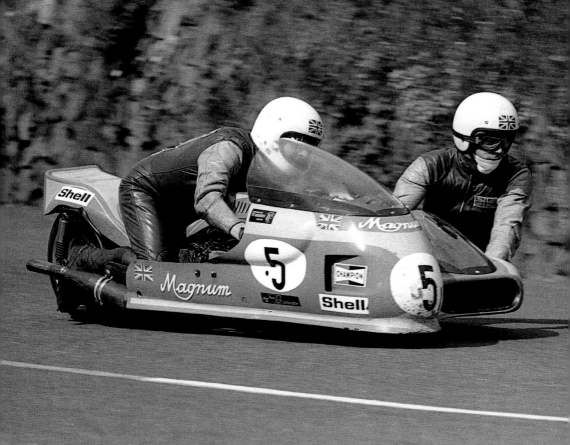

Left Steve Tonkin looks pleased with his third place in the 1977 Jubilee TT; as does runner-up George Fogarty (red leathers). The young lad in the Suzuki jacket (right) went on to win three TTs and four Superbike World Championships – Carl Fogarty.

Bottom left Mike Hailwood returned to TT racing after a gap of 11 years, with a fairy tale win in the 1978 Formula One TT on the Sports Motorcycle Ducati.

Bottom right Forty years after finishing third in the 1939 Senior TT, Stanley Woods once more rode the 500cc works Velocette on the Isle of Man in the Classic Parade. Of 37 TT races from 1922 to 1939, Stanley won ten.

Opposite Mike Hailwood and his Sports Motorcycles Ducati team wait to start his victorious TT comeback in the 1978 Formula One TT.

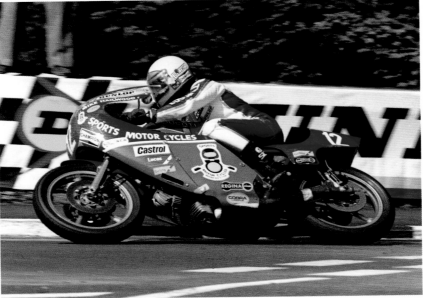

ISLE OF MAN TT
1980s

Opposite Self-captioned! Ian Martin (Suzuki),
father of current TT (and TV) superstar Guy Martin,
at Quarter Bridge in the 1982 Formula One TT.

1980s

The new Formula 1 (750cc) and Classic (1,000cc) TTs started to outrank the traditional 500cc Senior TT, and in 1983 the Senior was opened to full one-litre bikes.

This made little difference to the man of the decade: Joey Dunlop won in 1987 on a 500cc GP Honda two-stroke, and in 1988 on a 750 four-stroke. He took nine wins in this period, including six successive F1 races, and in 1985 added a 250 Junior to take only the third hat-trick in history, after Hailwood's in 1961 and 1967.

Ulsterman Joey was the master of the Island; other winners included Mick Grant and Trevor Nation. In 1989 Dunlop was absent injured. It made way for a new name. Steve Hislop had won two TTs already, and joined the hat-trick group with three in a week in 1989.

Much had changed: pure GP bikes were out of favour; production classes in the ascendancy. The exhaust noise was lost, but the TT was going back to its original roots. Then a double tragedy in 1989, with top riders Steve Henshaw and Phil Mellor killed in separate accidents, saw the new production class suspended.

Opposite Mick Grant (Honda, 12) and Graeme Crosby (Suzuki, 11) battle it out through Braddan Bridge in the 1980 Formula One TT. Grant won by ten seconds from Crosby.

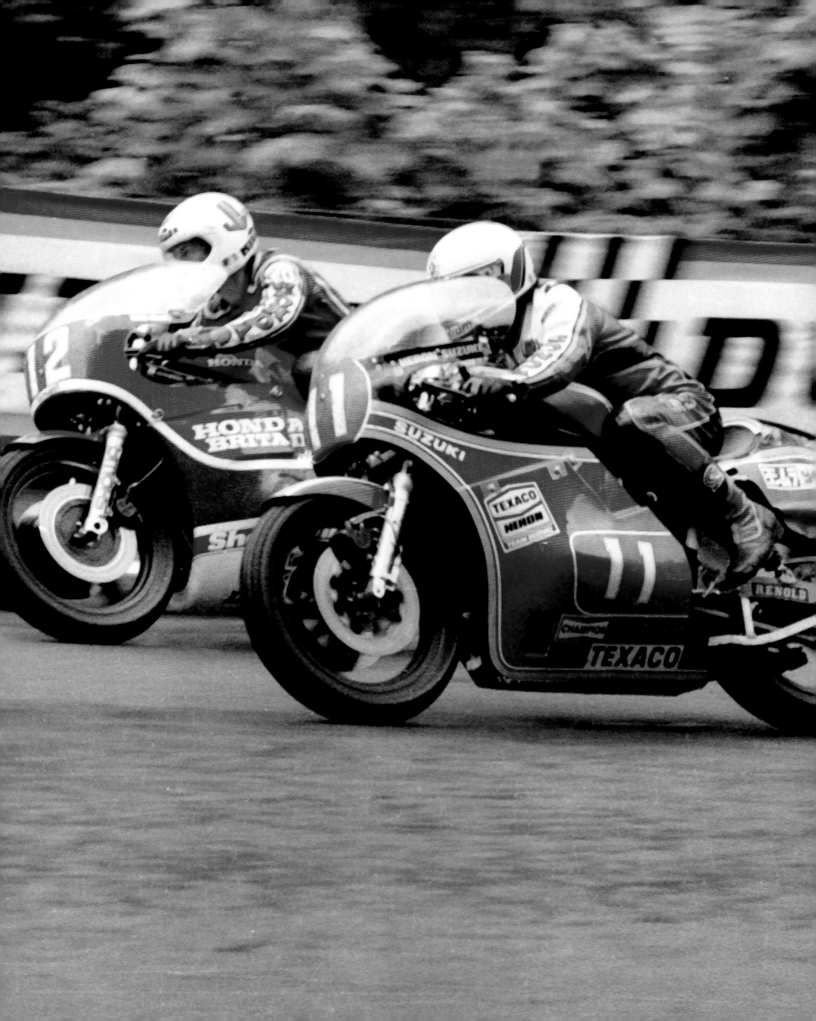

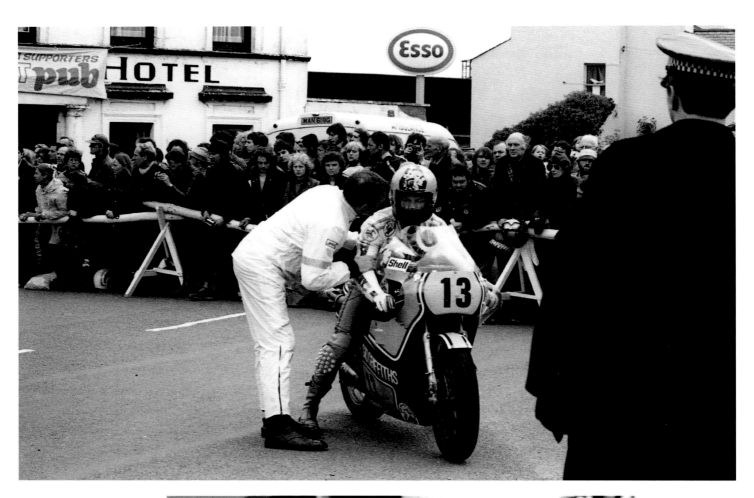

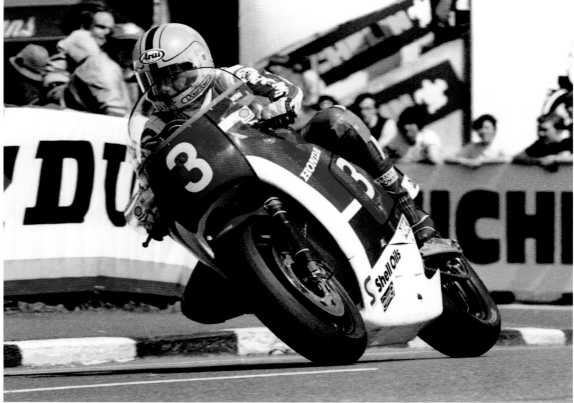

Opposite top Unlucky 13! Chris Guy was leading the 1981 Senior TT, when it was halted by worsening weather. In the restarted race, he slid off at Braddan Bridge.

Opposite bottom Joey Dunlop (Honda) at Quarter Bridge in the 1983 Formula One TT, winning the first of his six consecutive F1 victories.

Bottom Yorkshire-born Phil Mellor (EMC) at Parliament Square, in the 1983 Junior 250 TT.

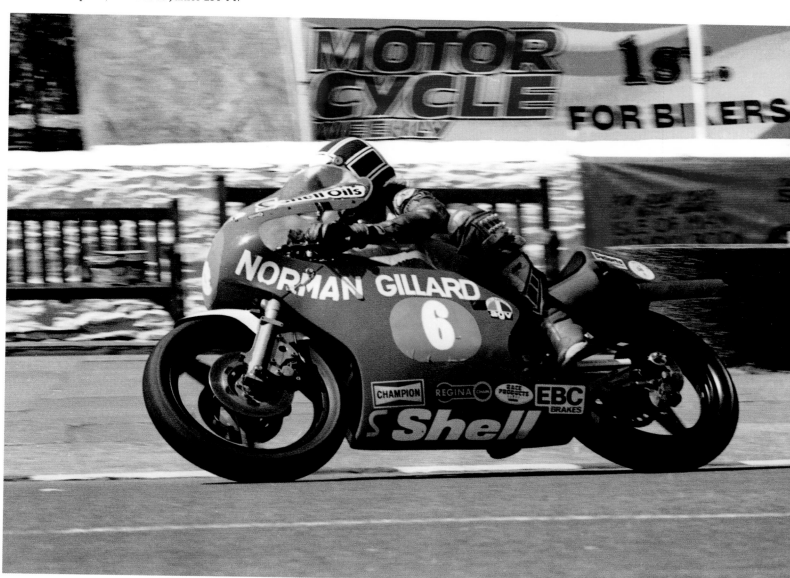

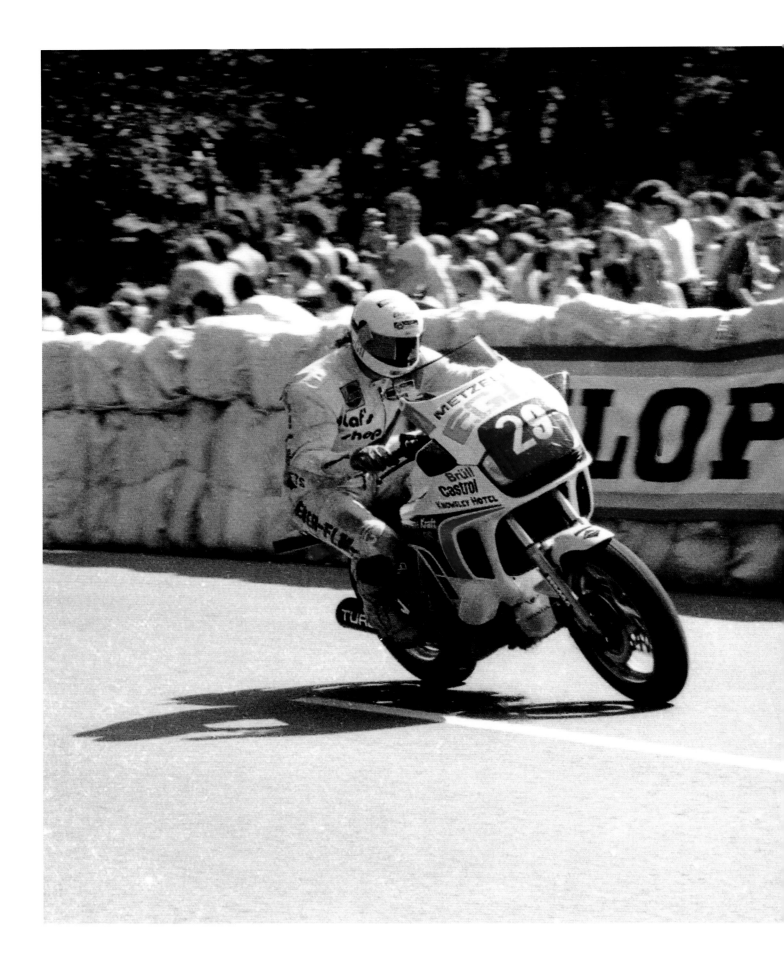

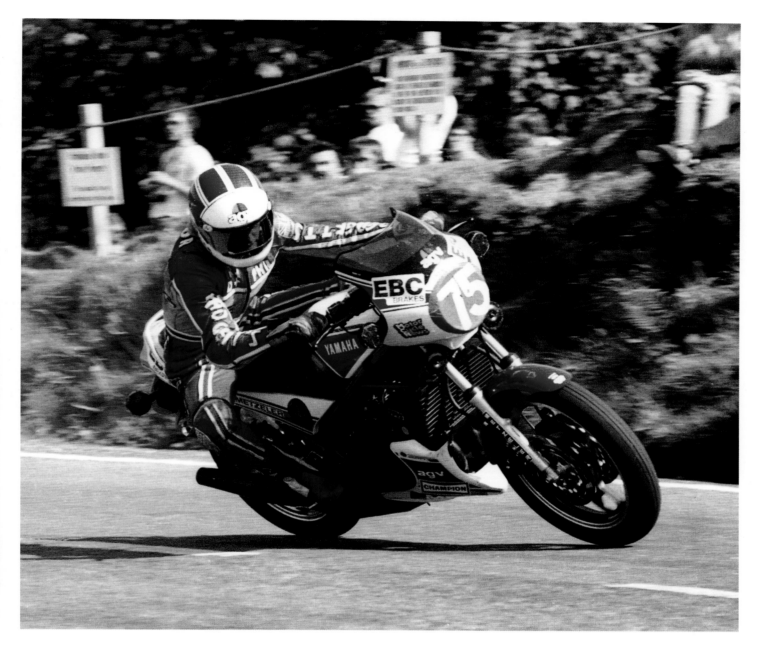

Above Phil Mellor started his racing days in the mid-1970s. He later rode Yamaha RD 350 machines, before moving on up to ride the works Suzuki. In 1984 he rode this Padgetts of Batley Yamaha to win the 250 Production race. Note the taped-up indicators!

Opposite Possibly riding the only turbo-charged machine to be ridden at the TT, Elmar Geulen (Honda) at Braddan Bridge in the 1984 Production TT Race.

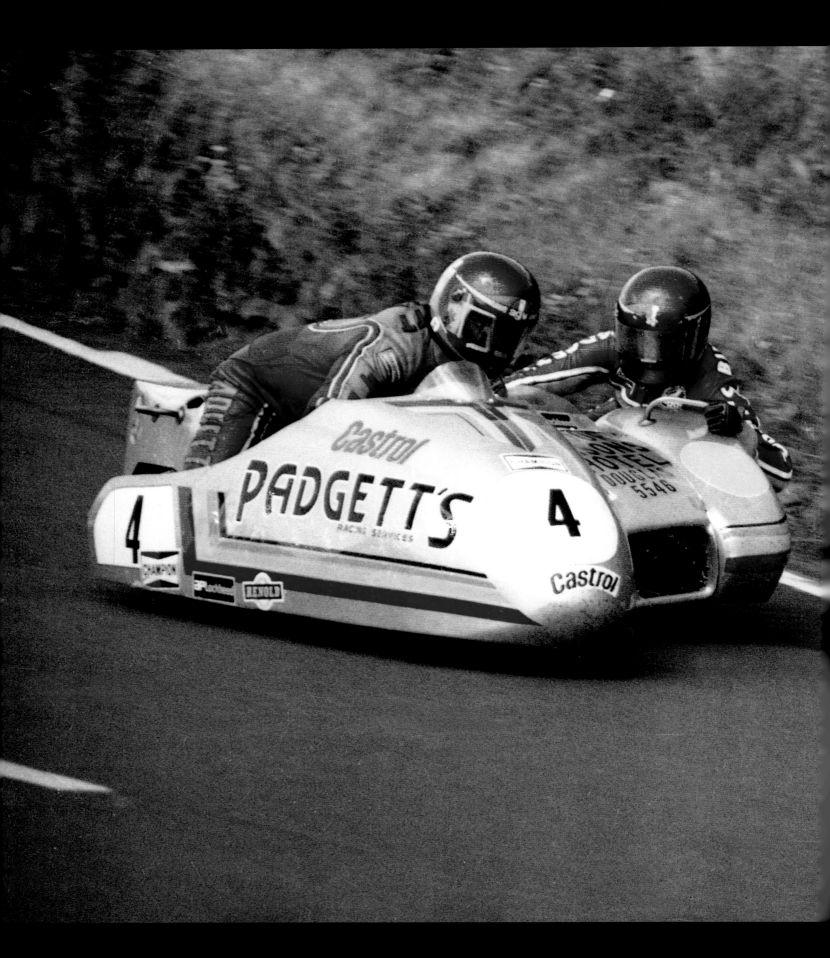

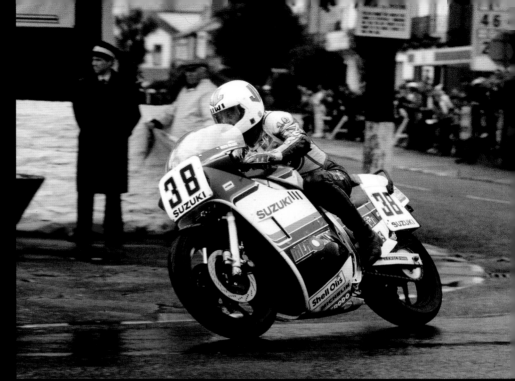

Right It's damp conditions for Mick Grant as he rounds a slippery Parliament Square. This 1985 Production B race gave the newly introduced GSXR750 Suzuki its inaugural TT success.

Opposite Julia Bingham, passengering for husband Dennis, was only the second woman to visit the winners' rostrum at the TT when the Padgetts-sponsored pairing took runner-up place in the second 1982 Sidecar TT. They finished second four times at the TT. A Bedstead Corner shot. Rose Arnold was the first woman to finish on a TT podium, finishing second in the 1967 Sidecar 750 TT race.

Below *The Motor Cycle* news journalist Mat Oxley (Honda NS250) in the 1985 Production 250cc race.

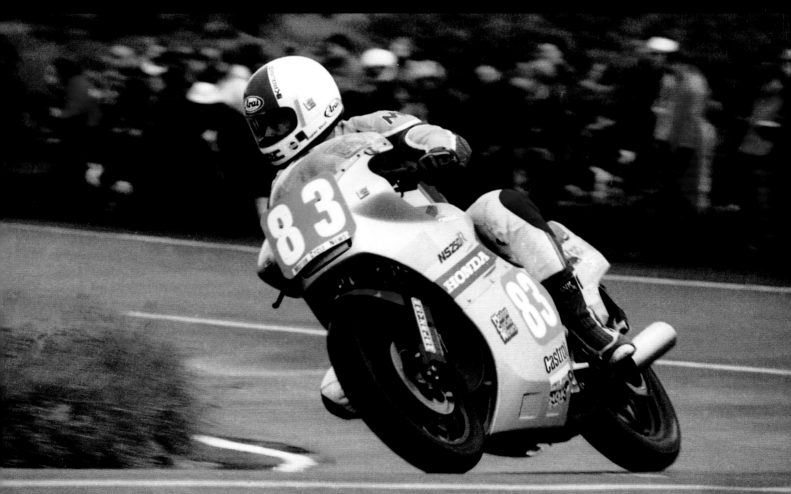

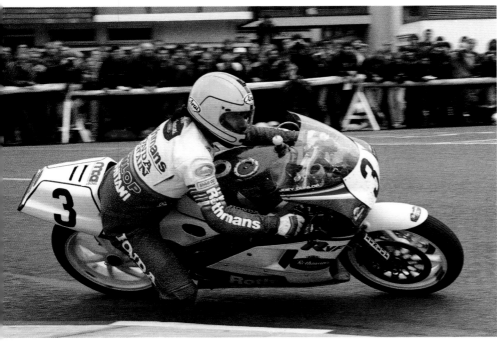

Left No. 3 on top of the pile; the 1986 Formula One TT was Joey Dunlop's fourth successive F1 victory.

Below Steve Cull (Honda) in control at Ballacraine, on his way to winning the 1986 Junior TT.

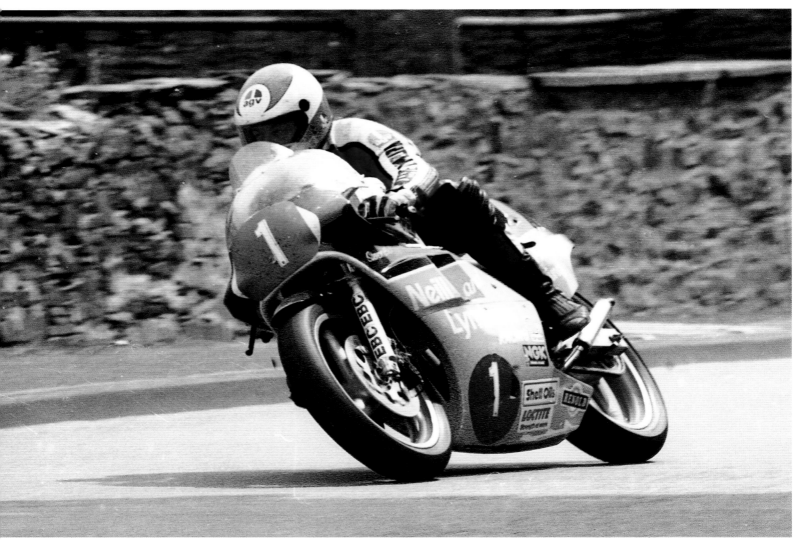

"People say it's a dangerous sport and that you are mad in the head and if I'm honest, yeah, I have a little touch in the head..."
Michael Dunlop

Below Nigel Rollason and Donny Williams gave the British-built Barton Phoenix its only TT win in 1986.

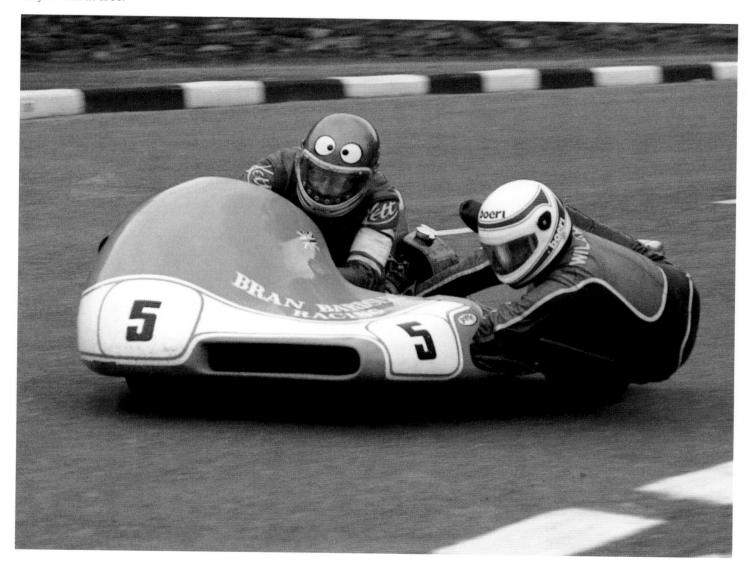

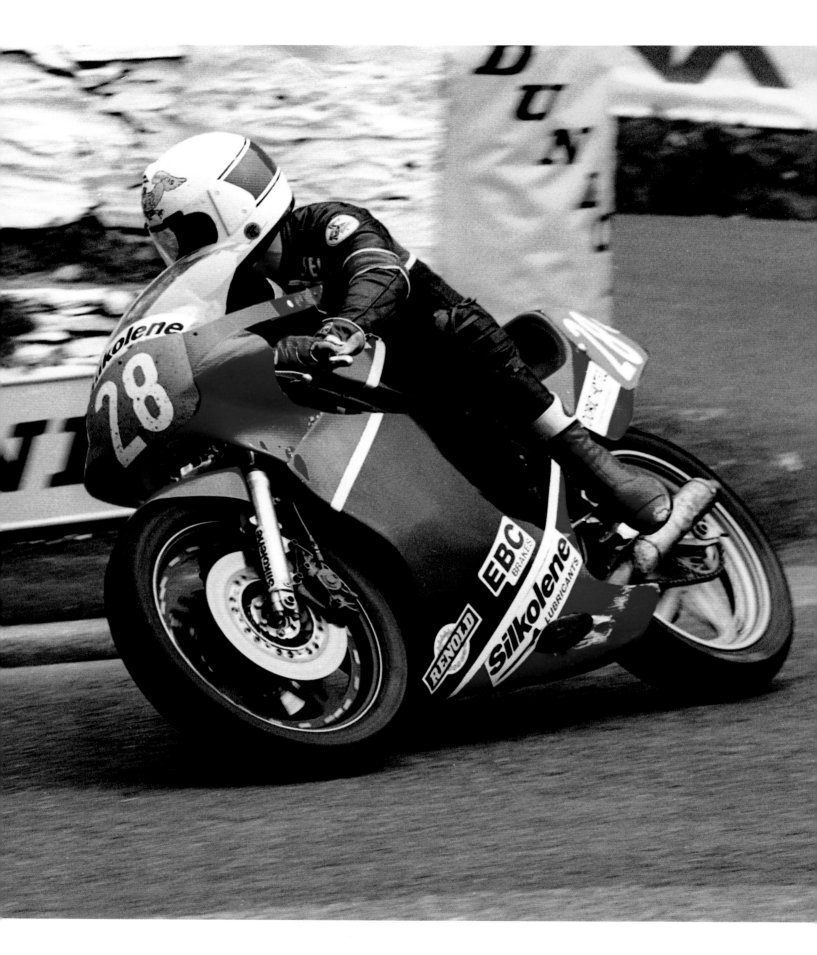

Opposite Hawick's Steve Hislop came to TT
prominence when he won the 1987 Formula
Two TT. With eleven TT wins to his name,
Steve is a worthy member of the TT Hall of Fame.

Below In winning Sidecar Race B in 1987,
49-year-old Ulsterman Lowry Burton, passengered
by Pat Cushnahan, became the oldest TT winner
until sidecar winner John Holden (54) in 2011.

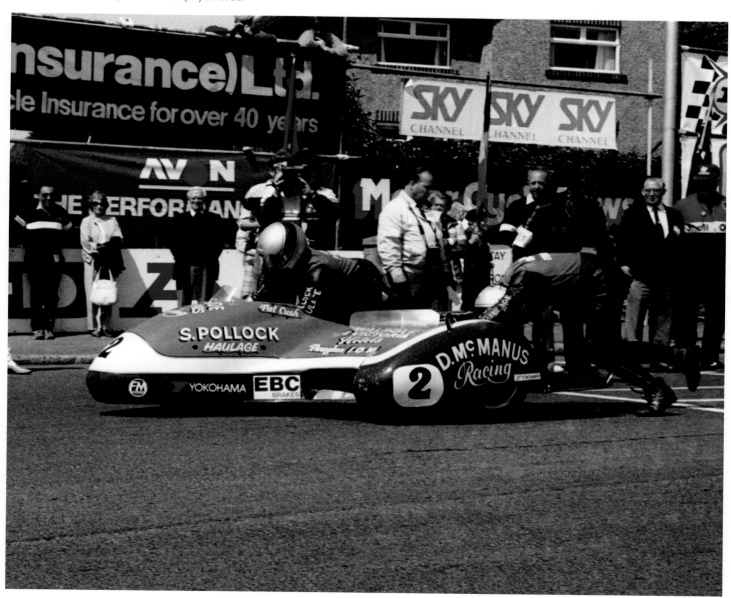

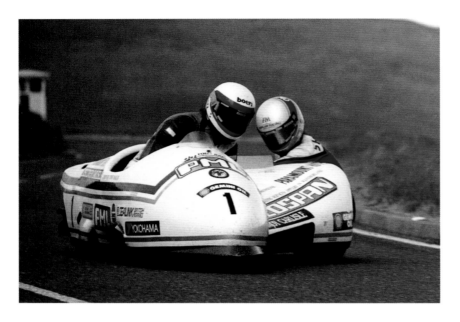

Above The last year of the big-engined outfits. From 1990 the sidecars were limited to F2 spec. Tony Baker and James Cochrane negotiate the Bungalow in 1988.

Right Joey Dunlop and his victorious team pose with his 1988 TT-winning Hondas. Behind Joey is Davy Wood, for many years Joey's mentor and manager.

" I never wanted to be a superstar. I just want to be myself. I hope that's how people remember me."
Joey Dunlop

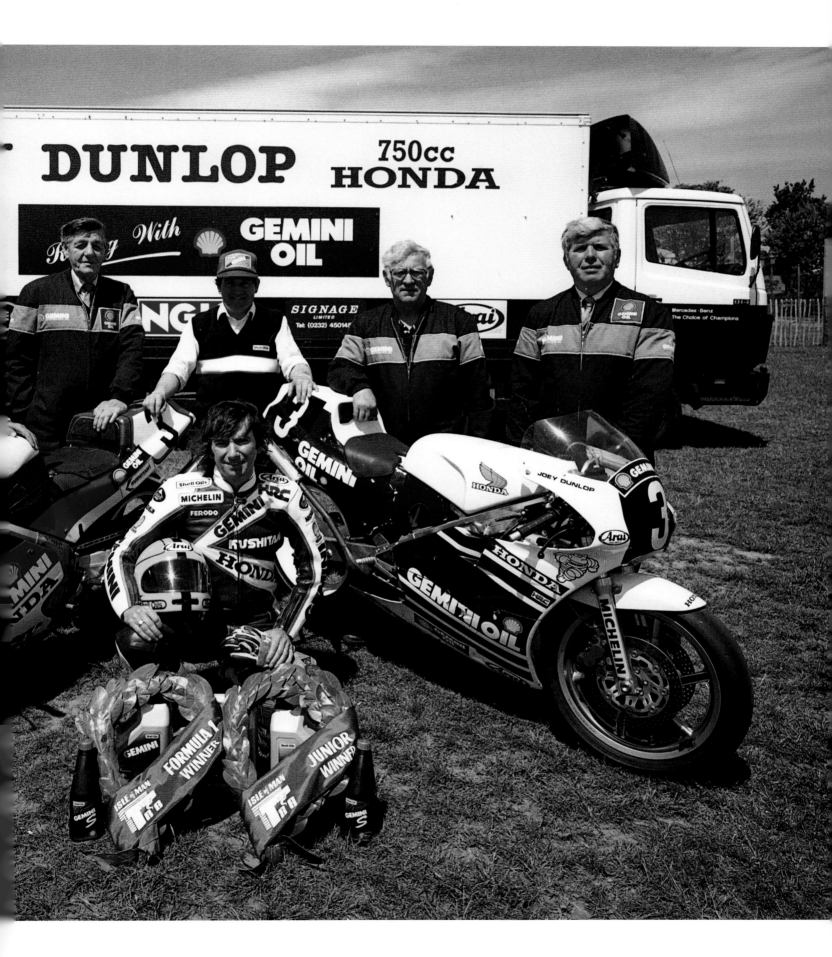

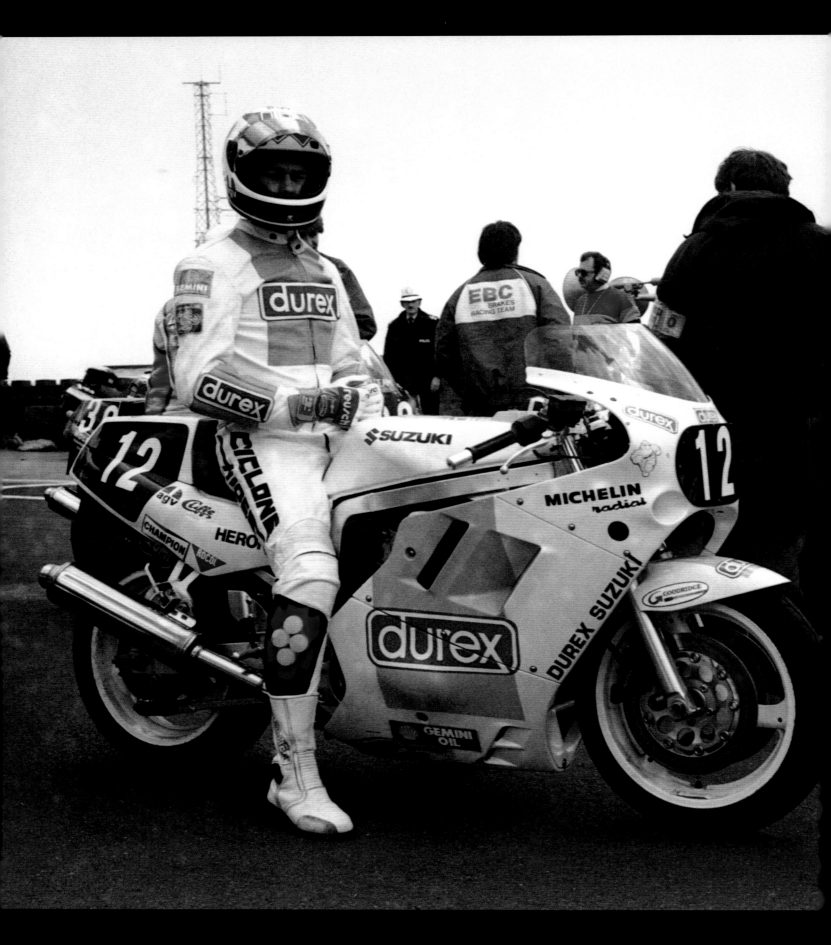

Opposite The London Rubber Co. sponsored the Suzuki team in 1989. TV race pundit Jamie Whitham lines up for practice.

Below Runner-up to Georg Meier in the 1939 Senior TT, Jock West once more took this supercharged BMW round the TT course in the 1989 TT Parade Lap. After the Second World War, Jock helped to retrieve the Senior TT trophy which had been taken to Germany.

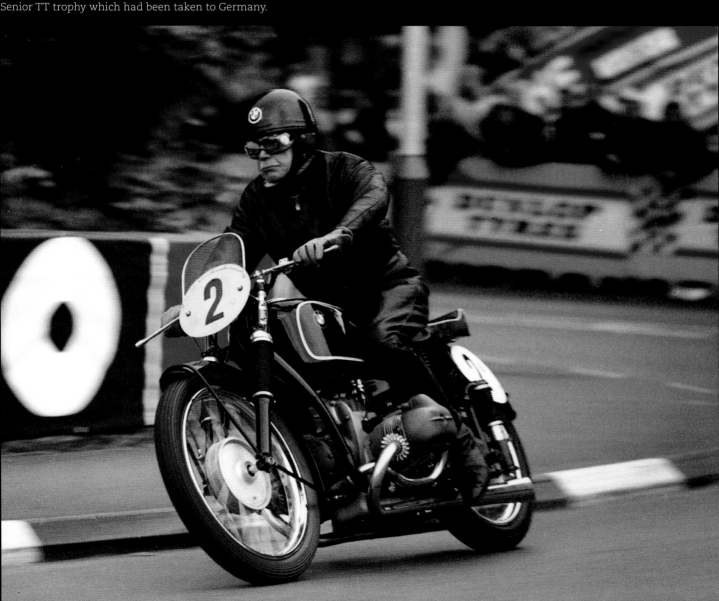

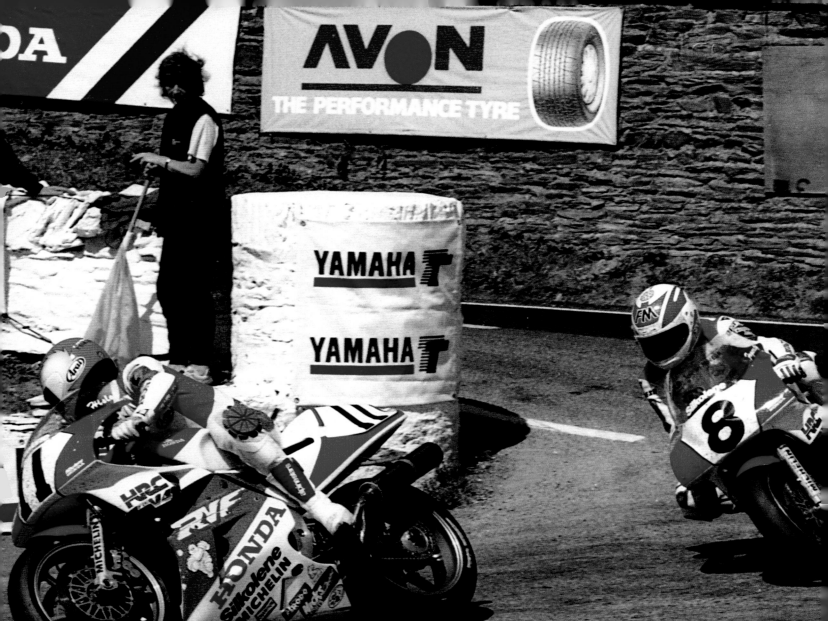

ISLE OF MAN TT
1990s

1990s

Records tumbled: Steve Hislop (Norton) ran 124.36 mph while rival Carl Fogarty (Yamaha) set a race lap record at 123.61 in 1992, when the pair clashed in an epic battle; victory going to future Superbike champion Foggy.

Ulsterman Phil McCallen was the major figure, with a new record of four wins in a week in 1996; yet the fans' hearts mainly belonged to Joey Dunlop. Although mostly in the smaller classes but for the 1995 Senior, Joey had piled up a still unbeaten record of 23 wins by 1998, with three more to come in 2000, before he was tragically killed in a road race in Estonia.

Norton was back with a rotary, Hislop claiming its first Senior win since 1961.

But Honda dominated, ever more strongly and loyal to the race that had launched the brand, unbeaten in 1996, 1997 and 1998, when the company's 50th birthday saw a special classic parade.

By the end of the decade, Hislop and McCallen had retired; but two new names claimed their first wins: John McGuinness and David Jefferies. They would become legends.

Right Thirty years after Hondas first TT win, Mick Boddice and Dave Wells finally gave them their first sidecar TT successes with a double at the 1991 TT.

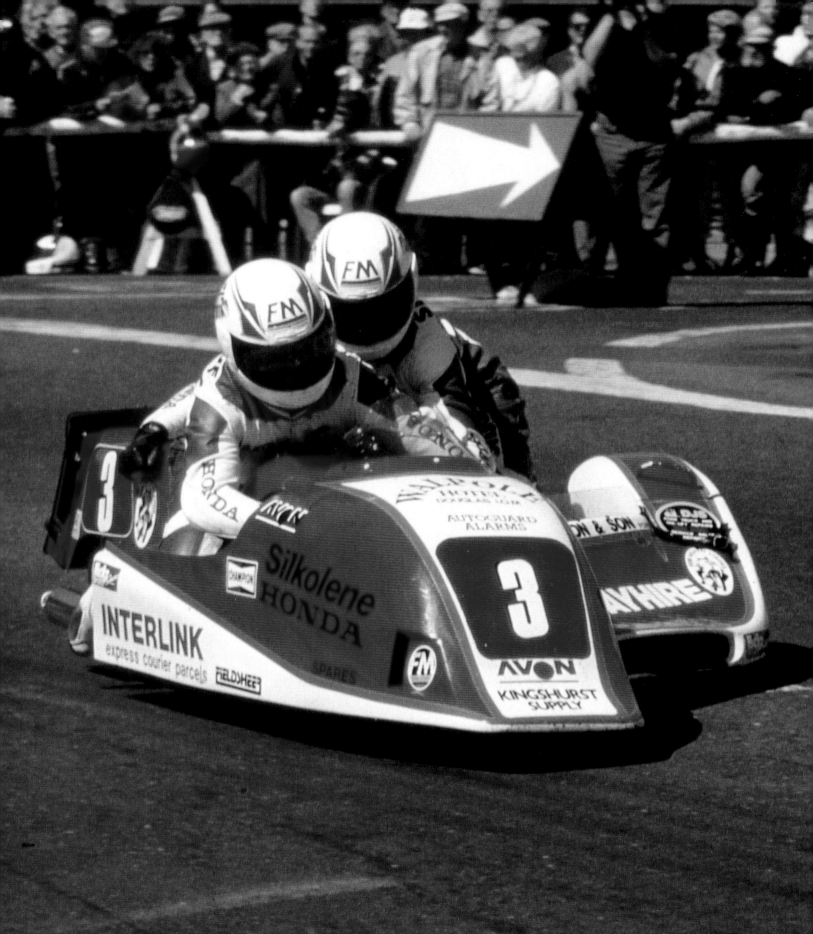

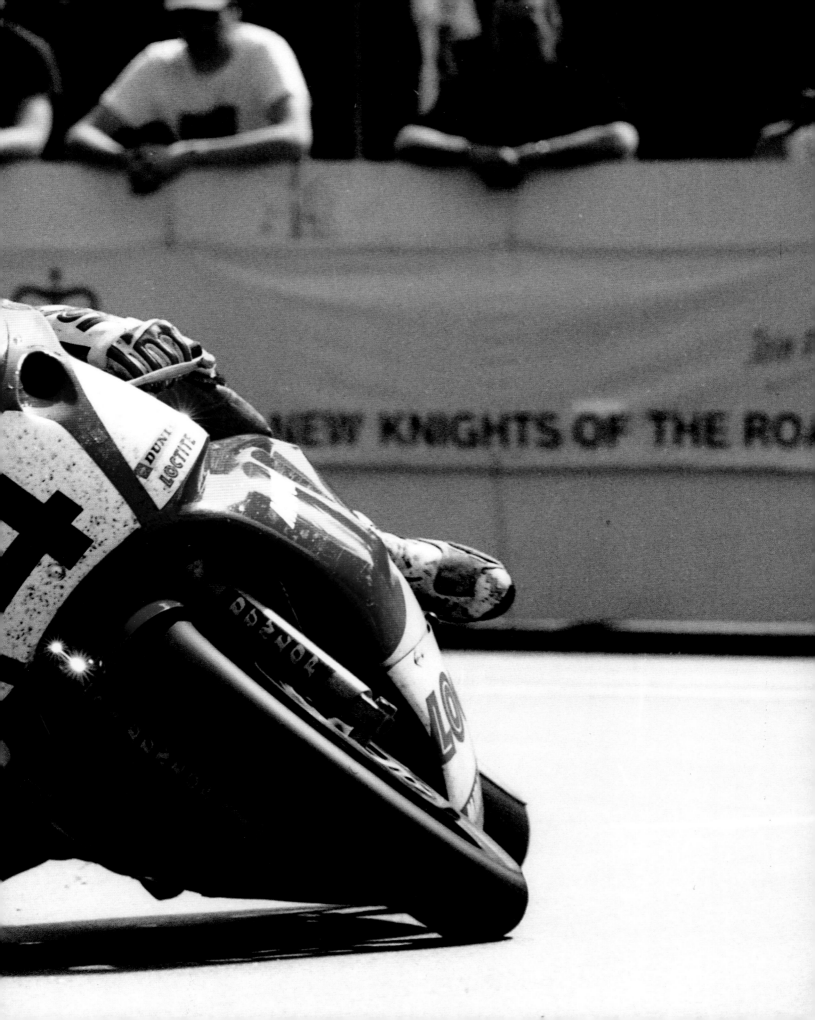

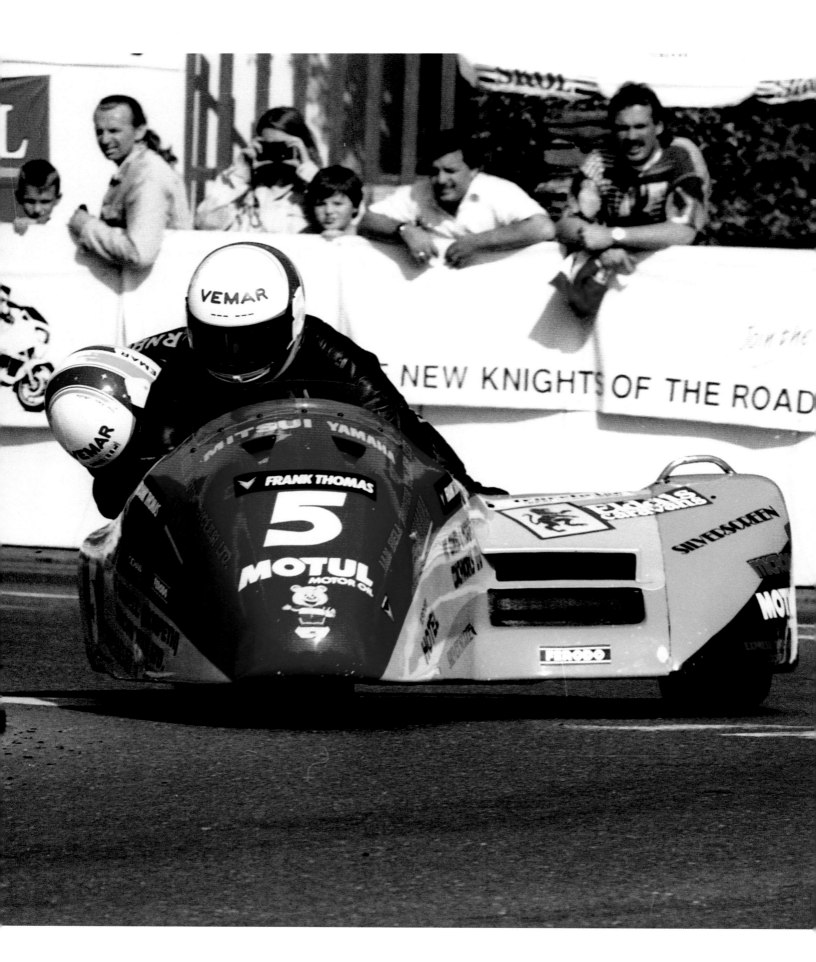

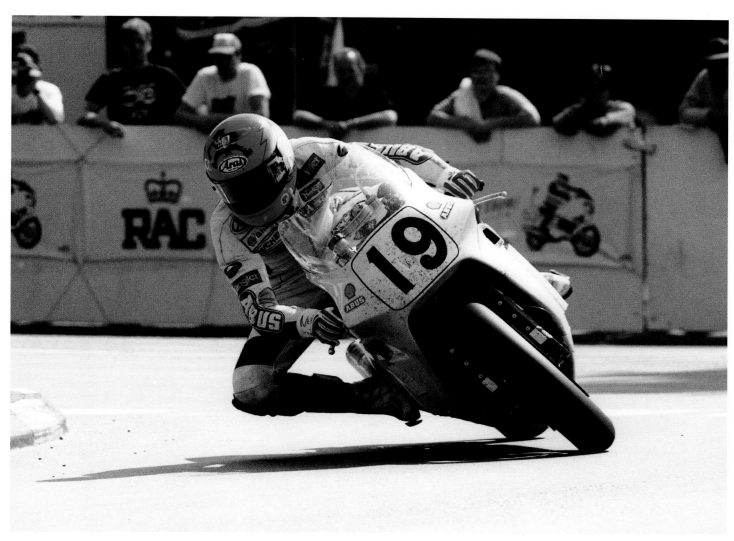

Above In the 1992 "race of the century", Steve Hislop beat Carl Fogarty by scant seconds in the 1992 Senior TT to give Norton its first TT victory since 1961.

Right Former French racing champion Bernard Guerrin rode this Mk VIII KTT Velocette to victory at the 1993 Classic TT, held on the Billown (Southern 100) circuit.

Opposite Geoff Bell and co-pilot Keith Cornbill took both TT wins in 1992 on their Mitsui Yamaha.

Previous pages Carl Fogarty at full stretch in his 1992 Senior TT battle with Steve Hislop. He was beaten by just four seconds.

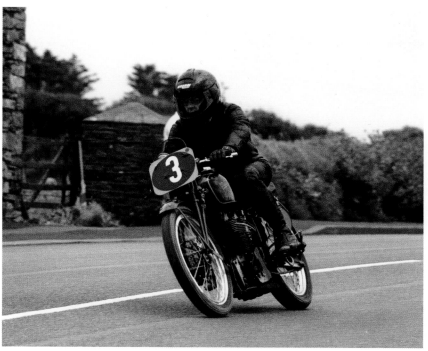

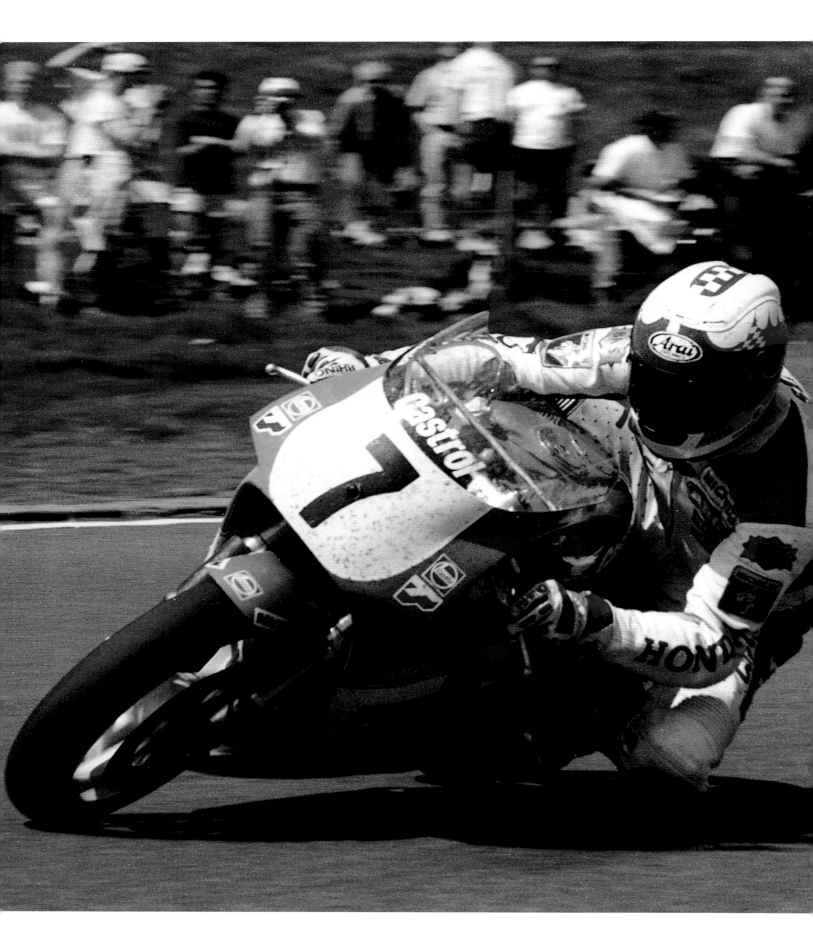

> "I had an obsession with winning so I wasn't concerned about the danger. I felt I was the greatest racer of all time."
> **Carl Fogarty**

Left Nick Jefferies won his only TT, the 1993 Formula One TT, on the Castrol Honda. Seen here at the Bungalow.

Below German sidecar rider Max Deubel (BMW) at the Gooseneck in the 1994 TT Classic Parade lap. He last competed in the TT back in 1966.

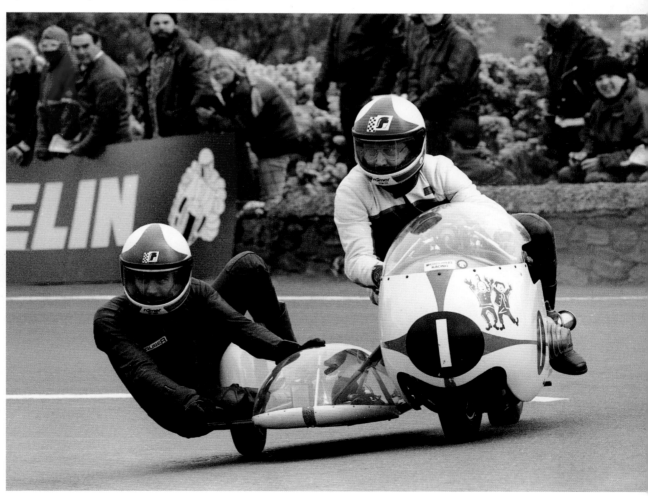

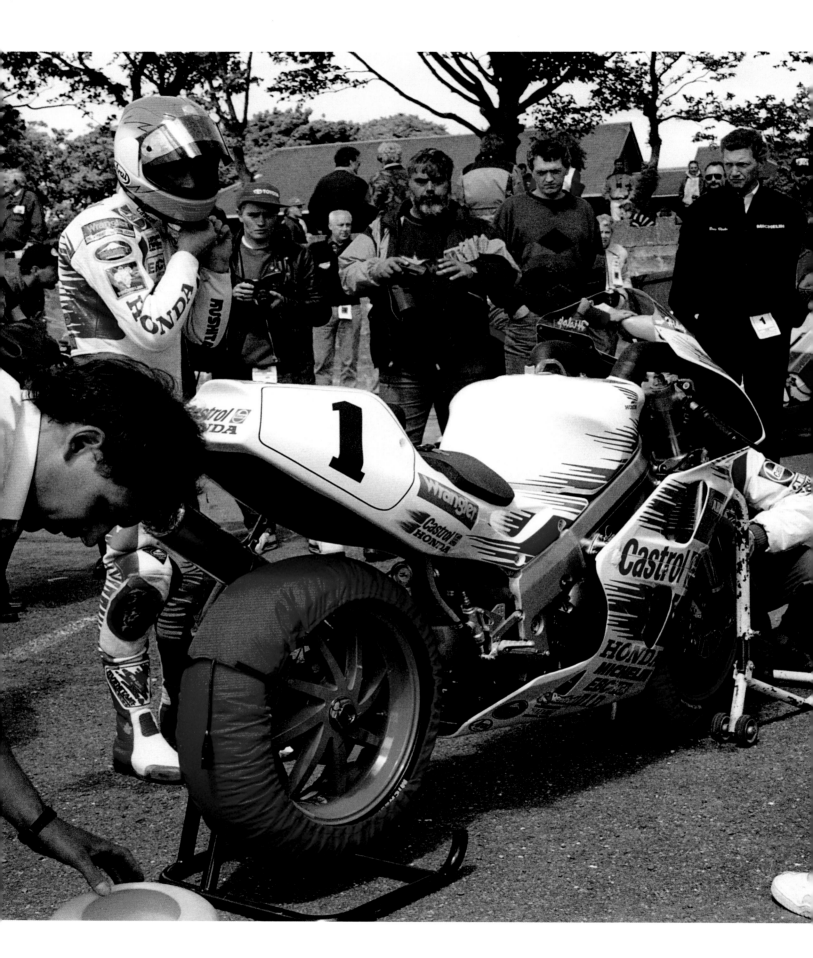

"They are the worst roads in the UK."
Steve Hislop

Opposite Steve Hislop and his Castrol Honda team make themselves ready for the 1994 Senior TT. This was to be Steve's last TT race; he led from flagfall to chequered flag.

Below Five-time Manx Grand Prix winner Bob Jackson (McAdoo Kawasaki) tackles Parliament Square in the 1995 Formula One TT event.

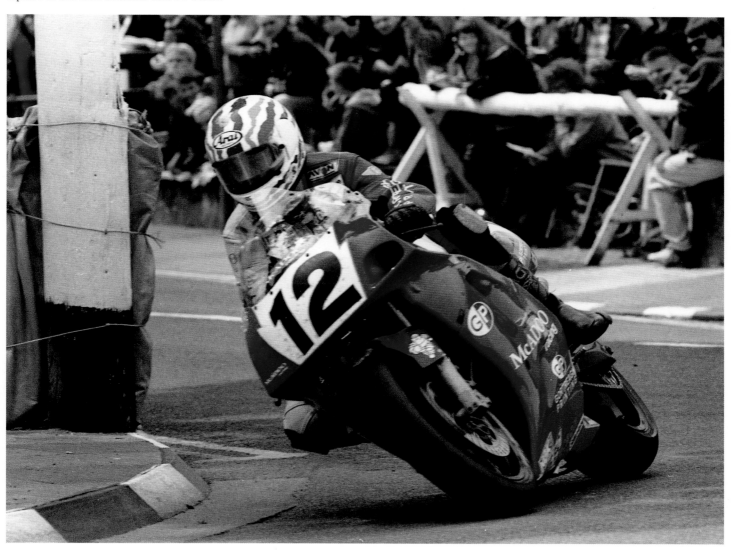

Opposite New Zealand rider Shaun Harris
(Tryphonos Suzuki) leans into the corner at
Creg-ny-Baa in the 1995 Senior TT.

Below Rob Fisher and Boyd Hutchinson balance
their Proton Yamaha on two wheels en route
to the second of their double TT victories in
1995. Rob was to win ten Sidecar TTs.

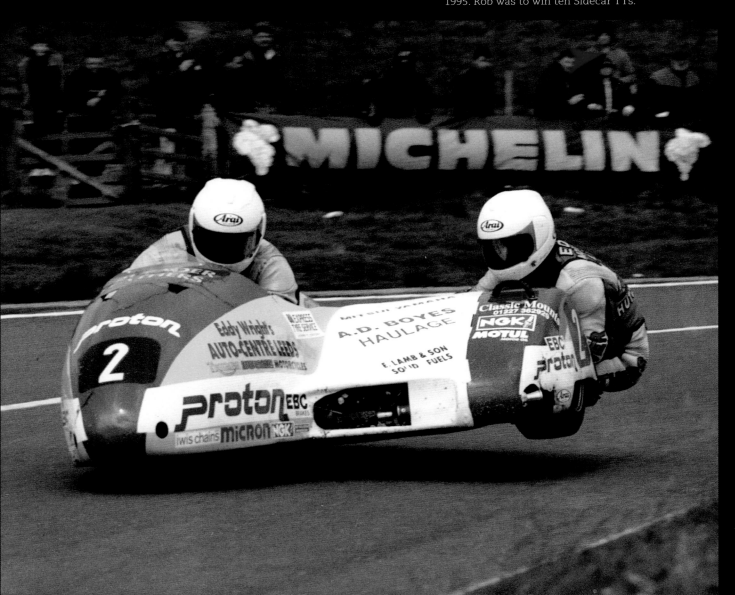

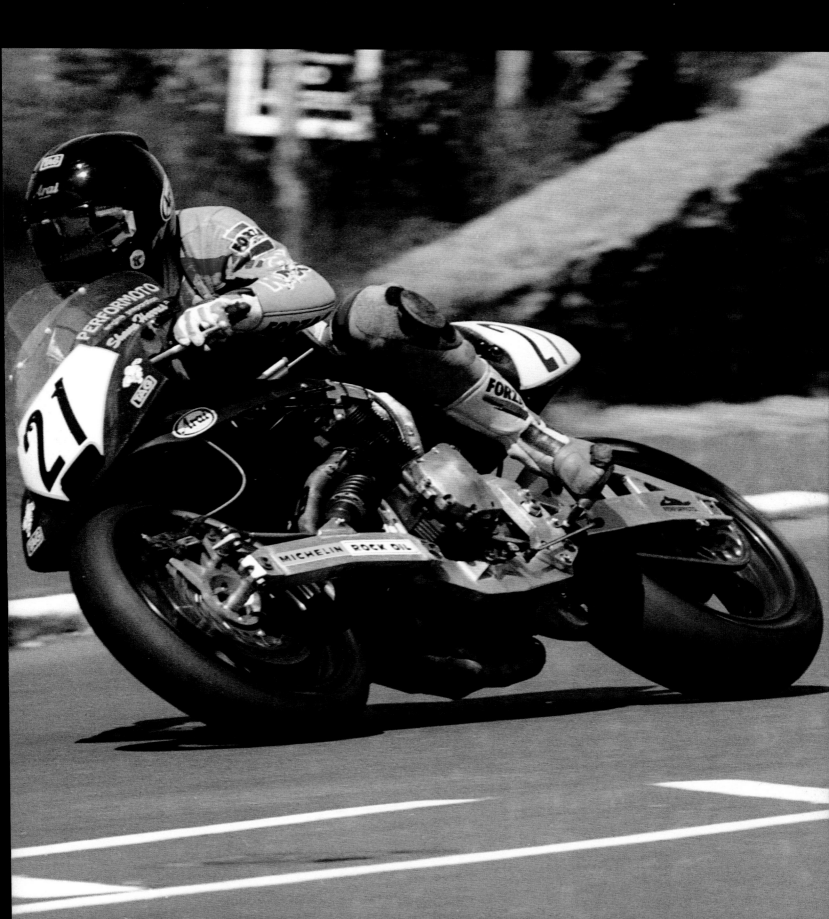

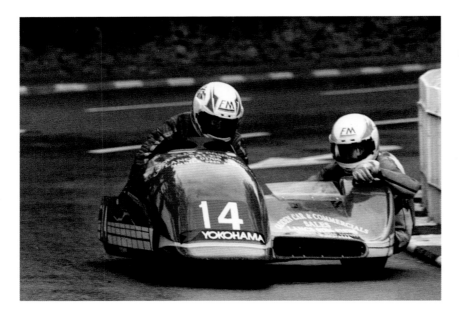

Above Peter Nuttall with Nick Crowe as passenger. Nick later went on to win five Sidecar TTs as a rider, and still holds the outright lap record, set in 2007.

Right Nearly on the home straight, Dave Morris (Chrysalis BMW) at Signpost Corner in the 1996 Singles TT. The 90-degree right-hand corner is situated betweem the 36- and 37-mile road markers.

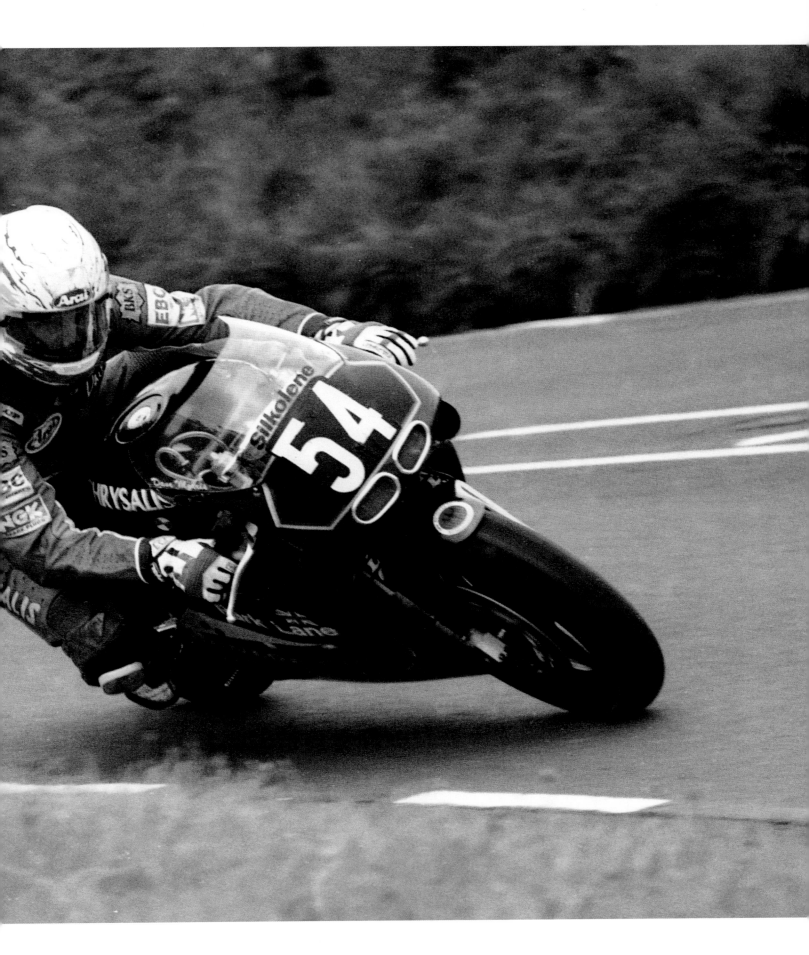

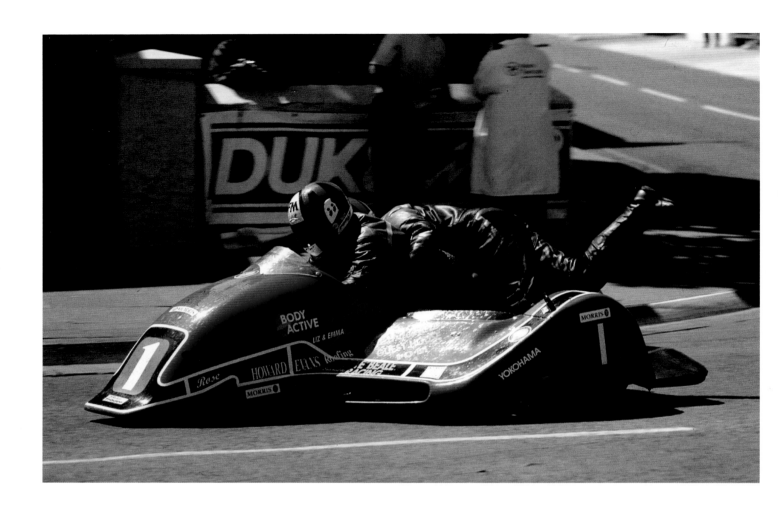

Previous pages New Zealand's Shaun Harris (Britten) at Parliament Square; 1996 Formula One TT.

Above Roy Hanks and Phillip Biggs won their only TT victory in 1997, by just 2.2 seconds!

Right Phillip McCallen rode the Honda Britain to another hat-trick of wins at TT 1997. Phillip eventually took eleven TT titles.

Opposite Northern Ireland's Tommy Robb (MZ) leaves Ramsey on the 1997 Classic Parade Lap.

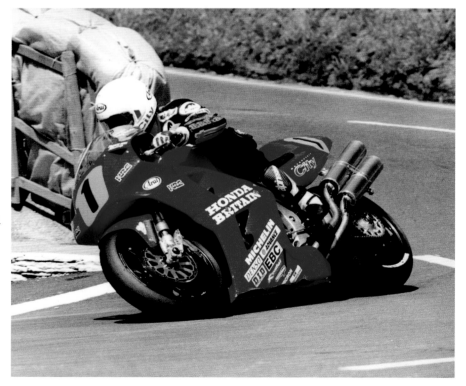

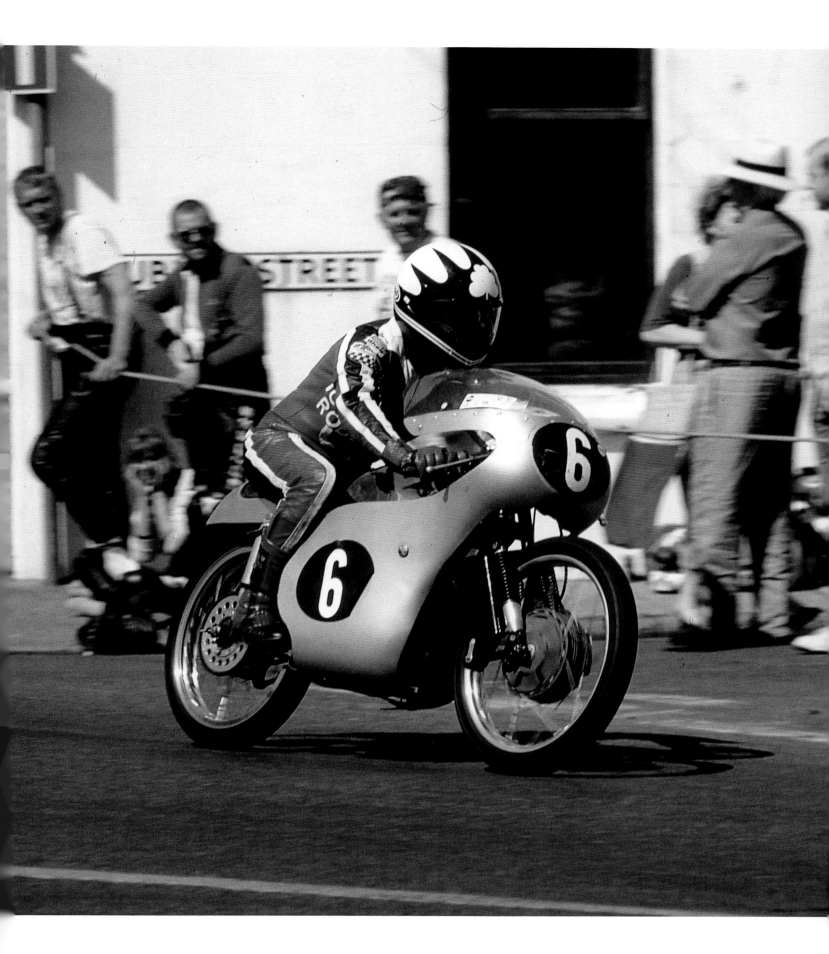

"No-one is forcing me to go, I'm doing it completely off my own back. I enjoy doing it."
David Jefferies

Right Robert Dunlop won the last of his five TTs in the 1998 Ultra Lightweight TT.

Below Super-fast David Jefferies riding his R1 Yamaha to fourth place in the 1998 Senior TT.

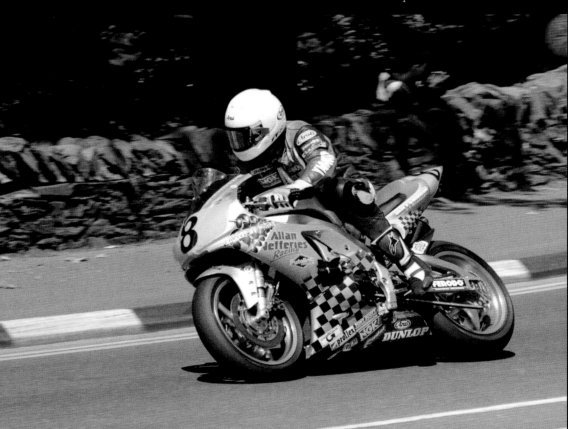

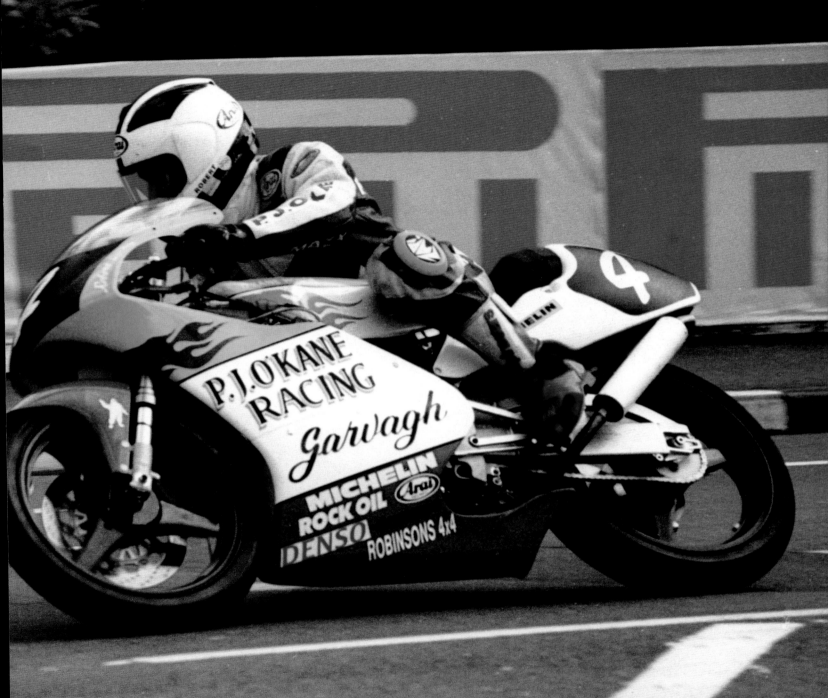

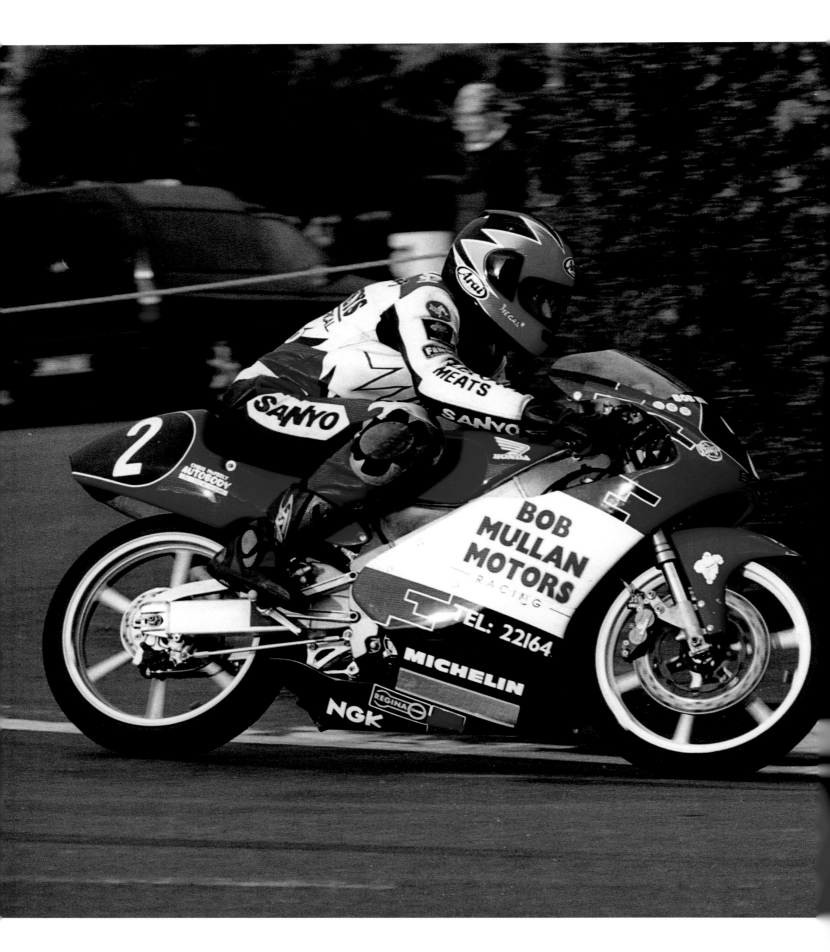

"It's the longest circuit in the world by far. It's part of history, almost where motorcycling started. The speeds are unbelievable."
John McGuinness

Left Denis McCullough (Lunney Honda) at White Gates; 1999 Ultra Lightweight TT.

Below An icon in the making: John McGuinness (Honda) in the 1999 Lightweight TT, John's first TT win.

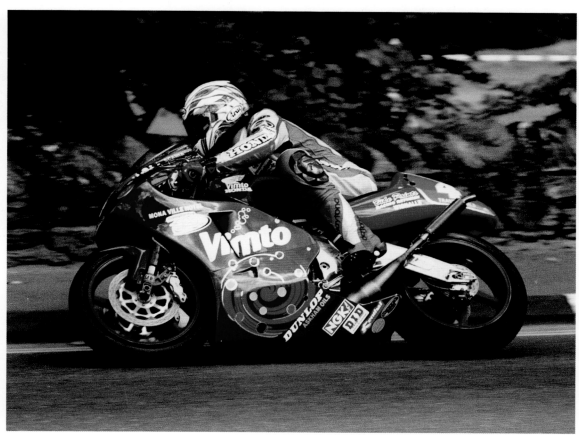

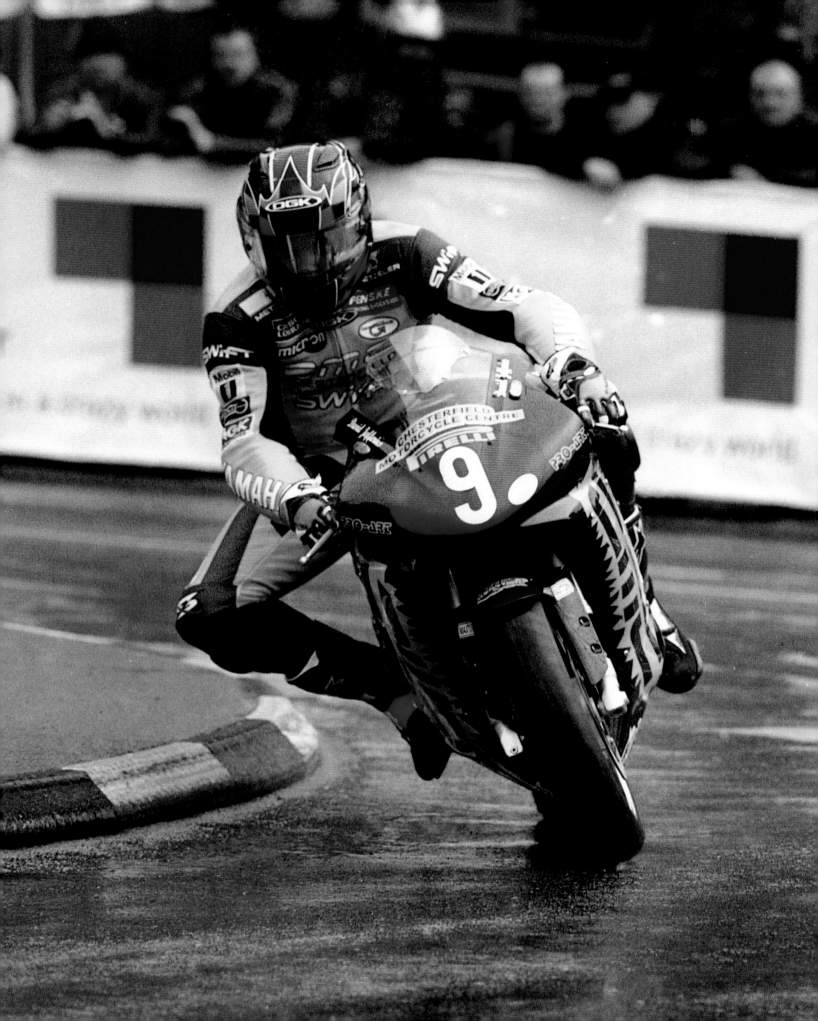

ISLE OF MAN TT
2000s

Left Tip-toeing round Quarter Bridge,
David Jefferies (Yamaha), won the
rain-shortened 2000 Production TT.

2000s

Modern production bikes were now faster than racers of ten years before. The TT had confirmed its classic identity. From 2005 the Manx government took over, remodelling classes to suit. Superb worldwide TV meant that, even with the unprecedented 2001 cancellation (due to the foot-and-mouth epidemic), it had a new lease of life.

And new heroes: English riders joined the mainly Irish road-racing specialists.

David Jefferies was one, winning three Seniors in a row before crashing fatally in 2003. The TT course has no favourites.

John McGuinness took over, with 23 wins by 2015.

In 2010 Ian Hutchinson set a new record: five wins in a week.

Ten-times winner Kiwi Bruce Anstey set a stunning 2014 new record of 132.298 mph, only to be surpassed by John McGuinness a year later with a new time of 132.701 mph.

But Ireland fought back, with the latest of the Dunlop dynasty. Joey's brother Robert won five TTs; now his son Michael emerged to take on McGuinness. Four wins in both 2013 and 2014 grew his total to 11, at the age of 25.

His record 2014 Senior win was BMW's first since 1939.

By now, even the TT-Zero (electric) bikes are lapping at over 119 mph.

Deadly dangerous, utterly compelling, at almost 110 years old, the TT remains the supreme challenge.

Opposite Joey Dunlop unclips his trademark yellow Arai helmet for the last time in the Isle of Man. Winner of three races in 2000, he finished third in the Senior TT. No-one has eclipsed his 26 TT victories from 100 races round the TT course.

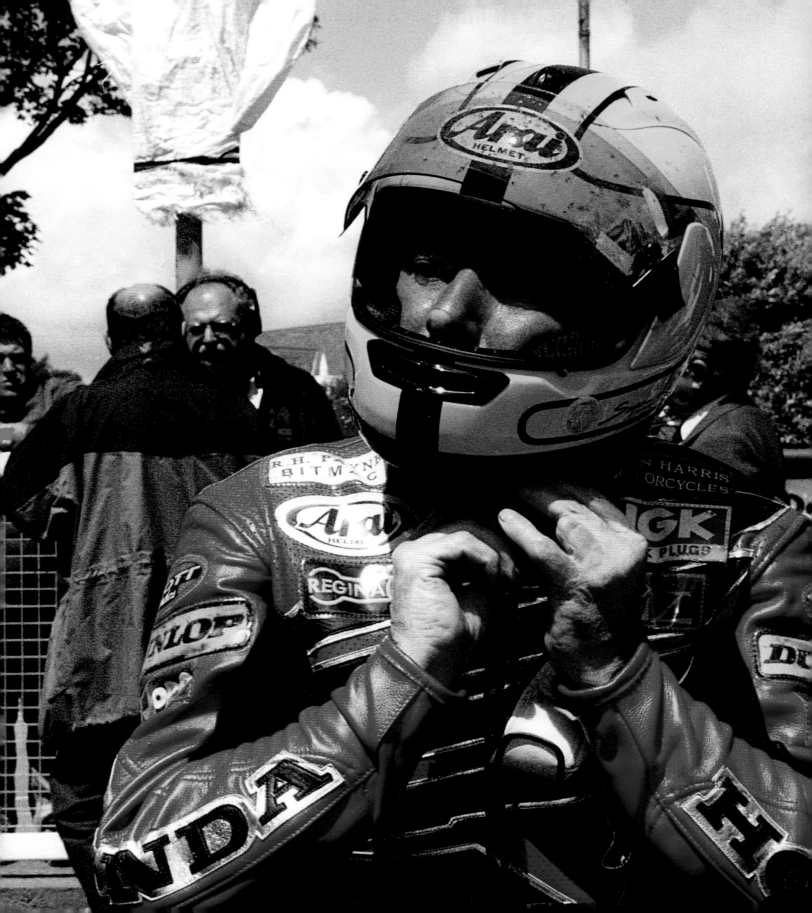

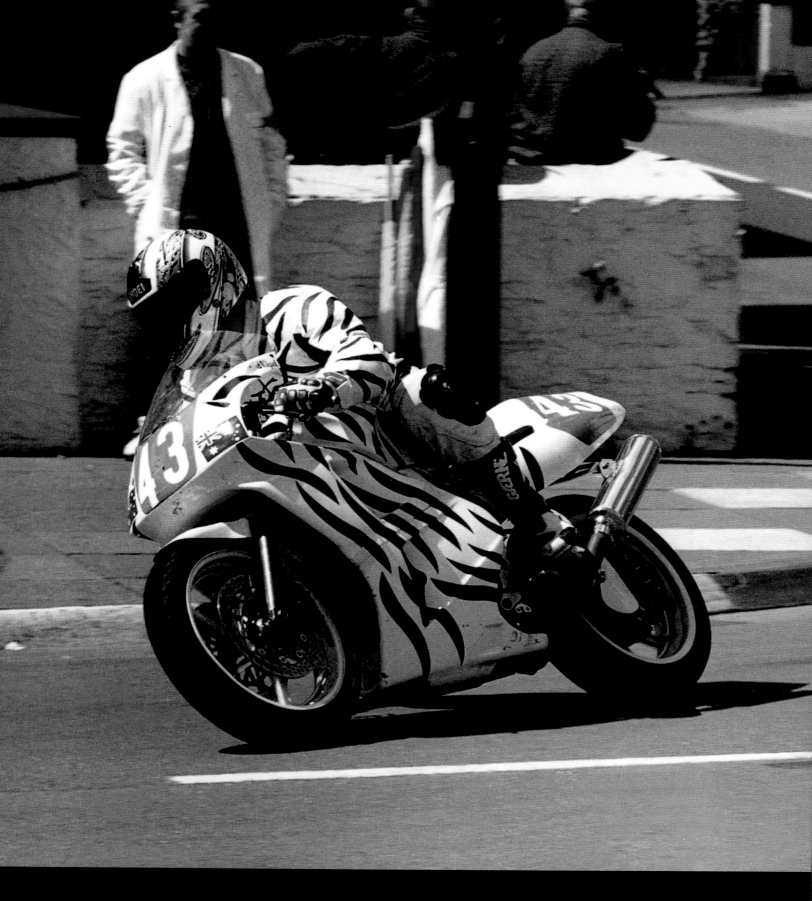

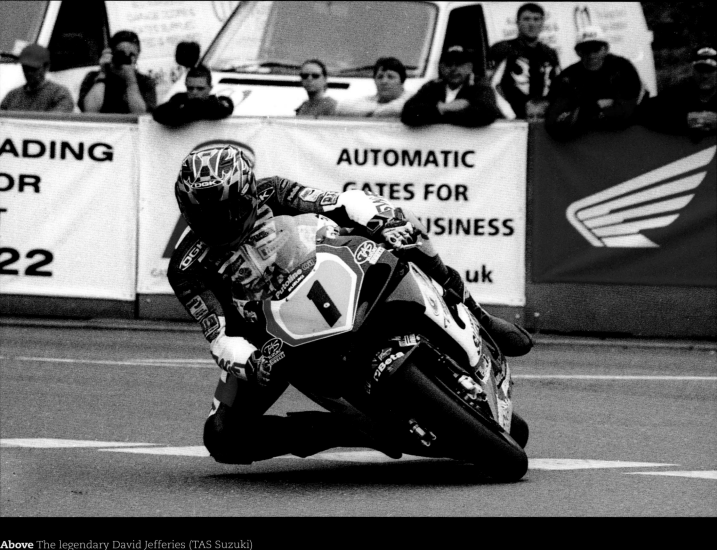

Above The legendary David Jefferies (TAS Suzuki)
takes Quarter Bridge with ease in the 2002 Senior TT.
He set the lap record at 17 min 47 sec in this race
at an average speed of 127.29 mph. He would be
tragically killed in a crash at the following year's TT.

Opposite Australian Nigel Bryan taking his
"camouflaged" Honda through Parliament
Square in the 2002 Lightweight 400 TT.

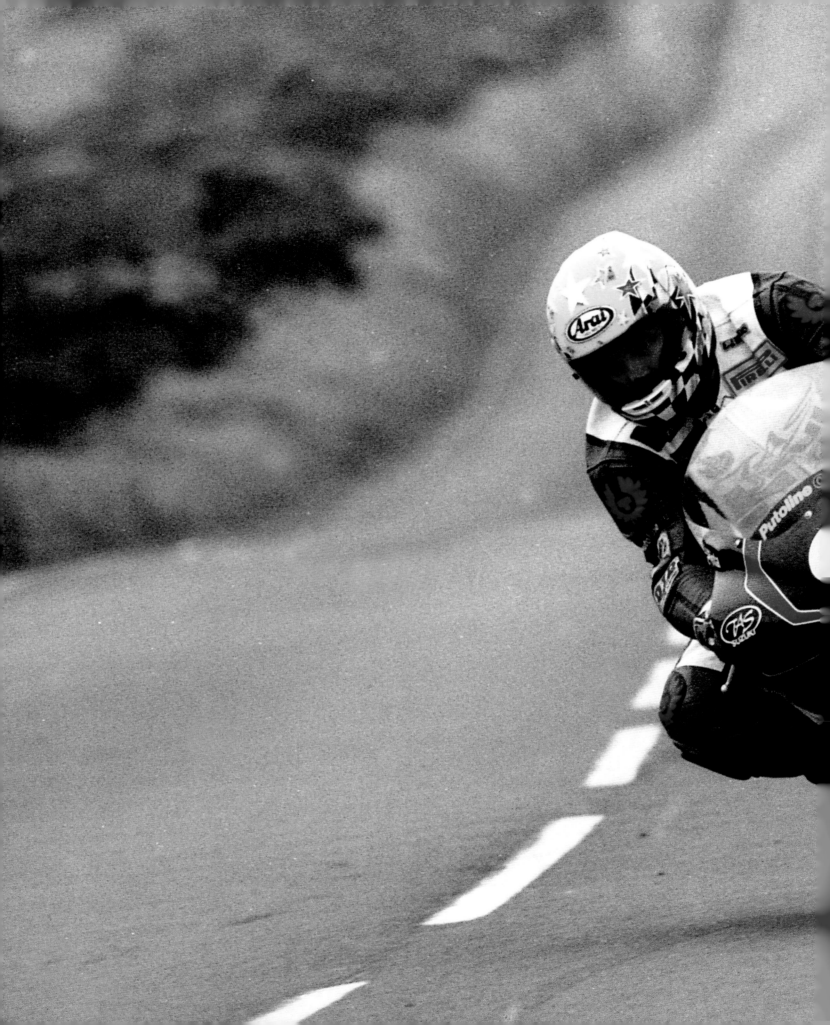

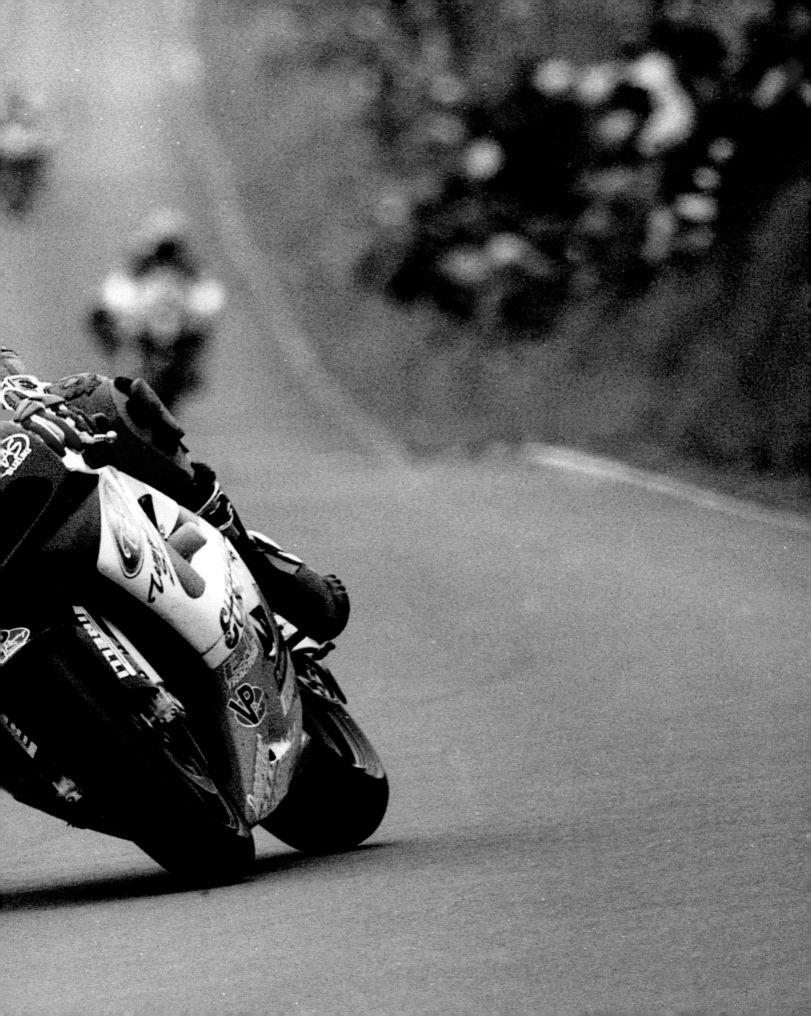

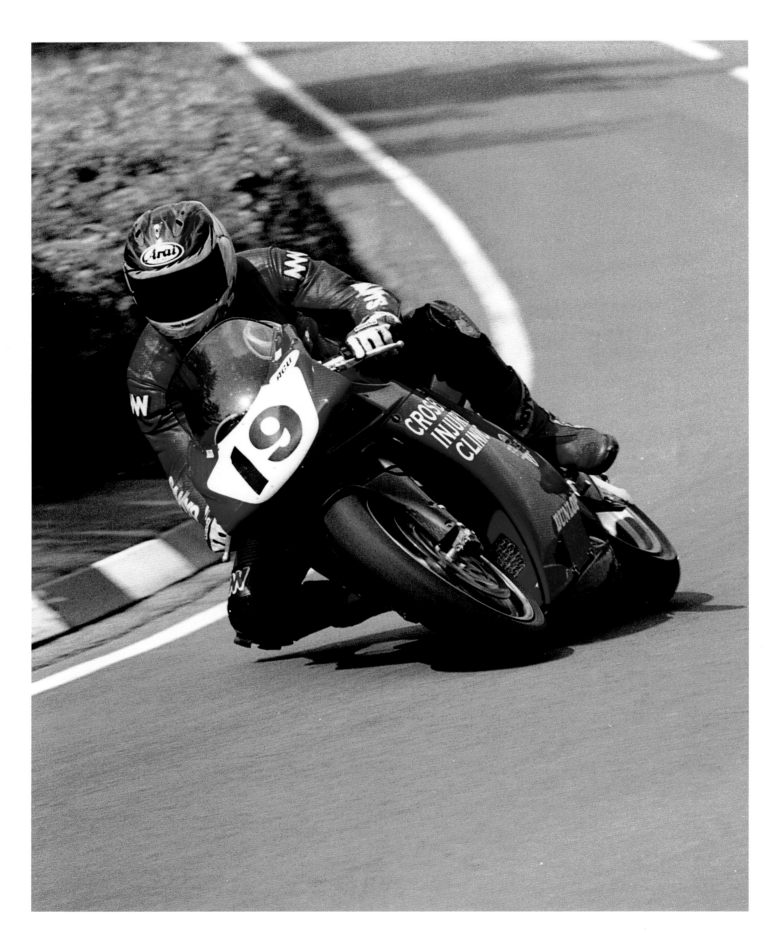

Previous pages Ten times a TT winner, Ian Lougher won the fiercely competitive 2002 Production 600 race.

Opposite Islander John Barton (Ducati) at Stella Maris in the 2003 Formula One TT.

Below Bruce Anstey gave the British motorcycle industry a massive boost by winning the 2003 Junior TT on a Triumph.

Bottom left Four lean years for Dave Molyneux came to an end when he won the 2003 Sidecar Race B. Seen here at Sulby Bridge with Craig Hallam keeping the rear wheel down.

Bottom right French built and French ridden: Fabrice Miguet (Voxan) at Parliament Square.

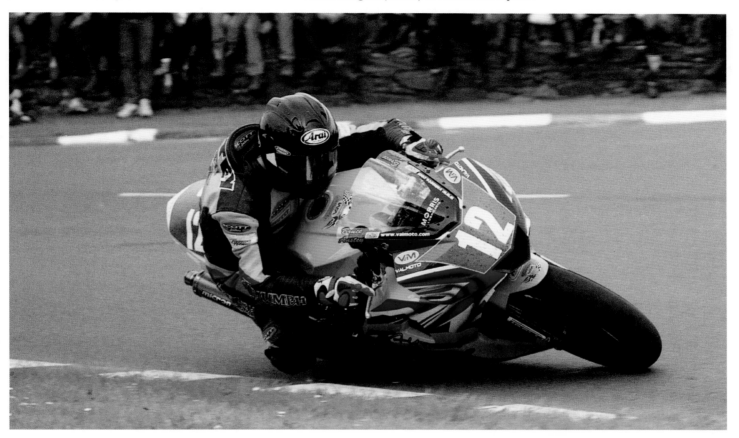

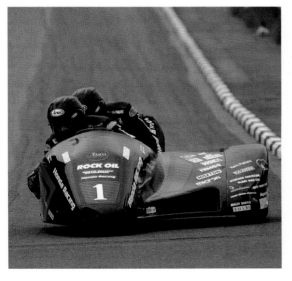

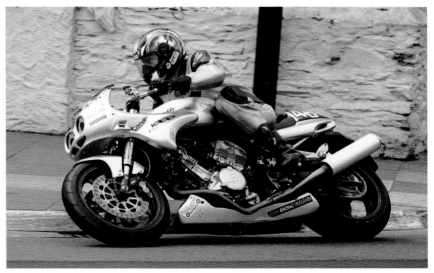

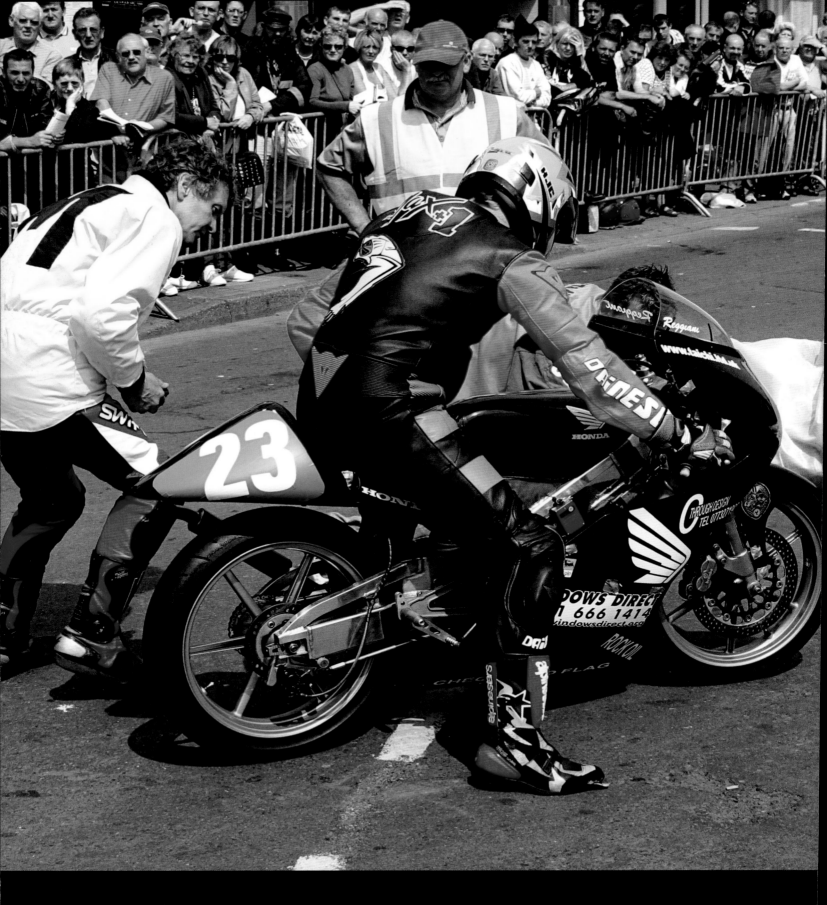

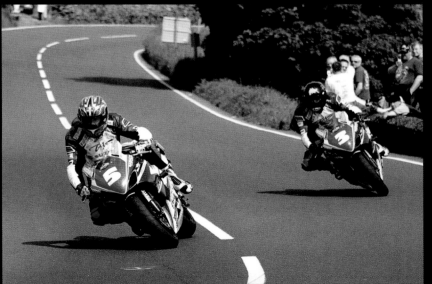

Opposite Having been black-flagged at Ramsey, Reg Lennon gets his Honda checked over by marshals under the eagle eye of travelling marshal Ned Bowers(left). Reg finished the 2004 Ultra Lightweight TT in 14th place, the last rider to finish the race.

Above left A slight overshoot! Brian Alflatt and Christophe Darras (Baker Honda) compare notes after overshooting Sulby Bridge, 2005 Sidecar Race B.

Above right Ten out of ten for information – eight out of ten for spelling! It should, of course, read Keppel Gate.

Left TAS Suzuki team-mates play tag at the Gooseneck; Adrian Archibald leads Bruce Anstey on the road, and by more than 20 seconds ahead on corrected time. Anstey went on to win the 2005 Superstock TT, Archibald retired, out of fuel after a bungled pit stop.

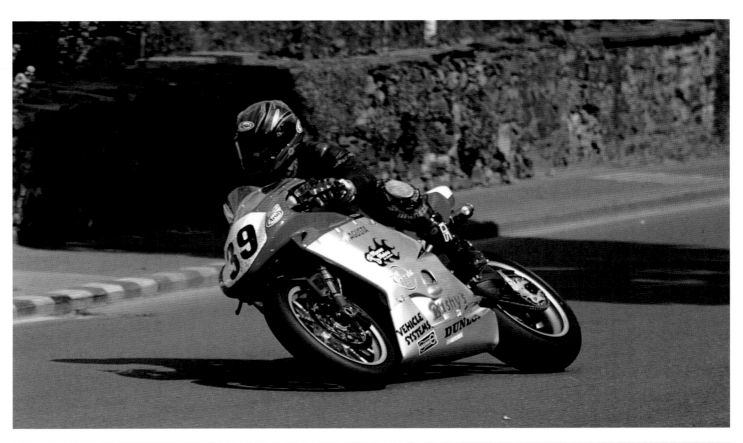

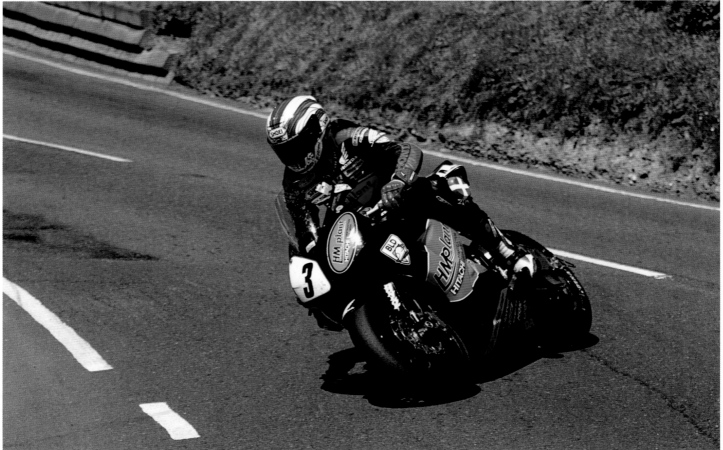

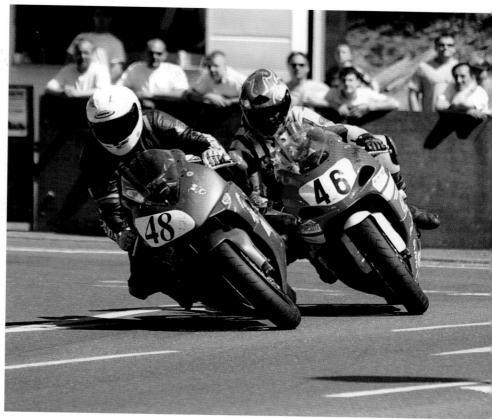

Right Manx-based riders Derran Slous (Honda, 48) and John Crellin (Suzuki, 46) contest the same piece of tarmac at Quarter Bridge; 2006 Superbike TT.

Opposite top American Thomas Montano (MV), a carpenter by trade, powers through Ballacraine in the 2005 Senior TT. He has lapped the course at almost 121 mph.

Opposite bottom Twenty-three-times TT winner John McGuinness (HM Plant Honda) sweeps into Governor's Bridge, winning the 2006 Superbike TT.

Below New Zealander Bruce Anstey (Suzuki GSXR) at Creg ny Baa, on his way to a thrilling victory in the 2006 Superstock TT. In a TT career dating nearly 20 years, he has won ten TT titles.

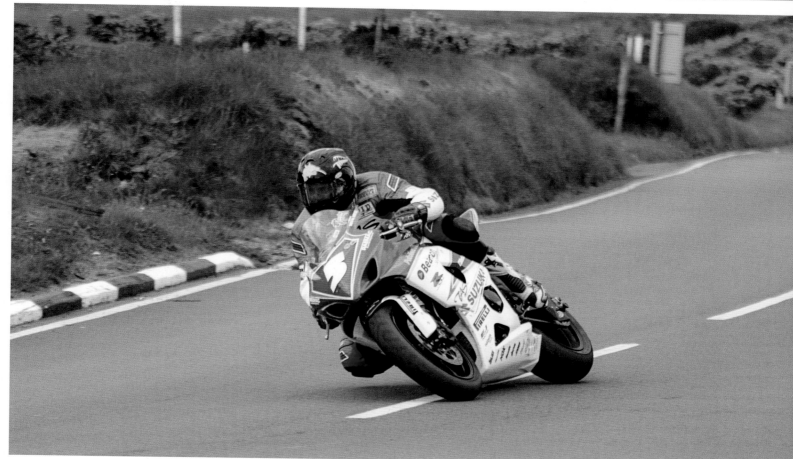

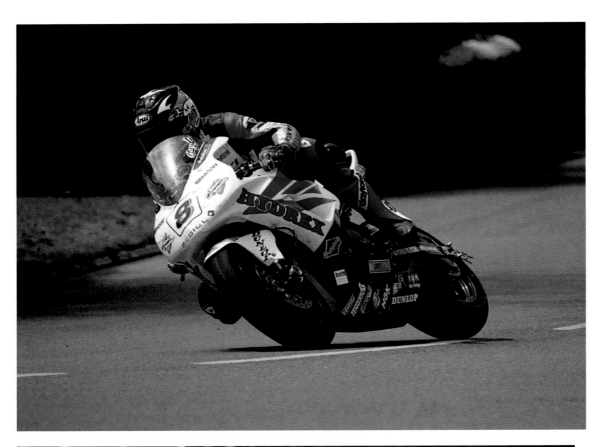

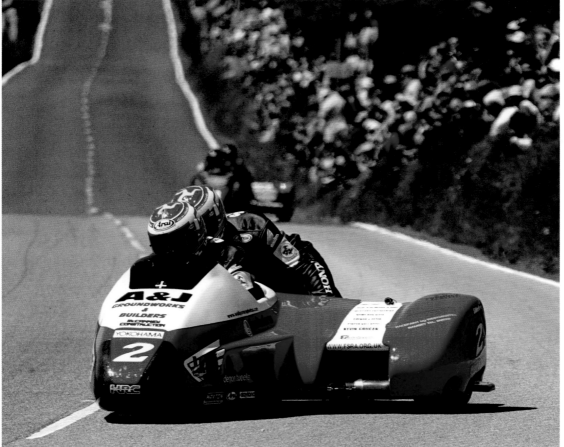

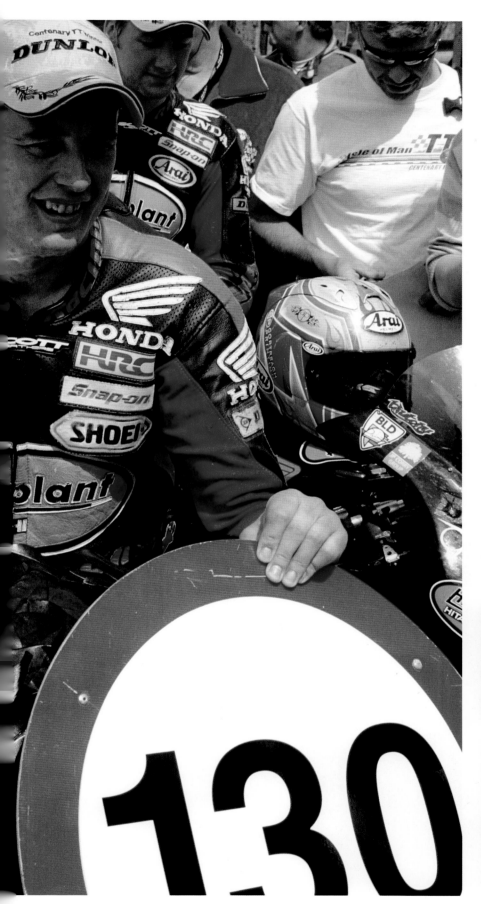

Left John McGuinness – nicknamed, rather aptly, "McPint" – reflects on his history-making 130 mph lap in the 2007 Senior TT.

Opposite top Man of the hour: Guy Martin (Hydrex Honda) at Sulby Bridge in the 2007 Superbike TT.

Opposite bottom Nick Crowe and Dan Sayle (Honda) set an incredible Sidecar TT lap record at 116.667 in the 2007 Sidecar TT. This record was only just pipped in 2015.

Below Steve Plater (AIM Yamaha), seen here at Sulby Bridge, took a superb tenth place in his TT debut: the 2007 Superbike TT. Steve went on to take two wins.

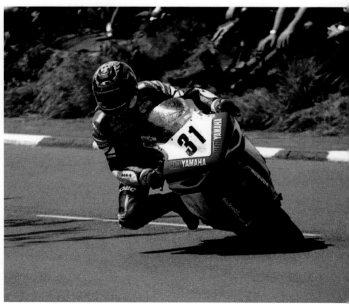

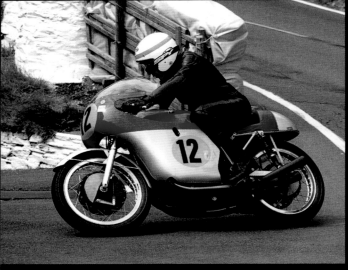

Left Former two- and four-wheel World Champion John Surtees rounds Governor's Bridge in the 2007 TT Parade Lap.

Right Richard Rose (FN, 85) and Nick Jefferies (Scott, 86) wait to get the nod from 2007 re-enactment organiser Tony East, to start their celebration lap of the original St John's course.

Below Canadian Michelle Duff rides a replica four-cylinder 250 Yamaha in the 2007 TT Parade Lap.

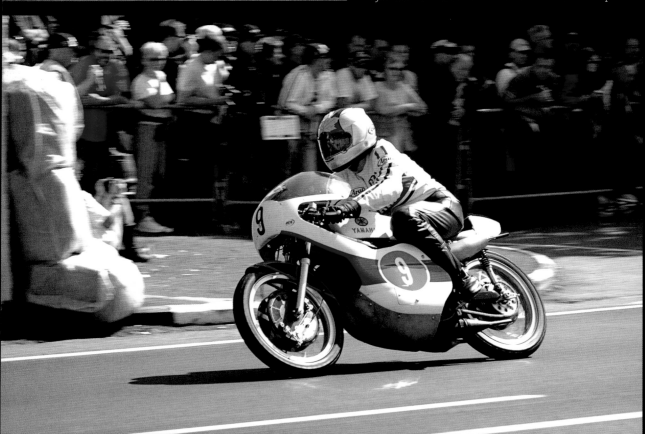

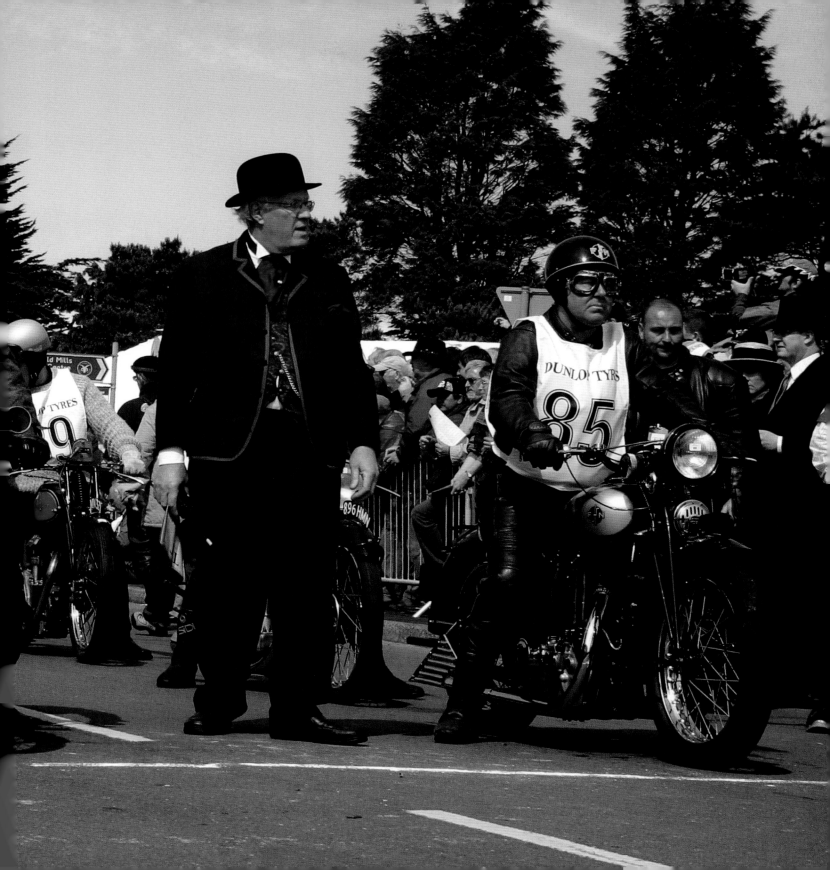

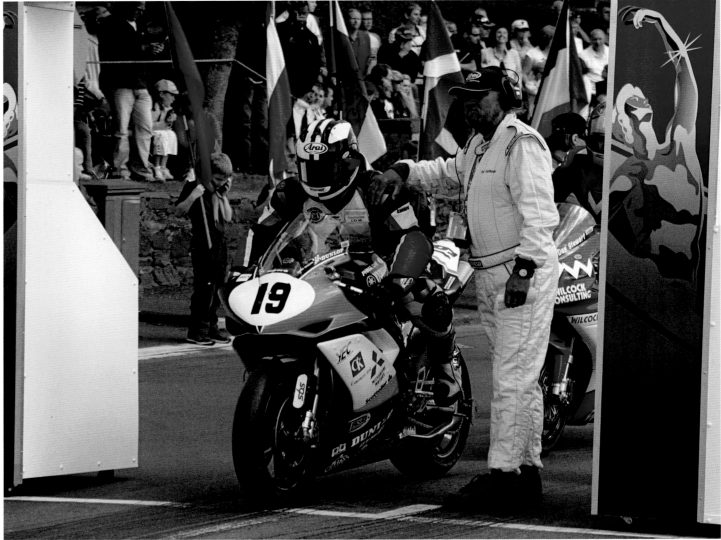

Opposite top far left Water, water! When Cameron Donald wheelied out of Quarter Bridge, his filler cap came loose, spilling fuel over a vital part of his anatomy!

Opposite top left After the medical crew doused and soothed the fuel-soaked intimate area, a leather-less Donald makes his way back to the paddock.

Opposite bottom Michael Dunlop waits to get the green light to unleash 180 bhp of Yamaha power down the Glencrutchery Road to start the 2008 Senior TT. Michael finished tenth, but more was to come from the man they call "Micky D".

Below Heading for the braking area at Sulby Bridge, Andy Laidlow and Martin Hull (LCR Suzuki, 17) hold a slender lead over Greg Lambert and Sally Wilson (DMR Honda, 18), but they are ten seconds down on corrected time.

> "You don't know how a bike works at the TT until you're at the TT."
> **Cameron Donald**

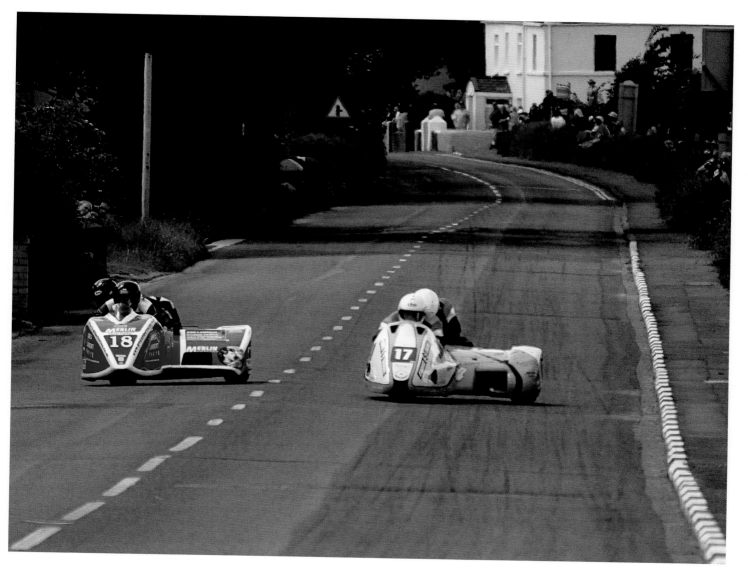

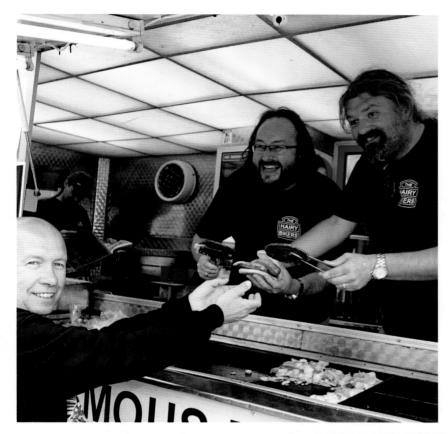

Left The Hairy TT Bikers! Isle of Man TT regulars Dave Myers and Si King serve a fan behind the Grandstand at the 2008 TT.

Opposite Behind the visor and the tearoffs, you can imagine the pure concentration in the eyes of Australian rider Cameron Donald at the start line. He won both the TT Superbike and Superstock titles in 2008.

Below Guy Martin racing for Hydrex Honda at Parliament Square; 2008 Supersport TT.

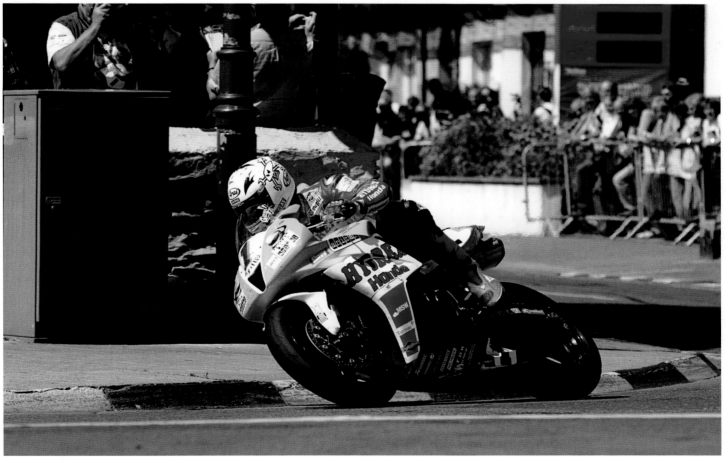

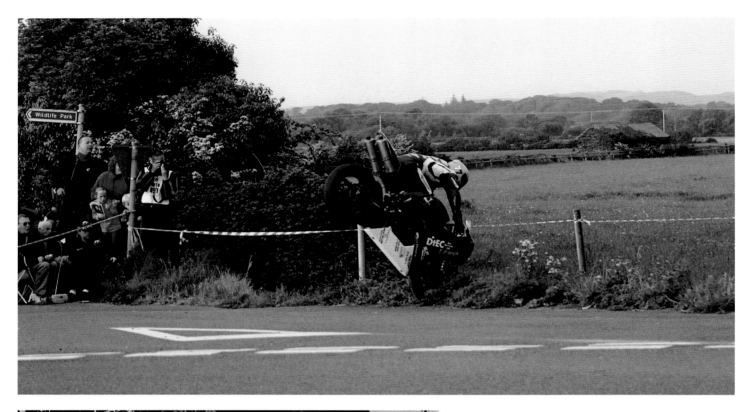

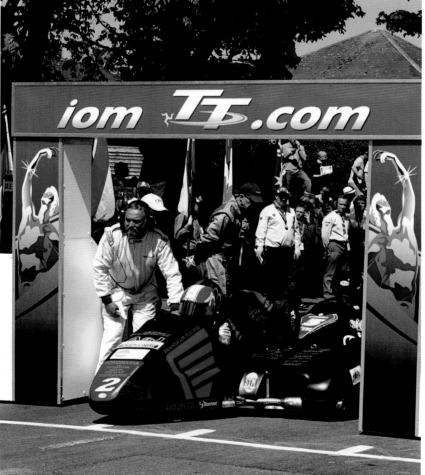

Above During practice for TT 2008, Les Shand left his braking too late for Sulby Bridge. After this stoppie, he fell five foot into the field! He was unhurt, and rode and finished five races at the TT in 2008.

Left With Mark Cox putting his weight over the back wheel for extra traction, Nick Crowe (LCR Honda) prepares to launch down Bray Hill; they won both races at the TT in 2008.

Opposite top After Bruce Anstey was disqualified for a technical infringement on his Suzuki, Steve Plater (Yamaha) won his first TT, the 2008 Supersport Junior TT 1 race.

Opposite bottom One of the best seats in the house! Braddan church provides the backdrop as spectators watch the 2008 Superstock TT. Seating is provided and the church hall provides TT teas.

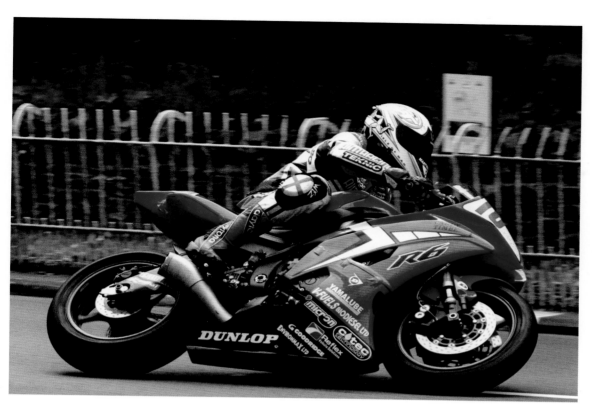

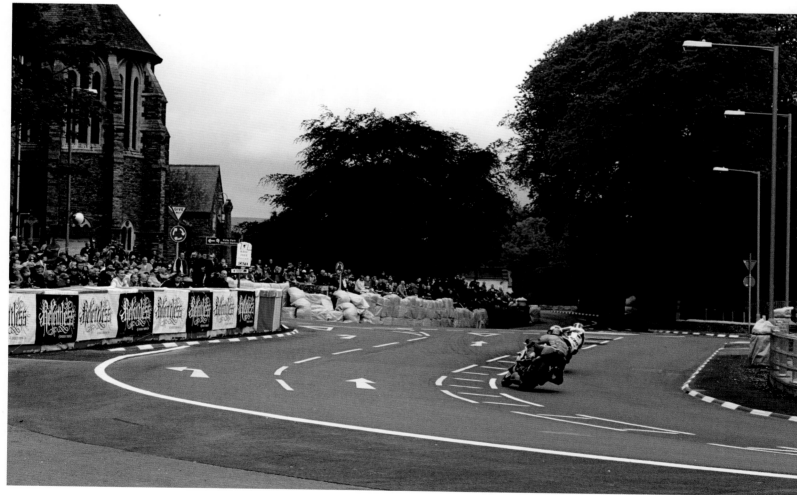

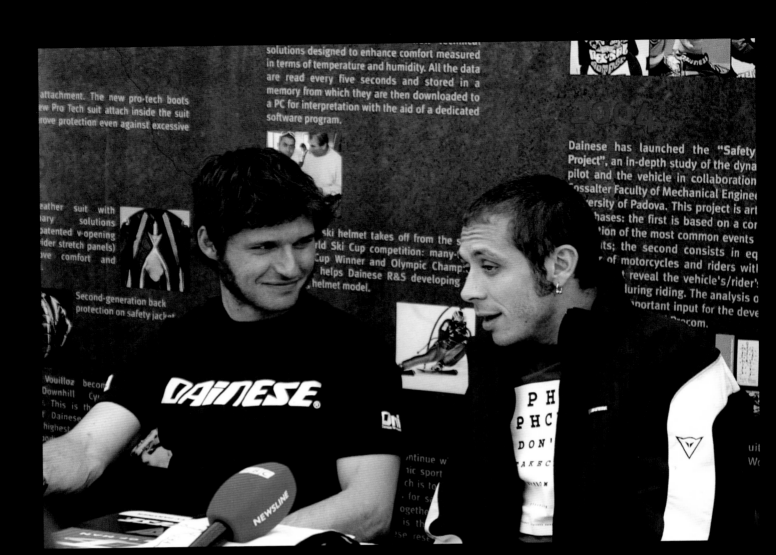



solutions designed to enhance comfort measured in terms of temperature and humidity. All the data are read every five seconds and stored in a memory from which they are then downloaded to a PC for interpretation with the aid of a dedicated software program.

attachment. The new pro-tech boots
new Pro Tech suit attach inside the suit
prove protection even against excessive

eather suit with
iary solutions
patented v-opening
ider stretch panels)
ave comfort and

Second-generation back
protection on safety jacket

ski helmet takes off from the s
rld Ski Cup competition: many-
Cup Winner and Olympic Champ
helps Dainese R&S developing
helmet model.

Vouilloz becon
Downhill Cy
. This is th
F Dainese
highest

Dainese has launched the "Safety
Project", an in-depth study of the dyna
pilot and the vehicle in collaboration
ossalter Faculty of Mechanical Enginee
ersity of Padova. This project is ar
hases: the first is based on a cor
ion of the most common events
ts; the second consists in eq
of motorcycles and riders with
reveal the vehicle's/rider's
uring riding. The analysis o
nortant input for the deve
ncom.

Above Two masters of their craft; Guy Martin listens as Valentino Rossi gives his views on racing at the TT. He is quoted as saying: "I did a lap of the Isle of Man, and I understand why people love this because it's f**king awesome – it's unbelievable, great. But, unfortunately, it's too dangerous. Sometimes, riders are crazy."

Right The start of a new TT era; American Robert Barber rode this Agni to victory in the first "Electric" TT in 2009

Opposite England's Gary Johnson (Honda) brakes hard for Governor's Bridge in the 2009 Superbike TT.

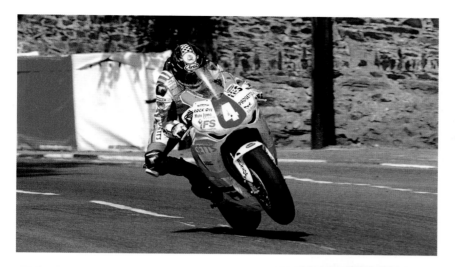

"If you never experience an Isle of Man TT, then you're not really into motorcycles."
Ian Hutchinson

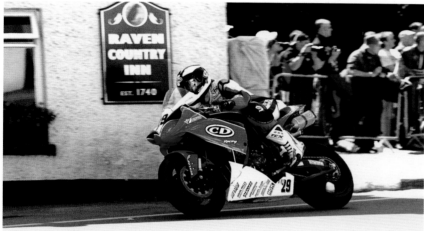

Top A celebratory, and well-deserved, wheelie for Ian Hutchinson (Honda) at May Hill, Ramsey in the 2010 Superstock TT.

Left William Dunlop – son of Robert, brother of Michael and nephew of Joey – leaving Ballaugh Bridge 2009 Senior TT.

Opposite On TT-top of the World! Ian Hutchinson shows his delight at his five-rides-five-wins haul in 2010.

Below Slick pitwork for Kawasaki-mounted Conor Cummins by the McAdoo mechanics; 2009 Senior TT – but has someone dropped the filler cap on the floor?

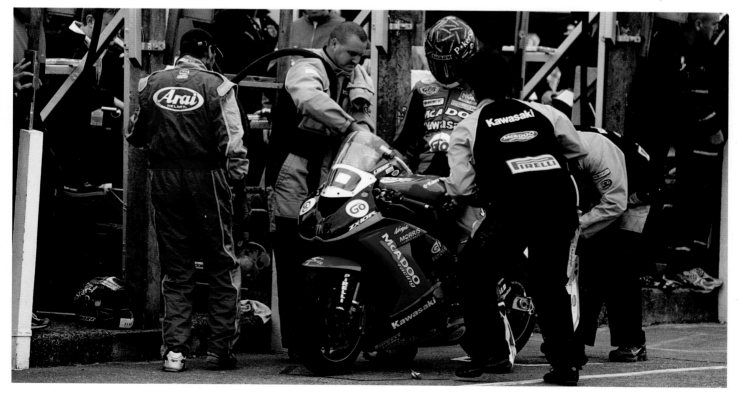

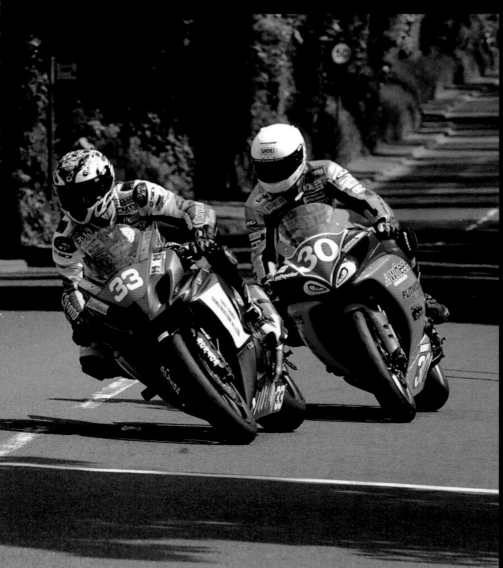

Top left John "The Morecambe Missile" McGuinness gives insight into the upcoming 2010 Senior TT to Radio TT's Chris Kinley.

Top right Northern Ireland's Michael Dunlop (Honda) leaves Parliament Square in the 2010 Superstock TT. The bike's scraped bellypan shows how hard he was pushing!

Left A long way from his home in Oregon, USA, Jimmy Moore (Suzuki, 33) leads Olie Linsdell (Yamaha) into Ballacraine; 2010 Superstock TT.

Opposite Oops! Somewhere in the bushes at the end of the Sulby Straight is a Suzuki and its rider (you can see his boot). We will save the rider's blushes by not identifying him!

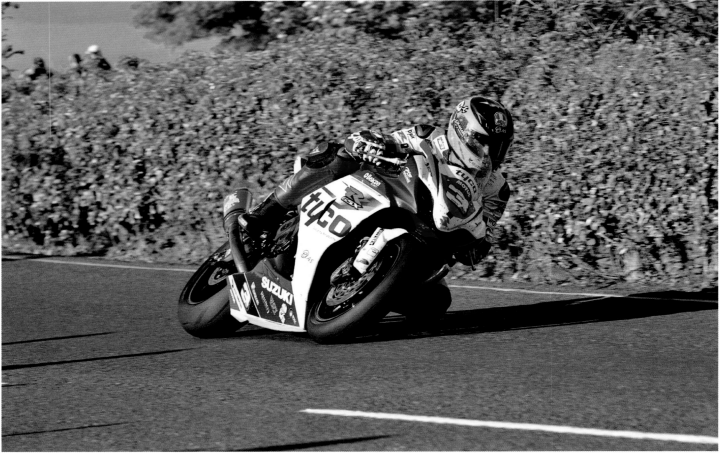

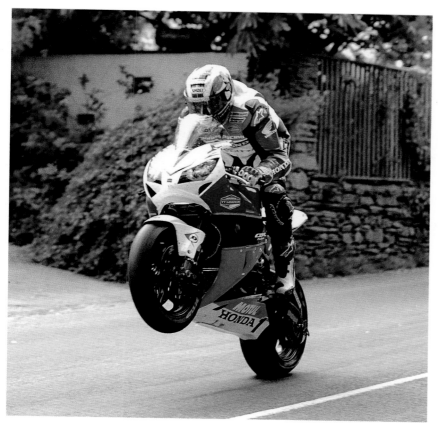

Left Multiple TT champion John McGuinness (Honda) flies through the air at the Ballacrye Jump in the 2012 Superbike TT.

Opposite top Islander Dave Molyneux and Patrick Farrance (DMR Honda) leave Ballaugh Bridge. They won both 2012 sidecar races and recorded the fastest sidecar lap of 114.486 mph.

Opposite bottom The eyes have it! TT racer, lorry mechanic and occasional TV presenter Guy Martin (TAS Suzuki) approaching the Gooseneck in the 2012 Superstock TT race. He finished in fourth place.

Below Kawasaki TT dust-up. Ryan Farquhar (2) leads James Hillier into Parliament Square in the 2012 Lightweight Supertwin TT. Farquhar has developed and campaigned the Supertwin class since its inception.

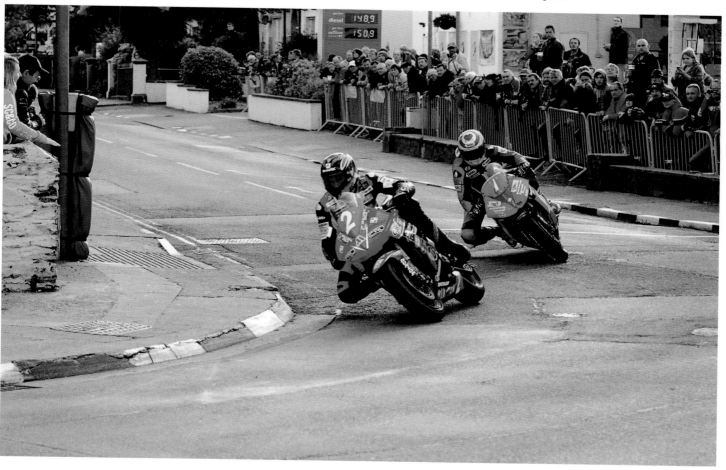

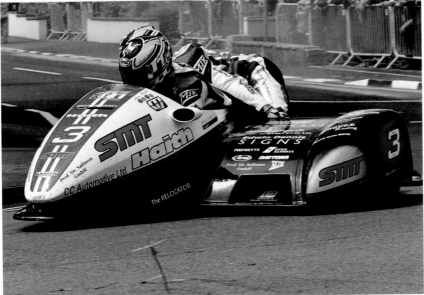

Above Yoshinari Matsushita watches as mechanics prepare his KMI Komatti for the 2012 Zero TT. The Japanese rider would be fatally injured in a crash at Ballacrye in the 2013 event,

Left Five-times World Champion Tim Reeves and eight-time TT winner Dan Sayle (LCR Honda) won the 2013 Sidecar Race 1. They are pictured here going round the bend at Parliament Square.

Opposite top Top three in one picture: Victor Michael Dunlop leads runner-up Cameron Donald with third-placed John McGuinness behind; 2013 Superbike TT. All were Honda-mounted.

Opposite bottom Man of the meeting: Michael Dunlop (BMW) won the first of four TT victories in 2014 in the Superbike TT.

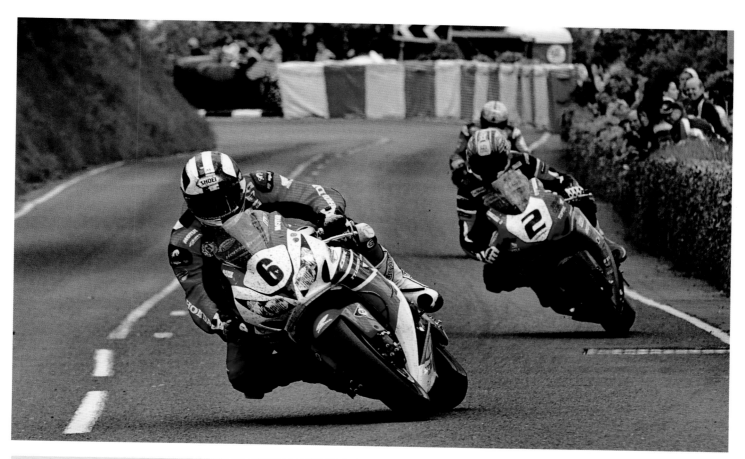

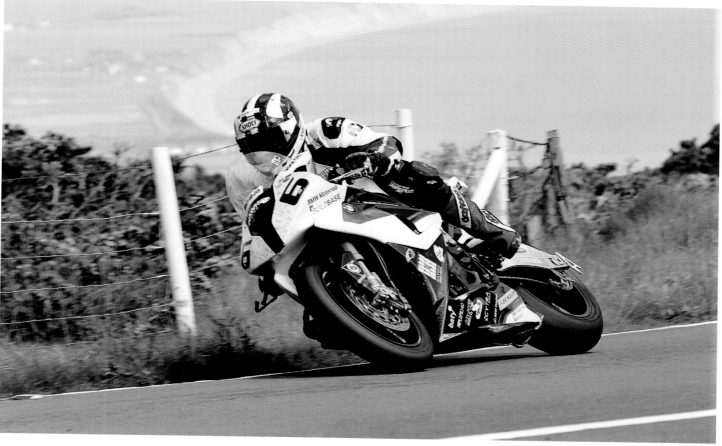

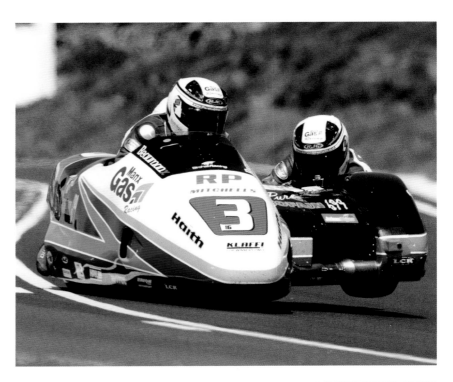

Left After a heavy crash in 2014, Ben and Tom Birchall recovered in style, winning both Sidecar races in 2015.

Below Despite suffering a retirement in the Superbike TT in 2015, Guy Martin secured a podium finish in the second Supersport race. His mixed 2015 Isle of Man TT outing was made up for by the release of his autobiography later that year, which became a bestseller.

Opposite Ian Hutchinson wheelied his way to victory in the second Supersport race in 2015, completing a remarkable treble.

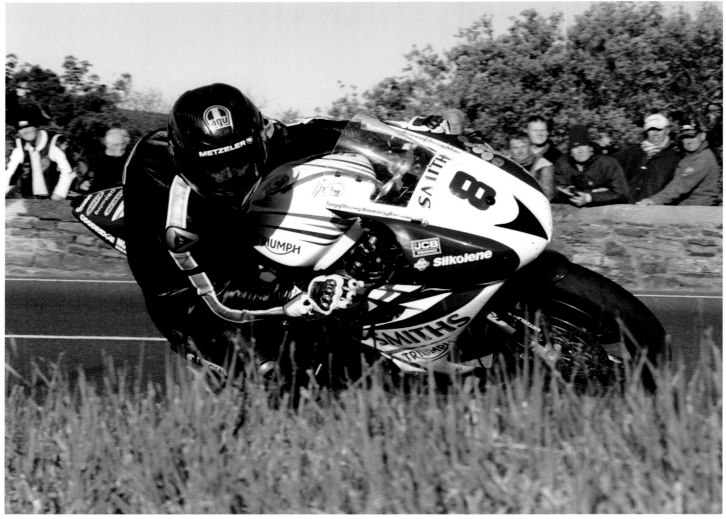

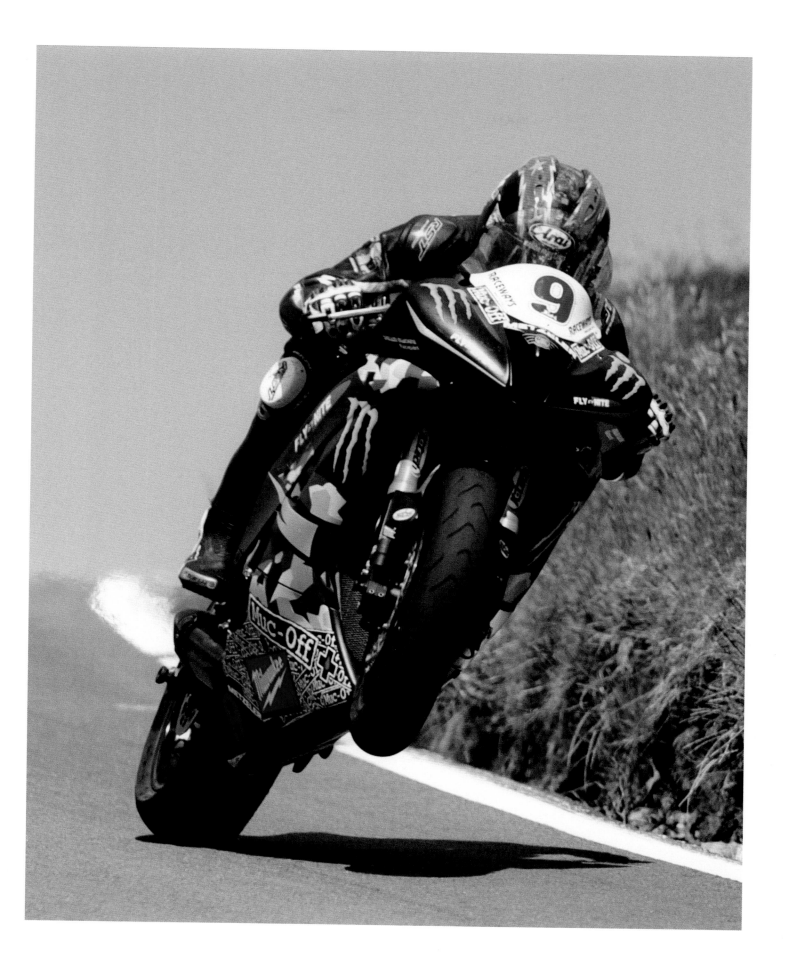

Records

The TT has always been about going faster.

The first lap record on the 1911 Mountain Course was 50.11 mph. By the Second World War, it stood at exactly 91.

- 100 mph fell in 1957, to Bob McIntyre's Gilera.
- 110 mph in 1976, to John Williams (Suzuki).
- 120 mph went to Steve Hislop (Honda) in 1989.
- 130 mph took until 2007: John McGuinness (Honda). It remains the domain of a very select few.

The first girl TT rider was Beryl Swain, in 1962 (22nd, 50cc TT). The fastest so far: Jenny Tinmouth in 2010, at 119.945 mph.

With up to ten races in a week (two sidecars), England's Ian Hutchinson holds the record: five wins in 2010, including the Senior. Irishman Phil McCallen took four in 1996; but Mike Hailwood's three of 1961 and 1967 was not equalled until 1985 by Joey Dunlop.

Island King Joey's 26 race win total has stood since 2000. Englishman John McGuinness has 23, his last in 2015. Before that, Mike Hailwood's record was 14.

Eight more riders have won ten or more TTs. Fast-rising Michael Dunlop and Ian Hutchinson are on 11, along with earlier stars Steve Hislop and Phillip McCallen. With ten wins, it's Agostini, Kiwi Anstey, Welsh TT specialist Ian Lougher and pre-war superstar Stanley Woods.

Although not solo riders, Dave Molyneux (17) and Rob Fisher (10) have both won ten TT's or more.

Opposite The fastest man round the TT course: John McGuinness smashed the absolute lap record on the second lap in 2015 with a time of 132.701 mph.

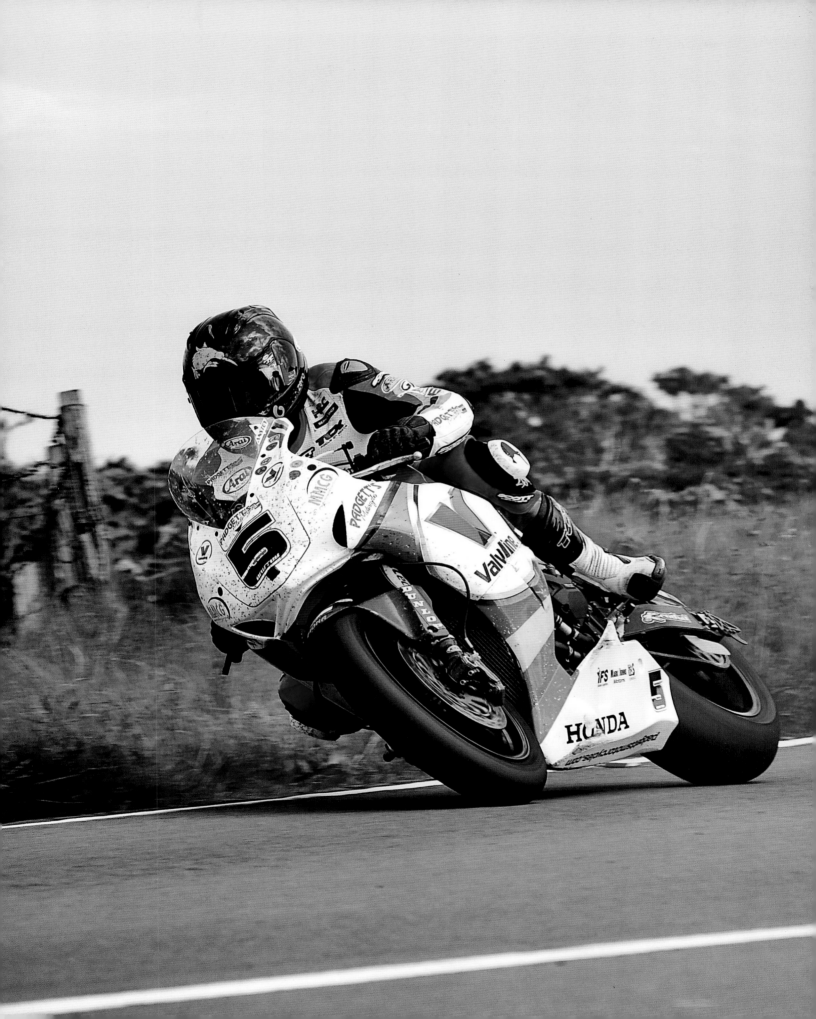

Isle of Man TT Results

1907
Single-cylinder (500cc) Charlie Collier
Twin-cylinder (750cc) Rem Fowler

1908
Single-cylinder (500cc) Jack Marshall
Twin-cylinder (750cc) Harry Reed

1909
Open .. Harry Collier

1910
Open .. Charlie Collier

1911
Junior ... Percy Evans
Senior Oliver Godfrey

1912
JuniorHarry Bashall
Senior Frank Applebee

1913
Junior .. Hugh Mason
Senior ..Tim Wood

1914
JuniorEric Williams
Senior ... Cyril Pullin

1915–19 *Cancelled due to First World War*

1920
JuniorCyril Williams
Senior Tommy de la Hay
Lightweight....................................R. O. Clark

1921
JuniorEric Williams
Senior Howard Davies
Lightweight............................. Doug Prentice

1922
JuniorTom Sheard
Senior Alec Bennett
Lightweight............................. Geoff Davison

1923
Junior Stanley Woods
SeniorTom Sheard
Lightweight................................ Jock Porter
Sidecar.......... Freddie Dixon & Walter Denny

1924
Junior Kenneth Twemlow
Senior Alec Bennett
Lightweight.......................... Edwin Twemlow
Sidecar.......... George Tucker & Walter Moore
Ultra Lightweight...........................Jock Porter

1925
Junior.. Wal Handley
Senior Howard Davies
Lightweight......................... Edwin Twemlow
Sidecar.............Len Parker & Ken Horstman
Ultra Lightweight...................... Wal Handley

1926
Junior .. Alec Bennett
SeniorStanley Woods
Lightweight.......................... Paddy Johnston

1927
JuniorFreddie Dixon
Senior Alec Bennett
Lightweight............................ Wal Handley

1928
Junior Alec Bennett
Senior Charlie Dodson
Lightweight........................ Frank Longman

1929
JuniorFreddie Hicks
Senior Charlie Dodson
Lightweight............................. Syd Crabtree

1930
Junior Tyrell Smith
Senior Wal Handley
Lightweight............................Jimmy Guthrie

1931
Junior .. Percy Hunt
Senior Percy Hunt
Lightweight......................... Graham Walker

1932
JuniorStanley Woods
SeniorStanley Woods
Lightweight............................ Leo Davenport

1933
JuniorStanley Woods
SeniorStanley Woods
Lightweight.............................. Sid Gleave

1934
JuniorJimmy Guthrie
SeniorJimmy Guthrie
Lightweight.........................Jimmy Simpson

1935
JuniorJimmy Guthrie
SeniorStanley Woods
Lightweight...........................Stanley Woods

1936
Junior Freddie Frith
SeniorJimmy Guthrie
Lightweight.................................. Bob Foster

1937
JuniorJimmy Guthrie
Senior Freddie Frith
Lightweight.........................Omobono Tenni

1938
JuniorStanley Woods
Senior Harold Daniell
Lightweight..............................Ewald Kluge

1939
JuniorStanley Woods
Senior Georg Meier
Lightweight.............................. Ted Mellors

1940–46 *Cancelled due to Second World War*

1947
Junior .. Bob Foster
Senior Harold Daniell
Lightweight...................... Manliff Barrington
Clubmans Junior Denis Parkinson
Clubmans Senior Eric Briggs
Clubmans Lightweight................... Basil Keys

1948
Junior .. Freddie Frith
Senior ... Artie Bell
Lightweight......................... Maurice Cann
Clubmans Junior Ronnie Hazlehurst
Clubmans Senior Jack Daniells
Clubmans Lightweight.......Monty Lockwood

1949
Junior .. Freddie Frith
Senior Harold Daniell
Lightweight..................... Manliff Barrington
Clubmans Junior Harold Clark
Clubmans Senior Geoff Duke
Clubmans Lightweight....................Cyril Taft
Clubmans 1000...................Dennis Lashmar

1950
Junior .. Artie Bell
Senior Geoff Duke
Lightweight....................Dario Ambrosini
Clubmans JuniorBrian Jackson
Clubmans SeniorPhil Carter
Clubmans Lightweight.......... Frank Fletcher
Clubmans 1000...........................Alex Phillip

1951
Junior .. Geoff Duke
Senior Geoff Duke
Ultra Lightweight..........Cromie McCandless
Lightweight........................ Tommy Wood
Clubmans Junior Brian Purslow
Clubmans Senior Ken Arber

1952

Junior .. Geoff Duke
Senior .. Reg Armstrong
Ultra Lightweight Cecil Sandford
Lightweight Fergus Anderson
Clubmans Junior Eric Houseley
Clubmans Senior Brian Hargreaves

1953

Junior .. Ray Amm
Senior .. Ray Amm
Ultra Lightweight Les Graham
Lightweight Fergus Anderson
Clubmans Junior Derek Powell
Clubmans Senior Bob Keeler
Clubmans 1000 George Douglas

1954

Junior .. Rod Coleman
Senior .. Ray Amm
Ultra Lightweight Rupert Hollaus
Lightweight Werner Haas
Clubmans Junior Philip Palmer
Clubmans Senior Alistair King
Sidecar Eric Oliver & Les Nutt

1955

Junior .. Bill Lomas
Senior .. Geoff Duke
Ultra Lightweight Carlo Ubbiali
Lightweight .. Bill Lomas
Clubmans Junior Jimmy Buchan
Clubmans Senior Eddie Dow
Sidecar Walter Schneider & Hans Strauss

1956

Junior .. Ken Kavanagh
Senior ... John Surtees
Ultra Lightweight Carlo Ubbiali
Lightweight Carlo Ubbiali
Clubmans Junior Bernard Codd
Clubmans Senior Bernard Codd
Sidecar Fritz Hillebrand &
... Manfred Grunwald

1957

Junior .. Bob McIntyre
Senior .. Bob McIntyre
Ultra Lightweight Tarquinio Provini
Lightweight Cecil Sandford
Sidecar Fritz Hillebrand &
... Manfred Grunwald

1958

Junior .. John Surtees
Senior .. John Surtees
Ultra Lightweight Carlo Ubbiali
Lightweight Tarquinio Provini
Sidecar Walter Schneider & Hans Strauss

1959

Junior .. John Surtees
Senior .. John Surtees
Ultra Lightweight Tarquinio Provini
Lightweight Tarquinio Provini
Sidecar Walter Schneider & Hans Strauss
Formula One 350cc Alistair King
Formula One 500cc Bob McIntyre

1960

Junior ..John Hartle
Senior .. John Surtees
Ultra Lightweight Carlo Ubbiali
Lightweight Gary Hocking
Sidecar.. Helmut Fath & Alfred Wohlgemuth

1961

Junior .. Phil Read
Senior Mike Hailwood
Ultra Lightweight Mike Hailwood
Lightweight Mike Hailwood
Sidecar Max Deubel & Emil Horner

1962

Junior Mike Hailwood
Senior Gary Hocking
Ultra Lightweight Luigi Taveri
Lightweight Derek Minter
50cc .. Ernst Degner
Sidecar Chris Vincent & Eric Bliss

1963

Junior .. Jim Redman
Senior Mike Hailwood
Ultra Lightweight Hugh Anderson
Lightweight Jim Redman
50cc .. Mitsui Itoh
Sidecar... Florian Camathias & Alfred Herzig

1964

Junior .. Jim Redman
Senior Mike Hailwood
Ultra Lightweight Luigi Taveri
Lightweight Jim Redman
50cc Hugh Anderson
Sidecar Max Deubel & Emil Horner

1965

Junior .. Jim Redman
Senior Mike Hailwood
Ultra Lightweight Phil Read
Lightweight Jim Redman
50cc .. Luigi Taveri
Sidecar Max Deubel & Emil Horner

1966

Junior Giacomo Agostini
Senior Mike Hailwood
Ultra Lightweight Bill Ivy
Lightweight Mike Hailwood
50cc Ralph Bryans
Sidecar... Fritz Scheidegger & John Robinson

1967

Junior Mike Hailwood
Senior Mike Hailwood
Ultra Lightweight Phil Read
Lightweight Mike Hailwood
50cc Stuart Graham
Production 250cc Bill Smith
Production 500cc Neil Kelly
Production 750cc John Hartle
Sidecar Siegfried Schauzu &
Horst Schneider

1968

Junior Giacomo Agostini
Senior Giacomo Agostini
Lightweight Phil Read
Ultra Lightweight Bill Ivy
50cc Barry Smith
Production 250cc Trevor Burgess
Production 500cc Ray Knight
Production 750cc Ray Pickrell
Sidecar 500cc Siegfried Schauzu &
... Horst Schneider
Sidecar 750cc Terry Vinicombe &
... John Flaxman

1969

Junior Giacomo Agostini
Senior Giacomo Agostini
Ultra Lightweight Dave Simmonds
Lightweight Kel Carruthers
Production 250cc Tony Rogers
Production 500cc Graham Penny
Production 750cc Malcolm Uphill
Sidecar 500cc Klaus Enders &
... Ralf Engelhardt
Sidecar 750cc Siegfried Schauzu &
... Horst Schneider

1970

Junior Giacomo Agostini
Senior Giacomo Agostini
Lightweight 125cc Dieter Braun
Lightweight 250cc Kel Carruthers
Production 250cc Chas Mortimer
Production 500cc Frank Whiteway
Production 750cc Malcolm Uphill
Sidecar 500cc Klaus Enders &
... Wolfgang Kalauch
Sidecar 750cc Siegfried Schauzu &
... Horst Schneider

1971

Junior .. Tony Jefferies
Senior Giacomo Agostini
Ultra Lightweight Chas Mortimer
Lightweight Phil Read
Production 250cc Bill Smith
Production 500cc John Williams
Production 750cc Ray Pickrell
Formula 750cc Tony Jefferies
Sidecar 500cc Siegfried Schauzu &
... Wolfgang Kalauch
Sidecar 750cc Georg Auerbacher &
... Hermann Hahn

1972

Junior Giacomo Agostini
Senior Giacomo Agostini
Ultra Lightweight Chas Mortimer
Lightweight Phil Read
Production 250cc John Williams
Production 500cc Stan Woods
Production 750cc Ray Pickrell
Formula 750cc Ray Pickrell
Sidecar 500cc Siegfried Schauzu &
... Wolfgang Kalauch
Sidecar 750cc Siegfried Schauzu &
... Wolfgang Kalauch

1973

Junior .. Tony Rutter
Senior ... Jack Findlay
Ultra Lightweight Tommy Robb
Lightweight Charlie Williams
Production 250cc Charlie Williams
Production 500cc Bill Smith
Production 750cc Tony Jefferies
Formula 750cc Tony Jefferies
Sidecar 500cc Klaus Enders &
... Ralf Engelhardt
Sidecar 750cc Klaus Enders &
... Ralf Engelhardt

1974

Junior .. Tony Rutter
Senior Phil Carpenter
Ultra Lightweight Clive Horton
Lightweight Charlie Williams
Production 250cc Charlie Williams
Production 500cc Keith Martin
Production 1000cc Mick Grant
Formula 750cc Chas Mortimer
Sidecar 500cc Heinz Luthringshauser &
.. Hermann Hahn
Sidecar 750cc Siegfried Schauzu &
.. Wolfgang Kalauch

1975

Junior Charlie Williams
Senior .. Mick Grant
Classic .. John Williams
Lightweight Chas Mortimer
Production Alex George & Dave Croxford
Sidecar 500cc Rolf Steinhausen &
... Josef Huber
Sidecar 1000cc Siegfried Schauzu &
.. Wolfgang Kalauch

1976

Junior Chas Mortimer
Senior ... Tom Herron
Classic .. John Williams
Lightweight 250cc Tom Herron
Production ... Bill Simpson & Chas Mortimer
Sidecar 500cc Rolf Steinhausen &
... Josef Huber
Sidecar 1000cc Mac Hobson & Mick Burns

1977

Junior 250cc Charlie Williams
Senior .. Phil Read
Classic .. Mick Grant
Jubilee ... Joey Dunlop
Sidecar 1st Leg . George O'Dell & Kenny Arthur
Sidecar 2nd Leg .. Mac Hobson & Stuart Collins
Formula One Phil Read
Formula Two Alan Jackson
Formula Three John Kidson

1978

Junior Chas Mortimer
Senior ... Tom Herron
Classic .. Mick Grant
Sidecar 1st Leg Dick Greasley &
.. Gordon Russell
Sidecar 2nd Leg Rolf Steinhausen &
.. Wolfgang Kalauch

Formula One Mike Hailwood
Formula Two Alan Jackson
Formula Three Bill Smith

1979

Junior Charlie Williams
Senior Mike Hailwood
Classic .. Alex George
Sidecar 1st Leg Trevor Ireson &
... Clive Pollington
Sidecar 2nd Leg Trevor Ireson &
... Clive Pollington
Formula One Alex George
Formula Two Alan Jackson
Formula Three Barry Smith

1980

Junior Charlie Williams
Senior Graeme Crosby
Classic ... Joey Dunlop
Sidecar 1st Leg Trevor Ireson &
... Clive Pollington
Sidecar 2nd Leg Jock Taylor &
... Benga Johansson
Formula One Mick Grant
Formula Two Charlie Williams
Formula Three Barry Smith

1981

Junior .. Steve Tonkin
Senior .. Mick Grant
Classic Graeme Crosby
Sidecar 1st Leg Jock Taylor &
... Benga Johansson
Sidecar 2nd Leg Jock Taylor &
... Benga Johansson
Formula One Graeme Crosby
Formula Two Tony Rutter
Formula Three Barry Smith

1982

Junior ... Con Law
Senior 350cc Tony Rutter
Senior 500cc Norman Brown
Classic Dennis Ireland
Sidecar 1st Leg Trevor Ireson &
... Don Williams
Sidecar 2nd Leg Jock Taylor &
... Benga Johansson
Formula One Ron Haslam
Formula Two Tony Rutter
Formula Three Gary Padgett

1983

Junior ... Con Law
350cc ... Phil Mellor
Senior Classic Rob McElnea
Sidecar 1st Leg Dick Greasley &
.. Stuart Atkinson
Sidecar 2nd Leg .. Mike Boddice & Chas Birks
Formula One Joey Dunlop
Formula Two Tony Rutter

1984

Junior Graeme McGregor
Senior .. Rob McElnea
Classic .. Rob McElnea
Historic 350cc Steve Cull

Historic 500cc Dave Roper
Production 250cc Phil Mellor
Production 750cc Trevor Nation
Production 1500cc Geoff Johnson
Sidecar 1st Leg ... Mike Boddice & Chas Birks
Sidecar 2nd Leg Steve Abbott &
.. Shaun Smith
Formula One Joey Dunlop
Formula Two Graeme McGregor

1985

Junior .. Joey Dunlop
Senior .. Joey Dunlop
Production 250cc Mat Oxley
Production 750cc Mick Grant
Production 1500cc Geoff Johnson
Sidecar Race A . Dave Hallam & John Gibbard
Sidecar Race B Mike Boddice & Chas Birks
Formula One Joey Dunlop
Formula Two Tony Rutter

1986

Junior .. Steve Cull
Senior Roger Burnett
Production A Trevor Nation
Production B Phil Mellor
Production C Gary Padgett
Production D Barry Woodland
Sidecar Race A Lowry Burton &
... Pat Cushnahan
Sidecar Race B Nigel Rollason &
... Don Williams
Formula One Joey Dunlop
Formula Two Brian Reid

1987

Junior Eddie Laycock
Senior .. Joey Dunlop
Production B Geoff Johnson
Production D Barry Woodland
Sidecar Race A Mike Boddice &
.. Don Williams
Sidecar Race B Lowry Burton &
... Pat Cushnahan
Formula One Joey Dunlop
Formula Two Steve Hislop

1988

Junior .. Joey Dunlop
Senior .. Joey Dunlop
Production A Dave Leach
Production B Steve Hislop
Production C Brian Morrison
Production D Barry Woodland
Sidecar Race A Mike Boddice & Chas Birks
Sidecar Race B Mike Boddice & Chas Birks
Formula One Joey Dunlop

1989

Junior .. Johnny Rea
Senior .. Steve Hislop
Ultra Lightweight Robert Dunlop
Production 750cc Carl Fogarty
Production 1300cc Dave Leach
Supersport 400cc Eddie Laycock
Supersport 600cc Steve Hislop
Sidecar Race A Dave Molyneux &
.. Colin Hardman

Sidecar Race BMike Boddice & Chas Birks
Formula One...............................Steve Hislop

1990
Junior.....................................Ian Lougher
SeniorCarl Fogarty
Ultra Lightweight...................Robert Dunlop
Supersport 400ccDave Leach
Supersport 600ccBrian Reid
Sidecar Race A.....Dave Saville & Nick Roche
Sidecar Race B.....Dave Saville & Nick Roche
Formula One..............................Carl Fogarty

1991
Junior.....................................Robert Dunlop
SeniorSteve Hislop
Ultra Lightweight...................Robert Dunlop
Supersport 400ccDave Leach
Supersport 600ccSteve Hislop
Sidecar Race A... Mike Boddice & Dave Wells
Sidecar Race B... Mike Boddice & Dave Wells
Formula One..............................Steve Hislop

1992
Junior.......................................Brian Reid
SeniorSteve Hislop
Ultra Lightweight...................Joey Dunlop
Supersport 400ccBrian Reid
Supersport 600ccPhillip McCallen
Sidecar Race A.... Geoff Bell & Keith Cornbill
Sidecar Race B.... Geoff Bell & Keith Cornbill
Formula One.........................Phillip McCallen

1993
Junior.......................................Brian Reid
SeniorPhillip McCallen
Ultra Lightweight......................Joey Dunlop
Supersport 400ccJim Moodie
Supersport 600ccJim Moodie
Sidecar Race A...................Dave Molyneux &
..Karl Ellison
Sidecar Race BDave Molyneux &
..Karl Ellison
Formula One.............................Nick Jefferies

1994
JuniorJoey Dunlop
SeniorSteve Hislop
Ultra Lightweight.......................Joey Dunlop
Singles.....................................Jim Moodie
Supersport 400ccJim Moodie
Supersport 600ccIain Duffus
Sidecar Race A.. Rob Fisher & Michael Wynn
Sidecar Race B.. Rob Fisher & Michael Wynn
Formula One..............................Steve Hislop

1995
Junior.......................................Iain Duffus
SeniorJoey Dunlop
Lightweight..................................Joey Dunlop
Ultra Lightweight...................Mark Baldwin
SinglesRobert Holden
Sidecar Race A...........................Rob Fisher &
...Boyd Hutchinson
Sidecar Race B Rob Fisher &
...Boyd Hutchinson
Formula One.........................Phillip McCallen

1996
JuniorPhillip McCallen
SeniorPhillip McCallen
Lightweight.............................. Joey Dunlop
Ultra Lightweight...................... Joey Dunlop
SinglesJim Moodie
ProductionPhillip McCallen
Sidecar Race A.... Dave Molyneux & Pete Hill
Sidecar Race B Dave Molyneux & Pete Hill
Formula One........................Phillip McCallen

1997
JuniorIan Simpson
SeniorPhillip McCallen
Lightweight.............................. Joey Dunlop
Ultra Lightweight......................Ian Lougher
Singles Dave Morris
ProductionPhillip McCallen
Sidecar Race A......Roy Hanks & Phillip Biggs
Sidecar Race BRob Fisher & Rick Long
Formula One..........................Phil McCallen

1998
JuniorMichael Rutter
SeniorIan Simpson
Lightweight............................. Joey Dunlop
Lightweight 400.....................Paul Williams
Ultra Lightweight...................Robert Dunlop
Singles Dave Morris
ProductionJim Moodie
Sidecar Race BDave Molyneux &
... Doug Jewell
Formula One..............................Ian Simpson

1999
JuniorJim Moodie
Senior David Jefferies
Lightweight 250cc..............John McGuinness
Lightweight 400cc....................Paul Williams
Ultra Lightweight......................Ian Lougher
Singles Dave Morris
ProductionDavid Jefferies
Sidecar Race A....................Dave Molyneux &
...Craig Hallam
Sidecar Race BRob Fisher & Rick Long
Formula One...........................David Jefferies

2000
Junior David Jefferies
Senior David Jefferies
Lightweight 250cc.................... Joey Dunlop
Lightweight 400cc................Brett Richmond
Ultra Lightweight...................... Joey Dunlop
SinglesJohn McGuinness
ProductionDavid Jefferies
Sidecar Race A..........Rob Fisher & Rick Long
Sidecar Race BRob Fisher & Rick Long
Formula One............................. Joey Dunlop

2001 – *Cancelled due to outbreak of foot &
mouth disease*

2002
JuniorJim Moodie
SeniorDavid Jefferies
Lightweight 250cc....................Bruce Anstey
Lightweight 400cc.................Richard Quayle
Ultra Lightweight.......................Ian Lougher

Production 600cc..........................Ian Lougher
Production 1000cc.................David Jefferies
Sidecar Race A..........Rob Fisher & Rick Long
Sidecar Race BRob Fisher & Rick Long
Formula OneDavid Jefferies

2003
Junior.....................................Bruce Anstey
SeniorAdrian Archibald
Lightweight 400cc............John McGuinness
Ultra Lightweight......................Chris Palmer
Production 600cc..................... Shaun Harris
Production 1000cc.....................Shaun Harris
Sidecar Race A.................................Ian Bell &
...Neil Carpenter
Sidecar Race BDave Molyneux &
...Craig Hallam
Formula One.....................Adrian Archibald

2004
Junior.................................John McGuinness
SeniorAdrian Archibald
Lightweight 400cc............John McGuinness
Ultra Lightweight......................Chris Palmer
Production 600cc.....................Ryan Farquhar
Production 1000cc.....................Bruce Anstey
Sidecar Race A....................Dave Molyneux &
..Daniel Sayle
Sidecar Race BDave Molyneux &
..Daniel Sayle
Formula One.....................John McGuinness

2005
Junior Race AIan Lougher
Junior Race BRyan Farquhar
SeniorJohn McGuinness
Superbike.............................John McGuinness
Superstock..............................Bruce Anstey
Sidecar Race A... Nick Crowe & Darren Hope
Sidecar Race BDave Molyneux &
..Daniel Sayle

2006
SeniorJohn McGuinness
Superbike.............................John McGuinness
Superstock..............................Bruce Anstey
SupersportJohn McGuinness
Sidecar Race A ...Nick Crowe & Darren Hope
Sidecar Race B ...Nick Crowe & Darren Hope

2007
SeniorJohn McGuinness
Superbike.............................John McGuinness
Superstock..............................Bruce Anstey
Supersport Ian Hutchinson
Sidecar Race A..Dave Molyneux & Nick Long
Sidecar Race B..Dave Molyneux & Nick Long

2008
Supersport Junior 1.....................Steve Plater
Supersport Junior 2...................Bruce Anstey
SeniorJohn McGuinness
Lightweight.............................Ian Lougher
Ultra Lightweight......................Chris Palmer
Superbike.............................Cameron Donald
SuperstockCameron Donald
Sidecar Race A......... Nick Crowe & Mark Cox
Sidecar Race B Nick Crowe & Mark Cox

2009

Senior	Steve Plater
Lightweight 1	Ian Lougher
Lightweight 2	Ian Lougher
Ultra Lightweight 1	Ian Lougher
Ultra Lightweight 2	Chris Palmer
Superbike	John McGuinness
Supersport 1	Ian Hutchinson
Supersport 2	Michael Dunlop
Superstock	Ian Hutchinson
TT Zero Pro	Robert Barber
TT Zero Open	Chris Heath
Sidecar Race 1	Dave Molyneux & Daniel Sayle
Sidecar Race 2	*cancelled*

2010

Senior	Ian Hutchinson
Superbike	Ian Hutchinson
Supersport 1	Ian Hutchinson
Supersport 2	Ian Hutchinson
Superstock	Ian Hutchinson
TT Zero	Mark Miller
Sidecar Race 1	Klaus Klaffenbock & Dan Sayle
Sidecar Race 2	Klaus Klaffenbock & Dan Sayle

2011

Senior	John McGuinness
Superbike	John McGuinness
Supersport 1	Bruce Anstey
Supersport 2	Gary Johnson
Superstock	Michael Dunlop
TT Zero	Michael Rutter
Sidecar Race 1	Klaus Klaffenbock & Dan Sayle
Sidecar Race 2	John Holden & Andrew Winkle

2012

Lightweight	Ryan Farquhar
Superbike	John McGuinness
Supersport 1	Bruce Anstey
Supersport 2	Michael Dunlop
Superstock	John McGuinness
TT Zero	Michael Rutter
Sidecar Race 1	Dave Molyneux & Patrick Farrance
Sidecar Race 2	Dave Molyneux & Patrick Farrance

2013

Senior	John McGuinness
Lightweight	James Hiller
Superbike	Michael Dunlop
Supersport 1	Michael Dunlop
Supersport 2	Michael Dunlop
Superstock	Michael Dunlop
TT Zero	Michael Rutter
Sidecar Race 1	Tim Reeves & Dan Sayle
Sidecar Race 2	Ben Birchall & Tom Birchall

2014

Senior	Michael Dunlop
Lightweight	Dean Harrison
Superbike	Michael Dunlop
Supersport 1	Gary Johnson
Supersport 2	Michael Dunlop
Superstock	Michael Dunlop
TT Zero	John McGuinness
Sidecar Race 1	Conrad Harrison & Mike Aylott
Sidecar Race 2	Dave Molyneux & Patrick Farrance

2015

Senior	John McGuinness
Lightweight	Ivan Lintin
Superbike	Bruce Anstey
Supersport 1	Ian Hutchinson
Supersport 2	Ian Hutchinson
Superstock	Ian Hutchinson
TT Zero	John McGuinness
Sidecar Race 1	Ben Birchall & Tom Birchall
Sidecar Race 2	Ben Birchall & Tom Birchall

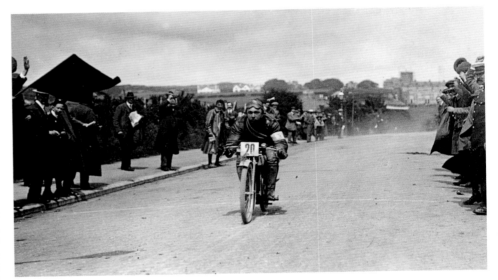

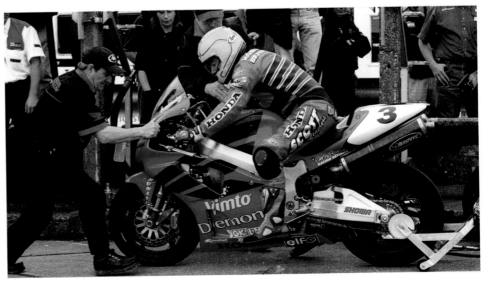

Top Harry Bashall (Douglas) on his way to winning the 1921 Junior TT.

Right Joey Dunlop's long-time manager Davy Wood fettles his Honda in a 2000 Formula One TT pit stop. It was just one of Joey's record 26 TT wins.

Opposite Michael Dunlop continued the dynasty, winning in the 2013 Supertock TT. He has amassed eleven TTs so far.

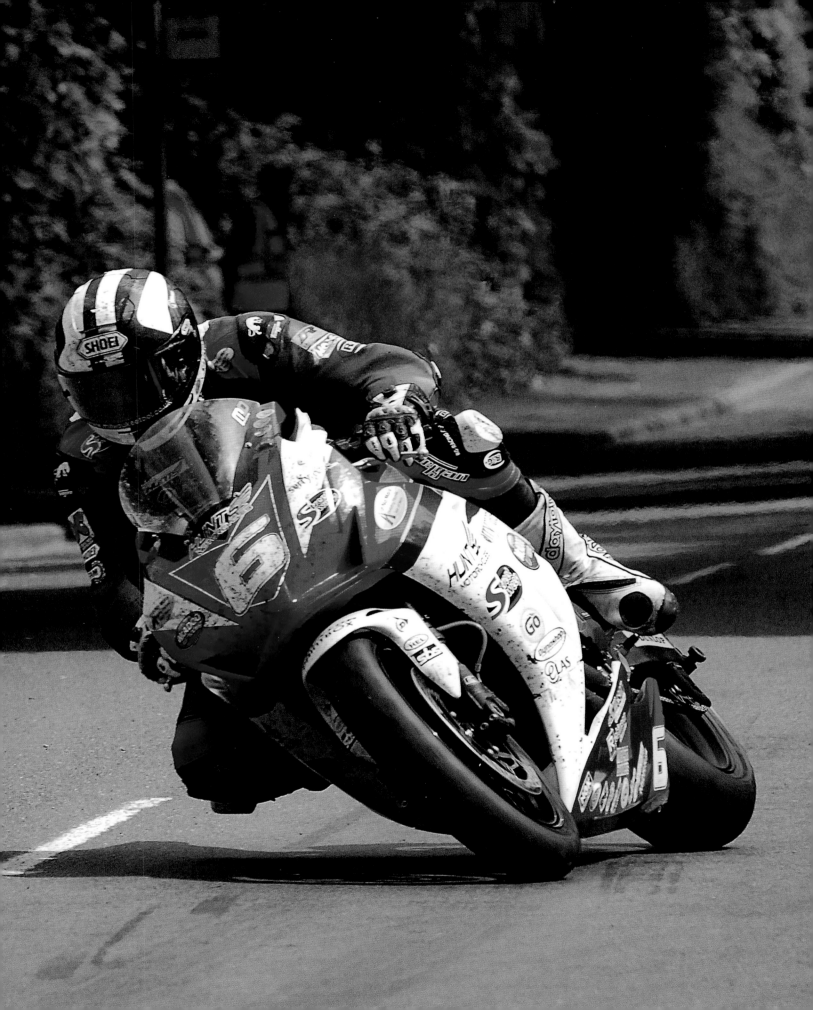

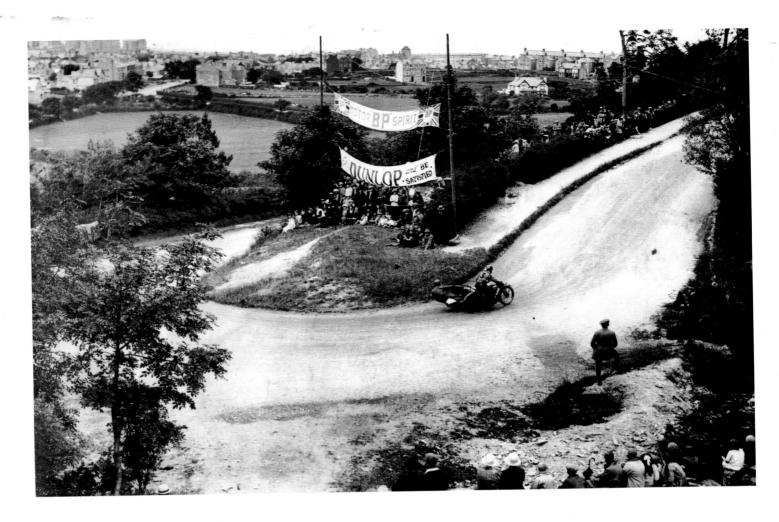

Above George Grinton and passenger A W Kinrade (Norton) make their way round Ramsey Hairpin and up the Mountain. The duo finished third in the 1925 Sidecar TT, the last year sidecars were raced on the Island until 1954, when they were reintroduced on the Clypse Course.

Credits

The publishers would like to thank the following sources for their kind permission to reproduce the pictures in this book.

ALL PHOTOGRAPHS © FOTTOFINDER BIKESPORT PHOTO ARCHIVES
Getty Images: /Fox Photos: 21T, 22T; /Hulton Archive: 20T, 23; /National Motor Museum/Heritage Images: 22B; /Popperfoto: 12; /Topical Press Agency/Hulton Archive: 15, 16T, 16B, 17, 18, 19T, 19B, 174T; /Ian Walton: 7
Topfoto: /Tim Williams/Actionplus: 11, 166T, 166B, 167, 169
WPFotos: /Peter Faragher: 3